The
CHINESE
BRUSH
PAINTING
BIBLE

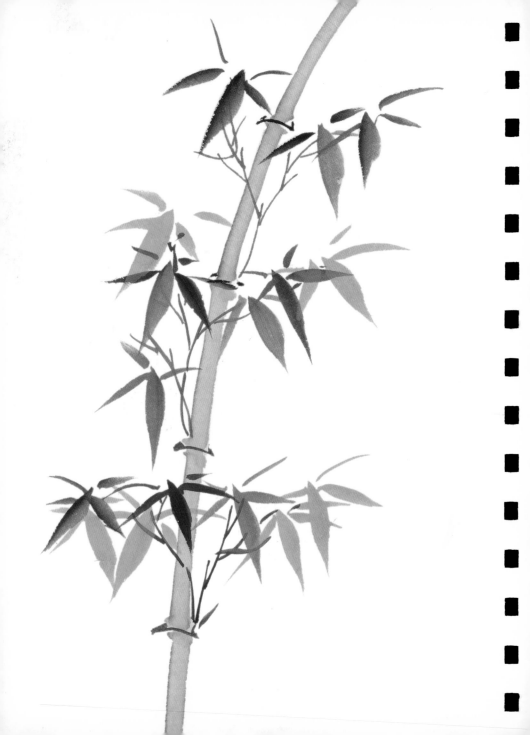

The CHINESE BRUSH PAINTING BIBLE

over 200 motifs with step-by-step illustrated instructions

JANE DWIGHT

NORTH LIGHT BOOKS
Cincinnati, Ohio
www.artistsnetwork.com

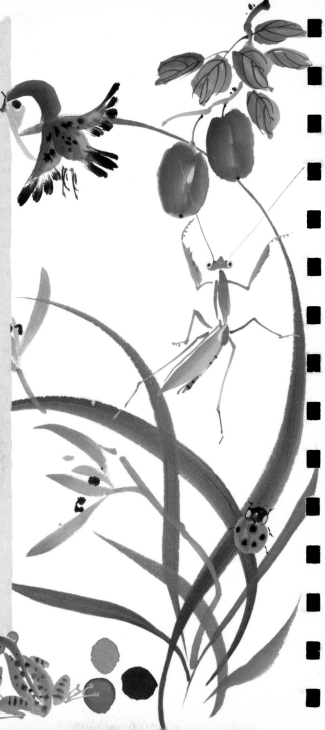

A QUARTO BOOK

First published in North America by
North Light Books,
An imprint of F+W Publications, Inc.
4700 East Galbraith Road
Cincinnati, Ohio 45236
1-800/289-0963
Distributed in Canada by Fraser Direct
100 Armstrong Avenue
Georgetown, ON, Canada L7G 5S4
(905) 877-4411

ISBN-13: 978-1-58180-952-7
ISBN-10: 1-58180-952-2

Conceived, designed, and produced by
Quarto Publishing plc
The Old Brewery
6 Blundell Street
London N7 9BH

QUA: CPM

Editor: *Michelle Pickering*
Senior art editor: *Penny Cobb*
Designer: *Karin Skånberg*
Photographer: *Paul Forrester*

Art director: *Moira Clinch*
Publisher: *Paul Carslake*

Color separation by *Modern Age
Repro House Ltd, Hong kong*
Printed by *Midas Printing
International Ltd, China*

Contents

Introduction

Chinese painting is becoming increasingly popular worldwide. It gives the artist so much more than just brush and paint. Absorbing and calming, spiritual and steeped in history, the tradition offers something for everyone. Beginners will soon produce pictures they like and serious artists will be challenged and intrigued. Most satisfyingly, the pictures you paint will be in your own "handwriting," unique to you. "Writing a picture" is the usual way of describing the painting process in China.

The book starts with a brief history of Chinese painting styles, followed by a chapter on materials, tools, and basic techniques. The heart of the book is a directory of 200 motifs, starting with the "Four Gentlemen"—the bamboo, orchid, plum blossom, and chrysanthemum. Chinese painting courses usually begin with the Four Gentlemen because the wide range of strokes required to paint each of them provides a catalog of strokes that can then be used to paint any other subject.

When you have practiced painting the Four Gentlemen, and feel more confident about holding and loading the brush, you

By practicing simple compositions such as a wisteria and swallow, you can eventually progress to more ambitious paintings such as this landscape in the style of Wang Ximeng.

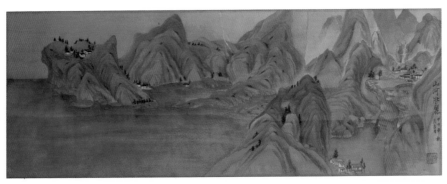

can look through the motif selector on pages 44–49 and pick ones that appeal. The motifs are organized into subject areas, such as flowers, birds, animals, people, fruit, vegetables, and landscapes. Within each subject area the styles of painting vary. This ensures that there will be something to suit everyone's taste. Some, such as the mouse and the snail, are very simple and should be easy to master in a few strokes. Others, such as the dragon and the tiger, will take a little more time and many more strokes. There are motifs of people that are wild and free, and others that are just very simple outlines. At the end of the directory are some simple compositions, comprising two motifs each. Practice these and you will soon feel confident to start composing pictures of your own.

Your paintings can be any size. They could be used as murals or painted onto greeting cards. Decorating furniture, tiles, and walls with Chinese motifs can be very satisfying, and giving images as gifts even more so. Many motifs have a special significance that makes them ideal as gifts—a picture with a crane and pine signifies a long life and happiness, for example. Most important of all, however, is the joy of learning a new skill that will give you hours of pleasure.

Jane Dwight

Chinese brushes allow you to create a wide variety of expressive strokes.

Motifs vary from wildlife to flora and fauna, with something to suit all occasions and tastes.

INTRODUCTION

7

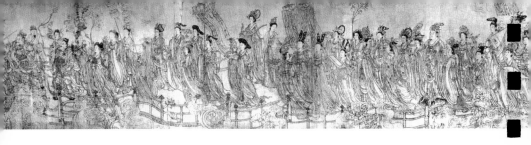

Chinese Painting Styles

The origins of Chinese art can be traced back to Paleolithic times. Rocks carved and painted with images have been found in the Yin Mountains and in Yunnan Province. Marvellous lifelike animals, peaceful village scenes, fierce battles, and elaborate ceremonies can all be studied on the rocky surfaces.

From Paleolithic times on, paintings began to appear on pottery, gorgeous lacquer works, and wooden musical instruments. Silk was invented in ancient China long before paper, and two of the earliest ink-on-silk pictures, dating from the 3rd century B.C., are in the Hunan Provincial Museum. They are silk banners, found in burial chambers, and show a profile of the person being buried. Dragons and birds accompany the figures, and they have all been drawn with ink and a brush in the outline technique. Ink and colors complete the pictures.

Paper was invented during the Han Dynasty (206 B.C.–A.D. 220). Over the next few centuries, calligraphy, poetry, painting, and seal engraving developed and famous individual artists began to emerge. Gradually, paintings were divided into three distinct groups: figures, landscapes, and bird-and-flower pictures. Animals and plants were included in the bird-and-flower group. The peaceful Sui and Tang Dynasties (581–906)

saw a great flowering of painting, calligraphy, and poetry. The golden age under Emperor Minghuang (712–756) is often described as the most brilliant era in Chinese history. Very rarely have so many gifted artists and writers lived at the same time. Great painters (such as Wu Daozi) rubbed shoulders with gifted poets (such as Li Bai) and wonderful calligraphers (such as Yan Zhenqing), delighting in and learning from each other's work. Wu Daozi painted public murals and crowds flocked to watch him perform "with a brush that swept around like a whirlwind."

It was another emperor, however, who was to go down in history as having the greatest influence on the course of Chinese painting. He was Zhao Ji (1082–1135) of the Song Dynasty (960–1271). Being the 11th son of Emperor Shenzong, Zhao Ji was very unlikely to inherit the title. This left him free to follow his passion for the arts and he became an expert at painting, poetry, and calligraphy. By a twist of fate, Zhao Ji did become the

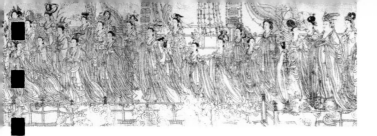

EIGHTY-SEVEN CELESTIALS
BY WU DAOZI (c.685–758)
Draft painting of fresco

Wu Daozi, the legendary artist from the Tang Dynasty, was a master of loose brush work. He could capture the essence of an object in just a few beautiful strokes. Unfortunately, none of his paintings survives, but some drawings, stone carvings, and murals have been attributed to him, or are copies of his work. In this draft work, a vast crowd of celestials shimmers and moves as a result of the energetic and brilliant brush work.

A THOUSAND LI OF RIVERS AND MOUNTAINS
BY WANG XIMENG (1096–1116)
Ink and color on silk **Palace Museum, Beijing**

One of the most famous court painters, taught by Emperor Huizong himself, was a young man called Wang Ximeng. He died very young and this is the only work of his left today. It is a perfect landscape picture in the meticulous Academic style. Brilliant mineral blue and mineral green mountain ranges rest in a golden glow, as if they are bathed in the twilight of a sunny day. This blue/green tradition, begun in the Tang Dynasty, was used widely during the Song and was adopted by the Imperial family, too.

next emperor of China, and was known as Emperor Huizong. This was very unfortunate for the country, because he had no heart for the task, but fortunate for the art world. Emperor Huizong reorganized the Zhao family painting academy and brought leading scholar-artists into the palace and many artists into the capital. The three aspects of painting that he imposed on the Song Academy painters were: an emphasis on realism, rooted in careful study; copying of past masters; and adding calligraphy and poetry to a picture.

During the Song Dynasty, another group of artists emerged whose influence on the development of Chinese painting was fundamental. These were the "Literati" artists. They were influenced by poets and writers, often adopting their ideas and translating them into paintings. Their paintings were more expressive, sought to achieve depth and simplicity, and were increasingly done

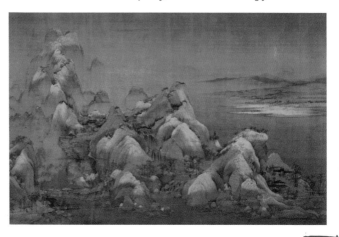

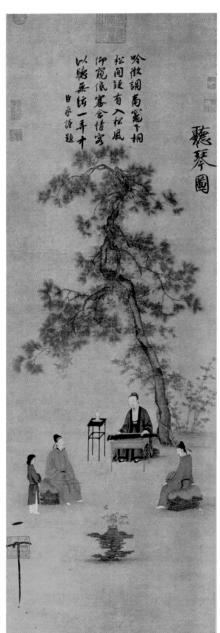

LISTENING TO THE QIN
BY EMPERIOR HUIZONG (1082–1135)
Ink and color on silk

Notice the jewel-like colors and the very fine lines in this painting by the Emperor Huizong. Each fold of fabric stands out and every leaf and flower is carefully depicted. There are lots of seals on the picture and lovely calligraphy, done by the Prime Minister Cai Jing, who is also in the picture.

on paper rather than silk. By the end of the Song Dynasty, the two basic painting styles of Chinese art had become established. The Academic artists leaned toward the fine-brush, meticulous, *gongbi* style, while the Literati artists painted with a free brush in the *xieyi* style.

The pictures painted in the Academic tradition were largely executed on treated silk. Figures, flowers, birds, and landscapes were meticulously drawn with fine brushwork. Colors were added in thin layers, and both the back and the front of the picture were painted. The pictures painted in the Literati tradition were very much more free. Usually painted on absorbent paper with deft brush strokes, pictures by the Literati artists show a skill much more concerned with capturing the spirit and emotion of a subject. The thoughts and ideas of the artist were often evident, and pictures incorporated poetry and calligraphy to complete the feelings being portrayed. Throughout the following Dynasties, the Literati tradition gathered strength and has become the major "freestyle" form of painting today.

Many famous artists have come and gone since the Song Dynasty, and both the

LANDSCAPE (DETAIL ABOVE)
& TWO BIRDS (LEFT)
BY CHU TA (1625–1705)
Both ink and color on silk **Academy of Arts, Honolulu (above) & Sammlung K. Sumitomo Gallery, Japan (left)**

Chu Ta, better known as Bada Shanren, was a member of the Ming royal family. When the dynasty was overthrown, he escaped into the mountains and became a monk. He used his extraordinary talent to paint the landscapes, birds, and plants around him. His clean and clever freestye technique, combined with fine calligraphy and poetry, made him one of China's most important artists.

Academic and Literati styles continued to develop and evolve. Most serious painters were well versed in both styles. Throughout this history of painting, four plants came to be regarded as the cornerstones for any study of Chinese art by new students. These have become known as the Four Gentlemen: the bamboo, chrysanthemum, plum blossom, and orchid. Each plant has its own distinct character. The bamboo is strong, true, and honest; the orchid shy, pale, and elegant. Chrysanthemums are brash and stoical, and capable of flowering in the snow, as are the tiny delicate plum blossoms that herald spring and hope. Each plant has several distinct brush strokes that need to be learned in order to paint them. They are studied first and appear at the beginning of the motif directory.

ORCHID
BY JANE DWIGHT
Ink and color on Xuan paper

This delicate orchid nodding in the breeze was painted on bamboo paper with an orchid-bamboo brush. The sweeping leaves are executed by pressing and lifting the brush as it moves across the paper. The hearts of the flowers are dotted with red to give a pretty contrast. Gossamer thin, gold-and-silver flecked paper was pasted over the image once it had dried.

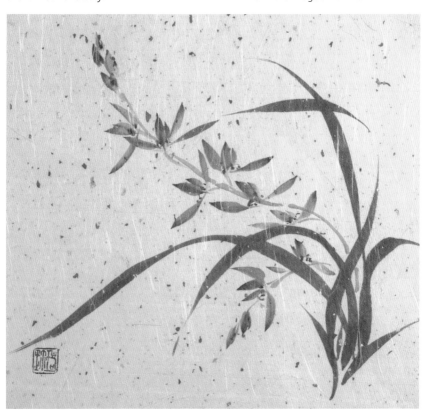

BAMBOO
BY JANE DWIGHT
Ink and color on Xuan paper

This freestyle bamboo was painted with a large soft-haired brush on very absorbent grass paper. Notice that the tones (or "colors") of the ink vary, as do the sizes of the canes. Wet and dry marks also add to the contrasts in the picture.

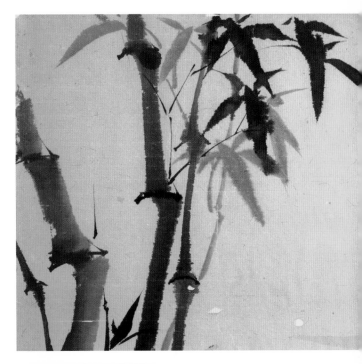

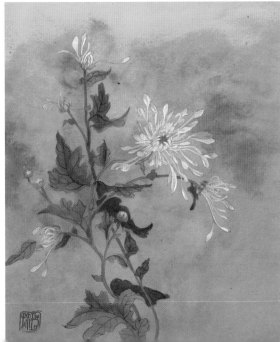

CHRYSANTHEMUM
BY JANE DWIGHT
Ink and color on Xuan paper

Outlined first with a fine-line brush, this meticulous-style painting of a spider chrysanthemum was painted on beige-colored, non-absorbent paper. A series of indigo and burnt sienna washes complete the picture.

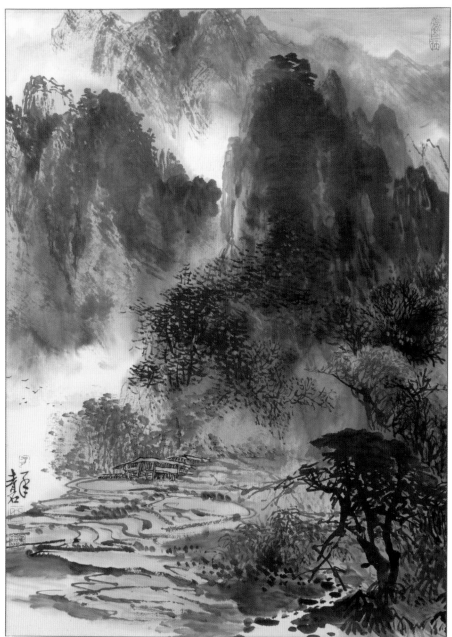

LANDSCAPE WITH PADDY FIELDS
BY QU LEILEI
Ink and color on Xuan paper

This picture, painted in the 21st century, is a lovely example of freestyle painting. The mountains are created with bold wet ink strokes, and the texture marks and trees are both wet and dry, light and dark. Some of the colors are muted, such as the soft blues and greens, while the bright flash of red leaves adds excitement. All these contrasts give the picture a wonderful depth. Birds wheel in the lingering light among the darkening mountains, and the peaceful homestead provides a focus for the viewer. It would be a wonderful place to live, with splendid views, mountains, and fields to walk in and babbling brooks to sit beside. The free brush strokes have caught the twilight perfectly.

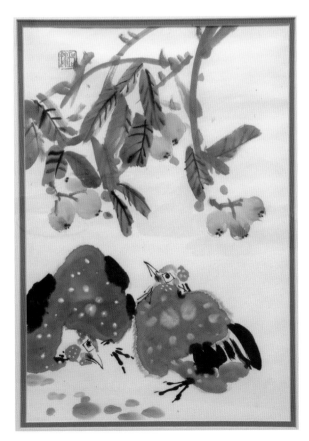

GUINEA FOWL AND LOQUATS
BY JANE DWIGHT
Ink and color on Xuan paper

Large, gray, wet ink blobs provide soft bodies for the two Guinea fowl in this picture. Their distinctive white spots were added while the ink was still wet. Their comical faces are painted with much finer lines, giving a nice contrast to the large wet strokes. The two birds are sharing a feast of loquats. The whole picture is a freestyle adventure.

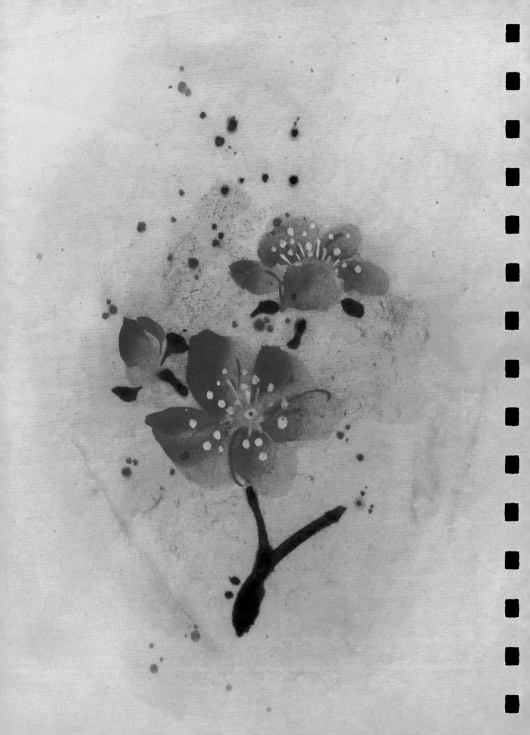

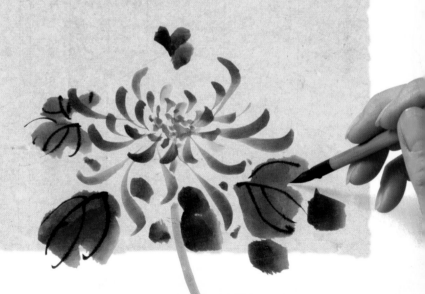

MATERIALS
and
TECHNIQUES

Chinese art materials are unique to the art form, but should be easy to purchase in any large shopping complex or over the internet. This chapter examines all the materials you will require and gives instructions for the basic techniques of using them.

The Scholar's Desk

For more than two thousand years, Chinese artists have arranged their materials and equipment, or "scholar's objects," on a "scholar's desk." The most important objects on the desk are the "Four Treasures"—brush, paper, ink, and inkstone.

SCHOLAR'S OBJECTS

Four Treasures: brush, paper, ink, and inkstone.

❋

Soft, feltlike painting mat

❋

Brush rest

❋

Paperweights

❋

Colored paints

❋

White plates or tiles for mixing colors

❋

Small water dropper

❋

One or two water containers

Setting up an orderly place to paint, with all the right materials to hand, provides a time of meditative ritual and a chance to think about the picture to be painted. Chinese painting is done horizontally, on a flat surface, and the scholar's desk is simple to arrange. First, place a piece of white felt or an old blanket on the desk. Cut the paper to the required size and place this on top of the felt. Put a paperweight at the top and bottom of the paper to hold it still as you paint (you can move these to one side if you prefer). Place all the other items within easy reach, on the right side of the felt if you are right-handed, and on the left if you are left-handed.

Use the time spent setting up your desk as an opportunity to contemplate the painting you are about to create.

ARTIST'S TIP

Before you begin to paint, try to adopt the proper sitting position. Ideally, the tabletop should be at waist level. Sit up straight, with the back at a right angle to the hips and the knees at right angles to the lower legs. Plant the feet firmly on the floor, hip width apart. You can also stand while painting, and large, generous strokes are made more easily this way.

Brushes

The brush is said to be the artist's true friend. Chinese brushes are highly flexible and can be shaped into a point for fine work, or the tip can be flattened or splayed to create different effects. The hairs in a Chinese brush are graded to hold a good deal of liquid, so while you can try painting with natural-hair Western artist's brushes, be aware that they will not produce the same strokes.

Firm brushes Known as wolf-hair brushes, these can be made from horse, fox, badger, sable, or rabbit hair. They are usually brown or black. Firm brushes produce firm strokes and fine lines, and are easier for beginners to control. The fine-line, small "plum blossom," and large "orchid bamboo" brushes (pictured from left to right) are used to paint the motifs in this book.

Soft brushes Known as sheep-hair brushes, these are made from sheep or goat hair and are usually white. Pliant and non-resilient, soft brushes are useful for freestyle painting. They hold colors perfectly, so they can produce beautiful petals or small washes. The vast range of special effects that can be produced with a soft brush make it the favorite of experienced artists. Choose the size of soft brush according to the size of the picture you want to paint.

Mixed-hair brushes Mixed-hair brushes usually have wolf hair in the center of the ferrule surrounded by sheep hair, giving a firm central core to the brush. A large mixed-hair "blue peak" brush is used to demonstrate the mark making in this chapter.

Mixed-hair brushes

Soft brushes

Firm brushes

Brushes with long mixed-hair ferrules are very useful for painting the veins on leaves.

Wash brushes Chinese wash brushes are made from soft goat hair and look like a Western hake brush (which can be used instead). They are used to paint washes of color over the finished painting.

Additional brushes As you become more experienced, try using some of the many other types of Chinese brushes available, such as the chicken-feather brush, whose swirling feathers can be used to produce wonderfully textured branches and rocks.

Wash brushes

19

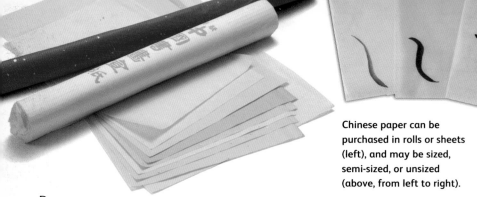

Chinese paper can be purchased in rolls or sheets (left), and may be sized, semi-sized, or unsized (above, from left to right).

Paper

The most common type of paper comes from Xuancheng in China. It is called Xuan paper and can be made from mulberry bark, hemp, or linen, but the best Xuan paper is made from sandalwood bark. Xuan paper is sold in large sheets or in convenient rolls. It comes in several thicknesses and many colors. Another popular paper is made from bamboo or straw. Called grass paper, or *mao bian*, it is a pretty cream color and is excellent for beginners and experienced painters alike.

Sizing It is the degree of absorbency of a paper that defines its quality, and the absorbency depends on the amount of size the paper contains. Size is a gluelike substance that binds the paper fibers together and gives the paper its surface. Normally, paper can be divided into three types: unsized, semi-sized, and sized. Unsized paper is very absorbent and fairly challenging to use. Semi-sized paper is a little more forgiving. Sized paper, known as meticulous paper, is usually used for fine brush work.

Fans and booklets Ready-made paper fans, books, and cards can be purchased. These make wonderful gifts when decorated with motifs (but practice the motifs first). Little booklets can be stood on a table, rather like a photo frame. The twelve signs in the Chinese zodiac are a popular way of decorating them.

ARTIST'S TIP

It is possible to paint Chinese motifs on Western watercolor paper, using Chinese brushes. The freestyle method of painting has evolved using absorbent Xuan paper, so the effect will not be quite the same. However, greeting cards can look very good.

Ink

Ink has been made in China for thousands of years. Soot, gathered from burning pine, charcoal, or lampblack, is mixed with glue and placed into molds. The mixture sets solid to produce an ink stick. Inkmakers may also add fragrances, preservatives, and for the wealthy, crushed gold or pearls. The three main kinds of ink stick give slightly different qualities when painting. Lampblack, or oil soot, is most commonly used because it gives a jet black, rich ink with lots of luster. It is good for all sorts of painting. The pine soot ink stick does not have as much glue in it and produces a cooler, paler color. Lots of meticulous paintings are made using pine soot ink sticks. Charcoal soot ink sticks give a less sticky ink because they have a lower glue and soot content. Freestyle artists enjoy the way charcoal ink is less easy to control on Xuan paper.

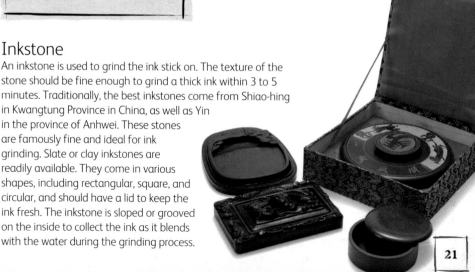

Although ink sticks are traditionally used, bottled inks work just as well for the beginner (above). You will need an inkstone (below) for grinding the ink if you use a stick.

> ### ARTIST'S TIP
>
> *Ink sticks molded into exotic shapes such as elephants or insects make ideal gifts, as do the many fabulously carved inkstones. They can be expensive, and antique ones fetch high prices.*

Inkstone

An inkstone is used to grind the ink stick on. The texture of the stone should be fine enough to grind a thick ink within 3 to 5 minutes. Traditionally, the best inkstones come from Shiao-hing in Kwangtung Province in China, as well as Yin in the province of Anhwei. These stones are famously fine and ideal for ink grinding. Slate or clay inkstones are readily available. They come in various shapes, including rectangular, square, and circular, and should have a lid to keep the ink fresh. The inkstone is sloped or grooved on the inside to collect the ink as it blends with the water during the grinding process.

Grinding the Ink

The ink stick needs to be ground on the inkstone just before you begin painting. This process produces its own magic. Savoring the lovely fragrance while you think about the picture to be painted will calm you and create the right frame of mind for painting.

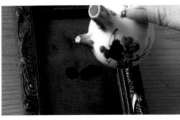

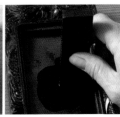

2 Hold the ink stick between the thumb and first two fingers and place it vertically into the water. Press firmly on the stone and slowly rotate the ink stick in a clockwise circular motion for 2 or 3 minutes.

1 Pour a few drops of water onto the inkstone. The length of time grinding takes will depend on how much water is used; you will learn the right amount with practice.

3 Grind the ink stick until a dry path follows the stick through the ink; the ink should be quite thick. If the ink becomes too thick, it will not flow over the paper, so add a little more water. Conversely, thin ink will run too quickly, so grind a little longer.

4 When you have finished grinding, dry the ink stick on a paper towel to prevent the stick from cracking. A wet stick will adhere to any surface it is left on, because it contains glue.

ARTIST'S TIP

When you have finished painting, always remember to wash the inkstone and dry it thoroughly. The ink will dry and stick to the stone if it is left.

MATERIALS AND TECHNIQUES

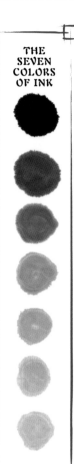

Ink colors

Ink is fundamental to Chinese brush painting, which is referred to as "ink painting" in China. One of the most important qualities of freshly ground ink is the range of tones it produces when diluted. These are known as "the colors of the ink." Traditionally, seven shades can be obtained by diluting jet black ink with water, down to the very palest gray. However, five tones are easier to produce.

Ink textures

By using the various tones, or colors, of ink with a wet or dry brush, it is possible to produce a variety of textures. "Water ink" texture is made by using a very wet brush and the palest tone of ink. "Dry light ink" needs a dry brush and light ink; this combination is commonly used to give rocks their texture. "Light ink" and "dark ink" combine light and dark tones of ink with varying amounts of water in the brush. "Burnt ink" is the very darkest black ink painted with a dry brush.

Water ink **Dry light ink** **Light ink** **Dark ink** **Burnt ink**

MATERIALS AND TECHNIQUES

23

Holding the Brush The Chinese
method of holding the brush will feel a little odd initially,
but persevere because authentic Chinese strokes cannot
be made without holding the brush correctly. When painting
a large picture, raise the wrist and elbow above the paper.
For a fine or small painting, rest the wrist lightly on the table.

Upright hold
The Chinese brush can be held upright,
perpendicular to the paper. Grasp the
brush handle just above the center, with
the thumb on one side and the index
and middle fingers on the other. Use
the ring finger to support the brush,
with the little finger pressed against
the ring finger.

45-degree hold
Some strokes require the brush to be
held at a 45-degree angle to the paper,
which allows more of the ferrule to
come into contact with the paper
surface. Grasp the brush in the same
way as for the upright hold, but angle
it at 45 degrees.

Horizontal hold
Some strokes require you to hold
the brush almost parallel to the paper
so that almost the whole side of the
ferrule is in contact.

ARTIST'S TIP

*Although a high grip on the
brush will produce more spirited
calligraphy and very interesting
marks, try holding it low down,
too. A grip that is a little bit above
center will probably be the most
comfortable, but keep changing
and experimenting to achieve the
widest variety of possibilities.*

Upright hold

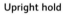

45-degree hold

Horizontal hold

Loading the Brush

A standard Chinese brush holds a lot more liquid than its equivalent in the West. Never load a brush by dabbing or scrubbing it on the inkstone because this will disorganize the hairs of the brush, making good strokes impossible.

1 Wet the brush thoroughly in clean, cold water. Remove excess water by pulling the brush across the edge of the water container.

2 Dip the brush into the ink and roll it, pulling it through the ink toward you, away from the tip. Aim to load the brush until it is three-quarters full while keeping the hairs in a tidy point. The top quarter should contain only water.

3 Pull the hairs of the brush across the lip of the inkstone to get rid of excess ink.

ARTIST'S TIP

When you first buy a Chinese brush, it will probably have a plastic or hollow bamboo cap over the starched and pointed ferrule. Take the cap off and throw it away. Replacing it will encourage mold to grow on the damp hairs as well as bending or breaking any stray hairs. The starch on the brush protects it during transport, and must be removed before you can use the brush. Simply dip the brush into cold water for half an hour, then gently bend the hairs with finger and thumb to make sure that they are free of starch. This is called "cracking the brush."

Mark Making—Ink

Experiment with mark making on any paper; newsprint is absorbent and cheap. Try painting the strokes in the different "colors" of the ink, and continue painting until the ink runs out. This will give you an idea of what a dry brush stroke looks like in the different tones of ink.

Lines

The linear strokes used in Chinese calligraphy are also fundamental to brush painting. Different types of lines can be used to paint everything from leaves to clothing.

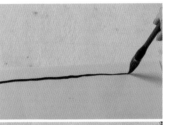

1 Load the brush with ink, hold it upright, and draw a line with the tip. Raise the brush to the very point of the tip toward the end of the line. Note how fine a line you can produce.

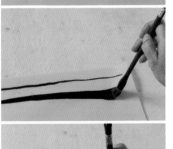

2 Draw another line, checking that your grip is still correct, that you are sitting upright, and that the brush is upright. Very slowly increase the pressure on the tip of the brush as you paint a line. The line will get wider and wider.

3 Begin another line with the tip of the brush, increase the pressure on the tip as you travel, then lift the brush back onto its point.

MATERIALS AND TECHNIQUES

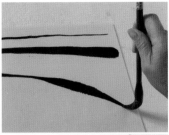

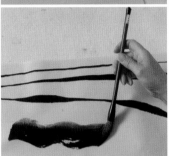

4 Keeping the brush upright, gently press and lift the brush again as you pull it along. Note that the tip of the brush runs through the center of the whole stroke. This press-and-release stroke is useful for leaves, such as those of the orchid.

5 Reload the brush and hold it almost horizontally to the paper. Paint a wriggling line using the side of the ferrule. This demonstrates three things: the line is very wide; there is water in the heel of the brush, which dilutes the ink on that side; and the ink runs out faster. This is a less common mark but can be useful.

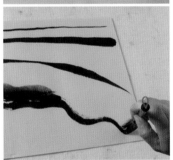

6 Return the brush to an upright position and continue the wavy line. The contrast in the size of the line is immediately apparent, indicating how important the brush-to-paper angle is.

THE PULL STROKE
Pull the brush tip over the paper surface, keeping the tip in the center of the line. This stroke is fundamental to the art and is used a great deal.

WET AND DRY BRUSHES

Some strokes require a very wet brush (below left) or a dry one (below right). For a very wet brush, soak the brush in clean, cold water and do not wipe off the excess on the side of the water container before you load the ink. If the brush marks begin to dry too quickly, simply dip the tip of the brush into the water to refresh it. If a dry brush is called for, load the brush and then press the heel of the brush onto a scrap of absorbent paper to take out the excess liquid.

THE PUSH STROKE
Push the brush tip over the paper surface, in the opposite direction to the pull stroke. The brush tip will bend, but it should still be kept in the center of the line.

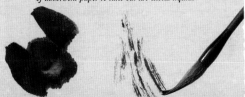

27

Dots

Dots are a vital part of Chinese painting. Said to be the source of Chinese calligraphy, all strokes have originated from the dot.

1 Hold the brush upright and press the tip onto the paper, lifting it quickly to leave round dots.

2 Try turning the brush with the thumb as you press the tip of the brush onto the paper. This will give a fuller dot.

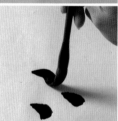

3 Try a teardrop dot by starting with the tip of the brush and pulling the brush a little as you press and turn it on the paper.

4 Create an even bigger dot by holding the brush upright, beginning the dot, and then moving the brush sideways to produce a long thin, short fat, or rounded mark.

5 Try combining some of these marks to paint leaves.

NAIL-HEAD STROKE

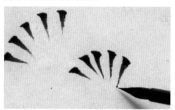

Hold the brush at a slight angle to the paper. Press the tip onto the paper and then move it into a downward stroke, lifting the brush into an upright position as you paint. Pine needles are sometimes done this way.

TIGER'S WHISKERS

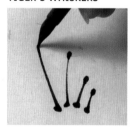

These fine, springy strokes are called "tiger's whiskers." Press the tip of the brush onto the paper, then lift the brush onto its very tip and move firmly upward. Press again and then lift the brush off the paper; do so with a downward movement, back toward the origin of the stroke, never upward. This stroke is often used to paint plum blossom stamens.

Bone stroke

A basic calligraphy stroke, this one takes a little practice. It is almost a straight line with points of pressure at either end.

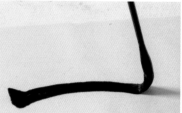

1 Press the brush on the paper with the tip pointed toward the top left of the page.

2 Lift the brush slowly and begin to pull to the right, coming out of the center of the first mark.

3 Press the brush again at the end of the stroke, then lift and end by painting back to the left a little way along the line. This process is called "hiding the tip."

Texture marks

There are many different marks used to give mountains and rocks their texture. They are called "cun fa." This is an example of just one of them.

1 With medium dry ink, and an uneven pulling stroke, describe a group of rocks. The combination of uneven strokes and dry ink will produce textured lines.

2 Using pale, dry ink, and holding the brush at a 45-degree angle, lightly scrape the surface of the paper behind the lines of the rocks to give them texture and dimension.

SPLAYED BRUSH TIP

To make a very pretty mark, try flattening the tip of the wet brush with your fingers. Now dip each side of the brush into ink. Paint the stroke with the flat tip traveling upward across the paper. The three-dimensional "tube" produced could be used to illustrate bamboo.

Chinese Colors
Chinese paintings have to be backed because the paper is so fine, so Chinese paints and inks contain enough glue to anchor them to the paper. Western paints do not contain the same amount of glue, so it is best if you mix them with a little Chinese ink or glue if you want to use them.

COLOR POWDERS
Color powders are sold in little envelopes. They are made from minerals such as vermilion, azurite, and malachite (these three minerals give red, blue, and green). Sometimes glue has to be added to the powder and ground, with a little water, using a pestle and mortar.

CHINESE WATERCOLORS
The easiest colors to use are tubes of Chinese watercolors. These are cheaper than Western watercolors and provide all the colors required.

COLOR CHIPS
Color chips come in little boxes. They are organic and made from plants such as indigo, gamboge, or safflower. Chip colors usually come ready-mixed with glue, so they are ready to use once water has been added.

COLOR STICKS
It is possible to buy sticks of color made from natural pigments mixed with glue. Grind them in the same way as ink sticks, but use a different inkstone.

JAPANESE TEPPACHI COLORS
Jewel-like Japanese Teppachi colors are also easy to use but can be very bright. Purists prefer the more muted Chinese palette.

Mixing colors

Mixing Chinese colors must be done with care, because organic colors are transparent and mineral colors opaque. Mixtures of transparent colors may produce very bright results, while mineral ones can be rather dull. The best thing to do is experiment. The colors listed for each of the motifs are just general guidelines—choose whatever appeals most to you.

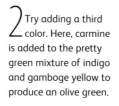

1 Always mix colors on a white tile or dish. Apply a dab of each color and then mix them together with the brush.

2 Try adding a third color. Here, carmine is added to the pretty green mixture of indigo and gamboge yellow to produce an olive green.

3 A darker olive green can be made by mixing gamboge yellow with ink. Ink can cause some colors to granulate, in which case the black tube color could be used.

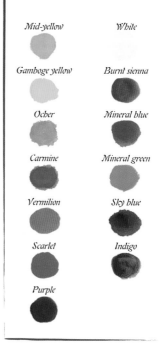

COLOR PALETTE

This basic color palette was used to paint the motifs in this book, but don't worry if your palette is different—just aim for a range of shades and mix them to create colors you like.

Mid-yellow

White

Gamboge yellow

Burnt sienna

Ocher

Mineral blue

Carmine

Mineral green

Vermilion

Sky blue

Scarlet

Indigo

Purple

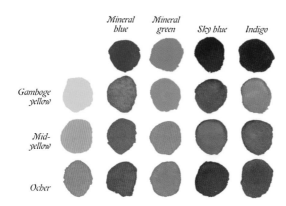

	Mineral blue	Mineral green	Sky blue	Indigo
Gamboge yellow				
Mid-yellow				
Ocher				

COLOR GRIDS

One of the most useful exercises for color mixing is to make a color grid. For example, paint a dot of each different yellow down the side of the page, and a dot of each blue and green along the top. Mix each pair of colors and paint a dot in the relevant place on the grid.

31

Color Loading

One of the most exciting qualities of the Chinese brush is its ability to hold two or three colors at the same time, and to keep them distinct. Try loading a large firm brush with two colors first, then try with three.

Double loading

ARTIST'S TIP

When loading a brush with more than one color, you can mix the colors a little by pressing the brush on the plate gently.

1 Wet the brush and load it three-quarters full with yellow in the same way as you would load it with ink (page 25).

2 Dip half of the ferrule into red.

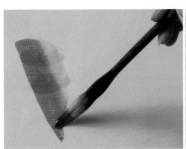

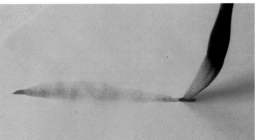

3 Hold the brush at 45 degrees to the paper and paint a stroke with the side of the ferrule. Both colors will appear separately.

4 Now try painting a stroke with the brush held upright, starting and ending with just the tip of the brush in contact with the paper and pressing a little in the middle of the stroke. Red will run through the center of the stroke, with yellow in the middle as well.

Triple loading

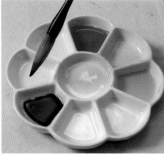

1 To produce a stroke displaying three colors, repeat the process for loading yellow and red, then dip just the very tip of the brush into indigo.

2 Hold the brush at 45 degrees to the paper and paint a stroke. As the stroke lengthens, the brush tip will become splayed and the colors will mix together. Lift the brush onto its tip and notice how the different colors disappear.

Flat-tip loading

This is not a traditional technique, but it demonstrates how versatile the Chinese brush can be and does give some lovely effects.

1 Dip a large firm brush into water, then flatten the tip with finger and thumb.

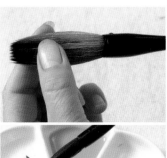

2 Dip the flattened tip into pale green and then carefully dip each side of the tip into indigo. Alternatively, use another brush to apply indigo to the sides of the flattened one.

3 Paint a series of wide strokes to form a bamboo stem. The indigo will be visible along the edges of the stem.

MATERIALS AND TECHNIQUES

33

Mark Making—Color

Color is always exciting, and if you are new to Chinese colors and brushes, hours of discovery lie ahead. All these marks will help you build up confidence with the movement of the brush and acquire a feeling for its possibilities and what it will do with color.

Lines

1 Try painting the same lines, in color, that you did earlier with ink (pages 26–27). Load the brush with a color of your choice and begin with a fine line. Gradually press and lift the brush as you move across the page. Bamboo and orchid leaves require this sort of movement.

2 Load the brush with two colors and begin a wide stroke with the brush held horizontally. Move the brush into an upright position at the end of the stroke; notice how the second color disappears as you raise the brush.

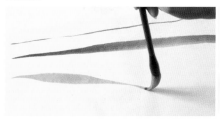

THE PULL STROKE
Make short pulling strokes, with the tip running through the center of each stroke. These could be used to give texture to bark or for water.

THE PUSH STROKE
Push the brush tip over the paper surface, keeping the brush tip in the center of the line. This stroke can be used to create similar effects to the pull stroke.

Curved strokes

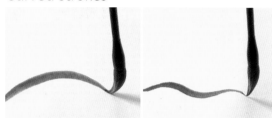

1 Paint a curved line, pressing and lifting as you move the brush. Long-leaved plants and grasses are painted with this kind of stroke.

2 Try to paint a more wavy line with an upright brush.

3 This curved stroke is used for chrysanthemum petals. Hold the brush at a slight angle and press the tip onto the paper. Paint a short curve, bringing the brush upright onto its tip by the end of the movement.

DOTS

Dots painted with the tip of the brush are useful to practice. They can be used to paint a variety of subjects, ranging from plum blossom petals to grapes and even panda ears. Hold the brush upright and twist it with the thumb to give a nice round shape.

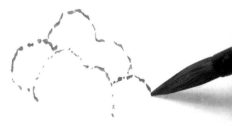

DRY MARKS

These tiny dry brush marks will produce a cauliflower. They need to be done very lightly with just the tip of the brush.

35

Painting Styles

Painting styles change constantly as artists learn how to use the tools and materials of an art form and then take flight. Here is a brief practical comparison of the two main styles of brush painting using a chrysanthemum as the subject.

Freestyle *(xieyi)*

Xieyi means "to write a picture." Brushwork is free and spontaneous, giving rise to spirited pictures. It is characteristic of the Literati school of painters of the Song Dynasty and is the most popular art form today. This picture has been painted on bamboo paper, which is absorbent and lends itself to xieyi work.

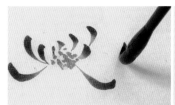

1 The painting begins with a cluster of dots, then petals are added in a contrasting color, beginning with the smallest ones. The "tails" of all the petals lead back to the cluster of dots.

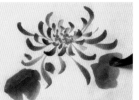

2 Large "dot" strokes form the leaves.

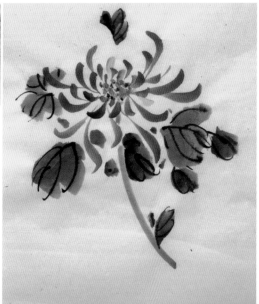

3 A slightly curved stem is added, then the tip of a small firm brush is used to paint dark veins on the leaves while damp. They become part of the leaf this way, rather than just resting on the surface.

Fine brushwork *(gongbi)*

Gongbi work is done on non-absorbent meticulous paper, as here, or on treated non-absorbent silk. It is the style of painting characteristic of the Academic school of artists of the Song Dynasty and involves very careful brush work. Fine, but energetic, lines describe the subject, and then ink and/or color is painted on in washes. Washes can be painted on the back of gongbi work done on silk.

1 Each petal is carefully outlined in pale ink using a fine brush.

2 Dark ink is used to dot the heart of the flower and to draw the leaves and stem with fine lines.

3 The petals are painted with red color washes. One brush is used to apply the color, then a clean brush is used to blend it. Successive layers of washes are applied, allowing each one to dry before another is added, and blending the paint further each time.

 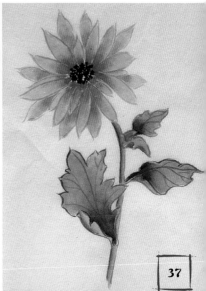

4 The leaves are colored in the same way, starting with the darkest color (indigo in this case, but it could be ink).

5 The tips and undersides of the leaves are painted with burnt sienna. When dry, the red petals are given a wash of yellow and the leaves a wash of green.

Washes

Washes of color can be applied to the front or back of a Chinese painting once it is dry. Generally, landscape and underwater pictures are washed on the front; white birds and flowers are washed on the back.

Front wash

1 Place the painting on a piece of felt or an old blanket. Lightly dampen the whole painting with clean water, either by spraying or using a wash brush. It should not be wringing wet, so blot any shiny areas with tissue paper.

2 Load the wash brush with color and apply to the front of the picture, spreading the color as far as it will go. Overlap the strokes to ensure an even blend. Try using more than one color, and don't rush the process.

3 If spots of color come through from the blanket, very gently lift the painting and wipe the blanket clean with a tissue. Allow the paper to dry thoroughly. The paper will tear very easily when it is wet, so avoid moving it if possible.

ARTIST'S TIP

Always mix enough color to complete the wash, and remember that the color should be subtle. Note that blue tends to dry more brightly. Never mix ink and color for a wash because the ink will cause the pigment to separate. Practice applying washes to pictures that you do not mind spoiling first.

BACK WASH
Here, a tea wash is being applied to the back of a picture. Put 3–4 teabags in a third of a cup of boiling water, to get a strong brown color. Dampen the picture with clean water and then paint the cold tea over the center of the painting, blending it outward. This will give the picture an antique look.

MATERIALS AND TECHNIQUES

38

Calligraphy and Seals

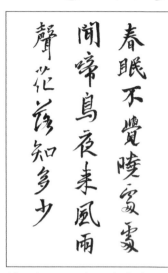

春眠不覺曉
處處聞啼鳥
夜來風雨聲
花落知多少

**After the spring sleep, the feeling of dawn wakes the birds.
After the nights of wind and rain,
The flowers know it has arrived.**

—MENG HAO REN

Chinese pictures are completed by adding the "Four Perfections" —the painting, a poem or proverb, the calligraphy used to write this, and one or more seals. Seals are often placed in a lower corner, to give the picture weight and balance, or in a blank area to "mend the white." Name seals can also go under any calligraphy, with the message seal in the opposite corner.

Calligraphy

Calligraphy has flourished for several thousand years in China and has developed into probably the most popular art form. Learning how to write your name in Chinese would enable you to sign your pictures, and learning the basic calligraphic strokes would improve all your painting strokes.

Seals

The square "name seal" is carved with the name of the artist. The "message seal," in any shape, is carved with a proverb or saying closely associated with the artist.

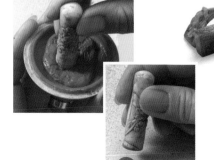

The seal ink is called cinnabar paste and is poisonous. Store it in an airtight container. Press the seal into the paste, then firmly onto the paper. Lift carefully to avoid smudges.

Backing and Framing

Chinese paper is usually very thin, so it needs to be backed to provide a second layer of support. The painting can then be framed, used to make greeting cards, pleated into fans, or cut to make pretty lampshades. All will make ideal gifts.

YOU WILL NEED

Chinese mounting brush, or similar wide firm brush

✣

Hake, or similar wide soft brush

✣

Wallpaper paste

✣

A piece of the same or heavier paper as the painting, at least 2 in. (5 cm) bigger all around

✣

A board that is larger than the backing paper

✣

Pencil and ruler

✣

Craft knife

Backing

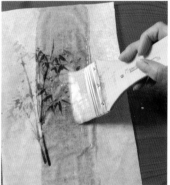

1 Place the picture face down on a clean tabletop. Use a hake brush to apply paste in the center of the back of the picture. Brushing the paste outward from the center each time, spread paste to the top, bottom, sides, and corners of the painting. Make sure there are no air bubbles and wipe away the paste from the table around the picture.

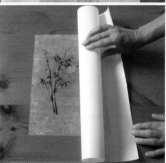

2 Roll up the backing paper and, making sure that a 2 in. (5 cm) border is left around the edges, gently unroll it onto the painting, pressing with either the palm of the hand or the mounting brush.

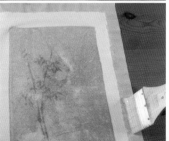

3 Use the hake to paste a 1-in. (2.5-cm) wide border all around edge of the backing paper.

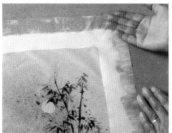

4 Using both hands, carefully lift the picture and place it face up onto the board. It is easier to do this if the board is propped vertically against a wall. Make sure that the border of the backing paper is firmly stuck. Do not press the picture itself onto the board.

5 Leave the board in a safe place for a couple of days until completely dry. Use a pencil and ruler to draw cutting guidelines around the painting, leaving a small border around it, then cut out the picture carefully using a craft knife.

Framing

1 Place a mat on the front of the picture, making sure that it frames the picture as required. Choose a color that will not detract from the colors in the painting.

CHINESE SCROLLS

In China, pictures are routinely made into scrolls, with silk edgings. These can be rolled up and put away. The process is an art form in itself and needs to be done by a specialist.

2 Place the picture and mat inside a glass frame in the conventional way.

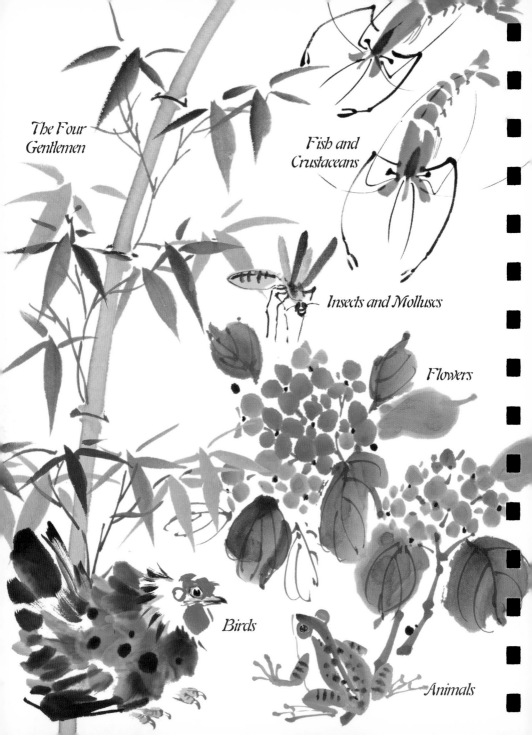

The Four
Gentlemen

Fish and
Crustaceans

Insects and Molluscs

Flowers

Birds

Animals

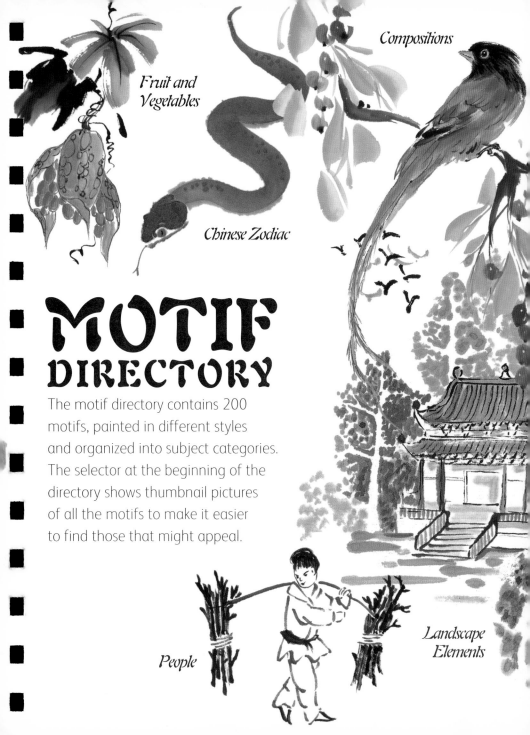

Fruit and
Vegetables

Compositions

Chinese Zodiac

MOTIF
DIRECTORY

The motif directory contains 200
motifs, painted in different styles
and organized into subject categories.
The selector at the beginning of the
directory shows thumbnail pictures
of all the motifs to make it easier
to find those that might appeal.

People

Landscape
Elements

Motif Selector All the motifs
featured in this book are displayed here. Use the
page reference to take you to the relevant instructions
for each one.

The Four Gentlemen

page 50

page 52

page 54

page 56

Flowers

page 58

page 59

page 60

page 61

page 62

page 63

page 64

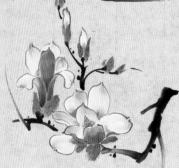

page 65

page 66

page 67

page 68

page 69

page 70

page 71

page 72

page 73

page 74

page 75

page 76

page 77

MOTIF DIRECTORY

page 78 page 79 page 80 page 81 page 82

page 83 page 84 page 85

Fruit and Vegetables

page 86 page 87 page 88 page 89

page 90 page 91 page 92 page 93 page 94

page 95 page 96 page 97 page 98 page 99

page 100 page 101 page 102 page 103 page 104

page 105 page 106 page 107 page 108 page 109

Insects and Molluscs

 page 110 page 111 page 112 page 113

Animals

Chinese Zodiac

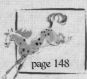 page 142

 page 143

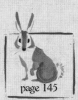 page 144

page 145

 page 146

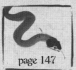 page 147

 page 148

 page 149

 page 150

 page 151

 page 152

 page 153

Birds

 page 154

 page 155

 page 156

 page 157

 page 158

 page 159

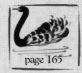 page 160

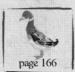 page 161

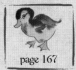 page 162

 page 163

 page 164

 page 165

 page 166

 page 167

 page 168

 page 169

 page 170

page 171

page 172

page 173

page 174

page 175

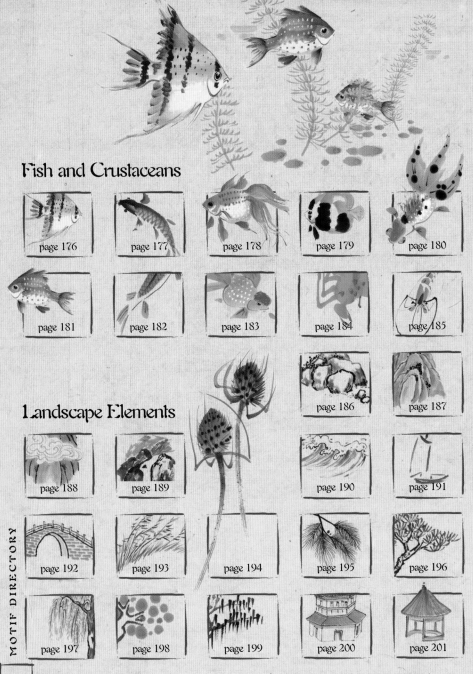

Fish and Crustaceans

page 176

page 177

page 178

page 179

page 180

page 181

page 182

page 183

page 184

page 185

page 186

page 187

Landscape Elements

page 188

page 189

page 190

page 191

page 192

page 193

page 194

page 195

page 196

page 197

page 198

page 199

page 200

page 201

People

page 202
page 203
page 204

page 205
page 206
page 207
page 208
page 209

Compositions

Each of the compositions features two motifs,
which you could paint on their own if you prefer.

page 210
page 212
page 214
page 216
page 218

page 220
page 222
page 224
page 226
page 228

page 230
page 232
page 234
page 236

page 238
page 240
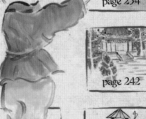
page 242
page 244

page 246
page 248
page 250
page 252

Bamboo

The four plants collectively known as the Four Gentlemen are the most popular subjects for teaching the fundamental skills of Chinese brush painting. Bamboo symbolizes strength, peace, and summer.

1 Ink motif Load a large firm brush with gray ink and paint a series of bone strokes for the segments of the canes, pressing at the beginning and end of each stroke and lifting the brush slightly in the middle. Use most of the ferrule for thick canes, and just the tip for narrow ones.

Color motif Load a medium soft brush with a light green mixture of indigo and yellow; dip the tip in indigo. Paint the segments of the cane with a series of bone strokes as for the ink motif.

2 Ink motif Use a fine brush and black ink to add joints between the segments of the canes.

Color motif Add joint strokes using the fine brush and indigo.

3 Ink motif Add side branches using the tip of the firm brush and black or dark gray ink.

Color motif Use the fine brush and a dark green mixture of indigo and yellow to paint the side branches.

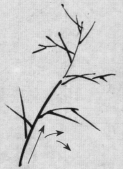

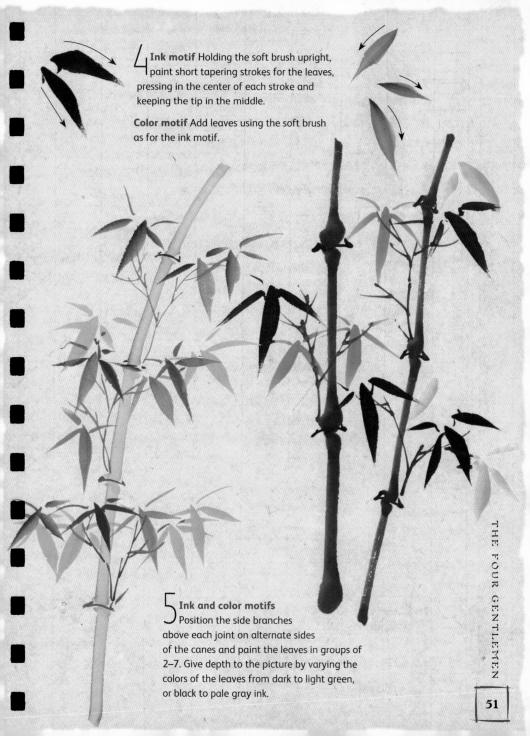

4 Ink motif Holding the soft brush upright, paint short tapering strokes for the leaves, pressing in the center of each stroke and keeping the tip in the middle.

Color motif Add leaves using the soft brush as for the ink motif.

5 Ink and color motifs
Position the side branches above each joint on alternate sides of the canes and paint the leaves in groups of 2–7. Give depth to the picture by varying the colors of the leaves from dark to light green, or black to pale gray ink.

Orchid

Symbolizing virtue and purity, the beauty and grace of the orchid embodies the spirit of spring.

YOU WILL NEED

Small firm brush

❖

Medium soft brush

❖

Fine brush

❖

Black ink

Gray ink

Indigo

Yellow

Red

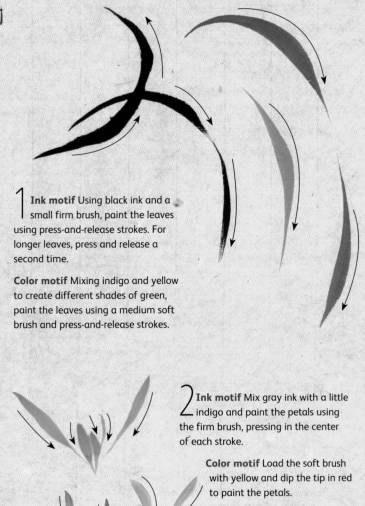

1 Ink motif Using black ink and a small firm brush, paint the leaves using press-and-release strokes. For longer leaves, press and release a second time.

Color motif Mixing indigo and yellow to create different shades of green, paint the leaves using a medium soft brush and press-and-release strokes.

2 Ink motif Mix gray ink with a little indigo and paint the petals using the firm brush, pressing in the center of each stroke.

Color motif Load the soft brush with yellow and dip the tip in red to paint the petals.

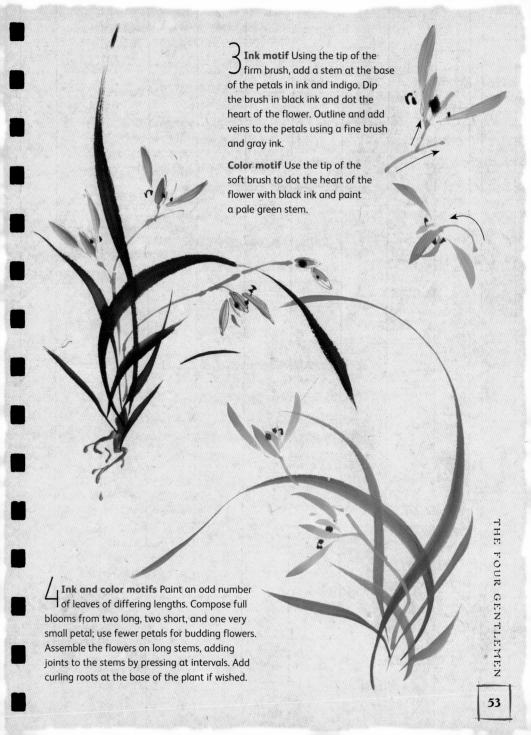

3 **Ink motif** Using the tip of the firm brush, add a stem at the base of the petals in ink and indigo. Dip the brush in black ink and dot the heart of the flower. Outline and add veins to the petals using a fine brush and gray ink.

Color motif Use the tip of the soft brush to dot the heart of the flower with black ink and paint a pale green stem.

4 **Ink and color motifs** Paint an odd number of leaves of differing lengths. Compose full blooms from two long, two short, and one very small petal; use fewer petals for budding flowers. Assemble the flowers on long stems, adding joints to the stems by pressing at intervals. Add curling roots at the base of the plant if wished.

Chrysanthemum

A fall-flowering plant, the chrysanthemum represents moral strength and cheerfulness in the face of adversity.

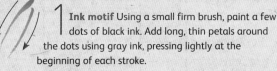

1 **Ink motif** Using a small firm brush, paint a few dots of black ink. Add long, thin petals around the dots using gray ink, pressing lightly at the beginning of each stroke.

Color motif Load the firm brush with pink and dip the tip in blue. Paint a series of dots at the center of the flower, then add small curving petals around them using press-and-release strokes.

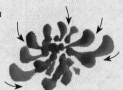

2 **Ink motif** Vary the angle of the petals and size of the flowers.

Color motif For large blooms, add larger pink petals around the small ones, always working from the outside toward the center.

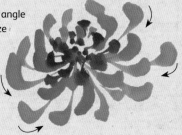

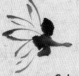

3 **Ink motif** Load a medium soft brush with various shades of gray ink and use the side of the brush to paint broad strokes for the leaves. Use the tip of the brush to add dark ink veins to the damp leaves.

Color motif Load the soft brush with a mixture of indigo and yellow; dip the tip in orange. Keeping the tip of the brush at the base of the leaf, press the heel down to create overlapping lobes. Add veins in indigo using the tip of the brush.

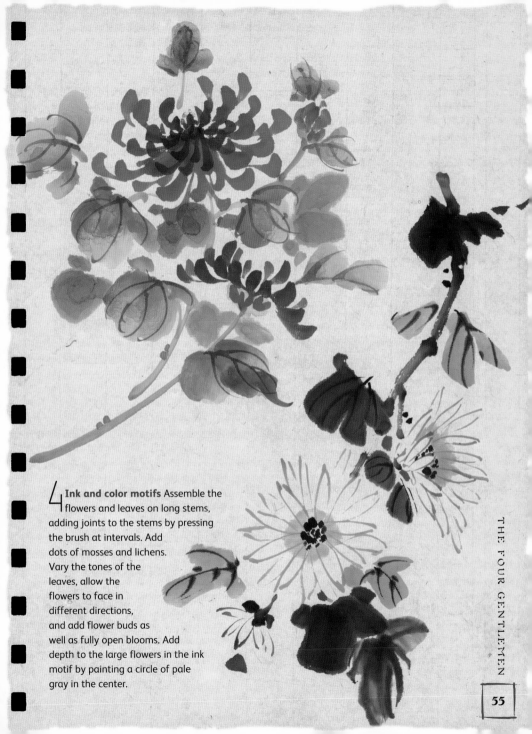

4 **Ink and color motifs** Assemble the
flowers and leaves on long stems,
adding joints to the stems by pressing
the brush at intervals. Add
dots of mosses and lichens.
Vary the tones of the
leaves, allow the
flowers to face in
different directions,
and add flower buds as
well as fully open blooms. Add
depth to the large flowers in the ink
motif by painting a circle of pale
gray in the center.

Plum Blossom

The national flower of China, the plum blossom represents perseverance, rejuvenation, and winter.

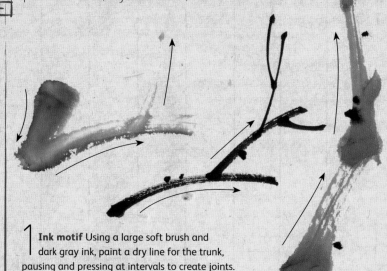

YOU WILL NEED

Large soft brush

❋

Fine brush

❋

Small firm brush

❋

Gray ink

Black ink

Burnt sienna

Red

White

1 Ink motif Using a large soft brush and dark gray ink, paint a dry line for the trunk, pausing and pressing at intervals to create joints. Use the tip of the brush to add branches. Paint some young, springy twigs in black ink.

Color motif Load the soft brush with a mixture of gray ink and burnt sienna to paint the branches. Add black ink dots for mosses and lichens.

2 Ink motif Using a fine brush and gray ink, compose each flower from oval petal shapes. Add "tiger's eyebrows" in dark ink for the stamens and pistils, forming each one from a vigorous bone stroke topped with a small dot.

Color motif Load the soft brush with various mixtures of red and white to paint the petals, turning the brush in a circle for each one. Add stamens and pistils as for the ink motif.

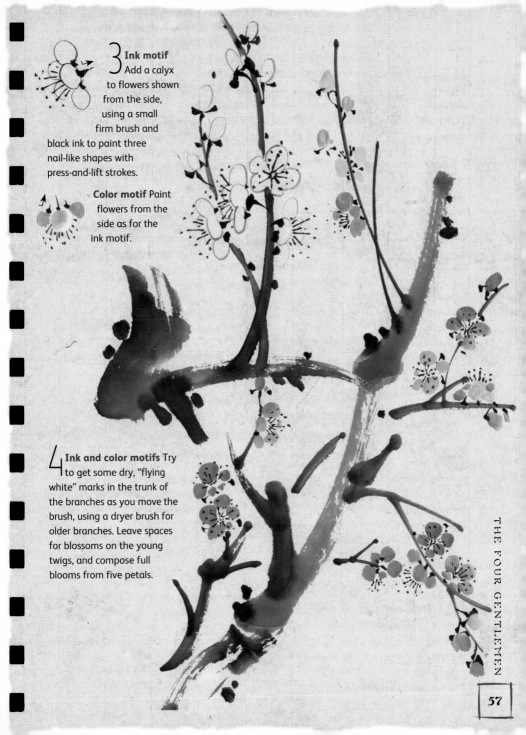

3 Ink motif Add a calyx to flowers shown from the side, using a small firm brush and black ink to paint three nail-like shapes with press-and-lift strokes.

Color motif Paint flowers from the side as for the ink motif.

4 Ink and color motifs Try to get some dry, "flying white" marks in the trunk of the branches as you move the brush, using a dryer brush for older branches. Leave spaces for blossoms on the young twigs, and compose full blooms from five petals.

57

Lily

A simple lily makes an attractive subject and could be painted as a gift to show caring.

YOU WILL NEED

Medium soft brush

❈

Small firm brush

❈

Fine brush

❈

White

Leaf green

Sage green

Olive green

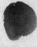

Dark ink

Orange

1 Load a medium soft brush with white and paint two long strokes for each petal. Add a calyx painted with a small firm brush and your choice of green.

2 Load the firm brush with leaf or sage green and dip the tip in olive green. Paint a long broad stroke with a thin stroke alongside to form each leaf. Vary the length of the leaves.

3 Paint a curving green stem, add a little green to the center of the flower, and paint some grass with strokes of dark ink. Use a fine brush to paint white lines topped with two small orange bars for stamens. Add a longer white pistil topped with lighter orange bars.

MOTIF DIRECTORY

Azalea

The azalea is known as the "Cuckoo Flower" in China, because the bird has a red throat that resembles the color of the flower. A beautiful woman is also compared to an azalea.

1 Load a medium soft brush with orange and paint two strokes for each petal. Press yellow into the center while damp.

2 Using various shades of green, black, and gray, paint two strokes for each leaf. Use the tip of the brush to add red veins while damp.

3 Paint two small orange strokes for flower buds. Add a green calyx and a gray ink stem. Use the tip of the brush to outline the buds with red.

4 Use a fine brush and mixtures of red and black to add stamens, pistils, and dotted markings to the flowers. Use a small firm brush and ink to paint a stem, pausing at intervals to create joints. Add dots of red lichen.

Morning Glory

A summer-flowering climbing plant in stunning blue, the morning glory is a delight to paint.

1 Load a medium soft brush with pale blue, then dip the tip in a stronger mixture. Holding the brush at a 45-degree angle to the page, paint a semicircle of three petals, with two small or large petals below them, depending on the angle of the flower.

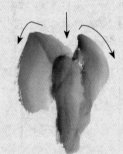

YOU WILL NEED

Medium soft brush

❉

Fine brush

❉

Blue

Sage green

Leaf green

Purple

2 Using the side of the brush and large bold strokes, paint three-lobed leaves, starting with the central lobe. Vary the shades of green.

3 Paint two strokes for each bud and a green calyx extending into points.

4 Use the tip of the brush and leaf green to add curling tendrils. Press green into the center of the flowers and dot it with purple. Change to a fine brush to add purple veins to the leaves and a few spots of purple lichen.

Snowdrop

This spring flower lends itself perfectly to Chinese brush strokes, with its lovely linear leaves and simple flower, both of which are easy to paint.

1 Load a small firm brush with white and paint a short broad stroke for the central petal.

2 Add a narrower petal on each side, then paint the little white petticoat inside the flower. Add a couple of leaf green dots to the petticoat with the tip of the brush, and a darker green calyx at the base of the petals.

3 Load the brush with sage green and paint long curving strokes for the leaves.

4 When the painting is dry, turn it over and apply lilac and blue washes to the back with a wash brush, blending the colors into one another.

YOU WILL NEED

Small firm brush

✢

Wash brush

✢

White

Leaf green

Sage green

Lilac

Blue

FLOWERS

Gladiolus

A bright and beautiful flower, the gladiolus offers the opportunity to use a wide variety of colors and some exciting strokes.

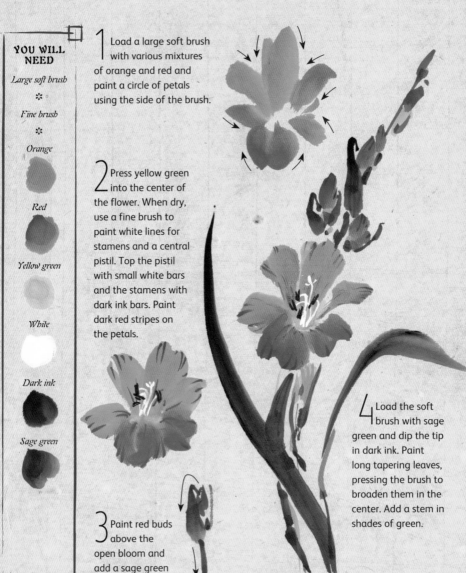

YOU WILL NEED

Large soft brush

❋

Fine brush

❋

Orange

Red

Yellow green

White

Dark ink

Sage green

1 Load a large soft brush with various mixtures of orange and red and paint a circle of petals using the side of the brush.

2 Press yellow green into the center of the flower. When dry, use a fine brush to paint white lines for stamens and a central pistil. Top the pistil with small white bars and the stamens with dark ink bars. Paint dark red stripes on the petals.

3 Paint red buds above the open bloom and add a sage green calyx and stalk.

4 Load the soft brush with sage green and dip the tip in dark ink. Paint long tapering leaves, pressing the brush to broaden them in the center. Add a stem in shades of green.

Carnation

The carnation symbolizes marriage in China. Try painting two or three layers of frilly petals to create fuller blooms.

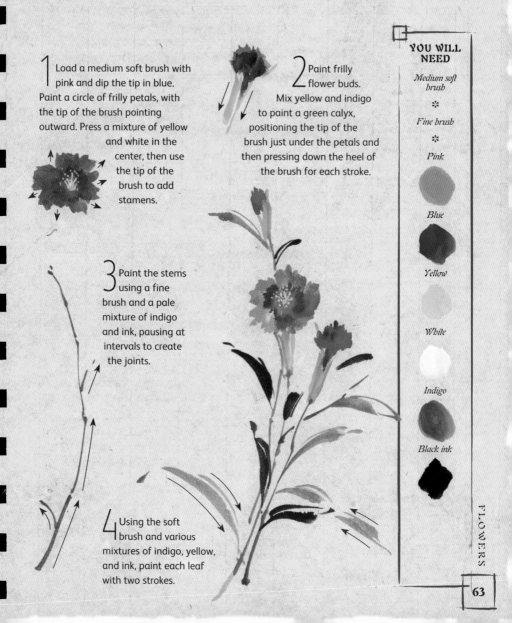

1 Load a medium soft brush with pink and dip the tip in blue. Paint a circle of frilly petals, with the tip of the brush pointing outward. Press a mixture of yellow and white in the center, then use the tip of the brush to add stamens.

2 Paint frilly flower buds. Mix yellow and indigo to paint a green calyx, positioning the tip of the brush just under the petals and then pressing down the heel of the brush for each stroke.

3 Paint the stems using a fine brush and a pale mixture of indigo and ink, pausing at intervals to create the joints.

4 Using the soft brush and various mixtures of indigo, yellow, and ink, paint each leaf with two strokes.

YOU WILL NEED

Medium soft brush

✿

Fine brush

✿

Pink

Blue

Yellow

White

Indigo

Black ink

FLOWERS

Sunflower

The sunflower head follows the sun in the sky and seems to reflect its warmth and happiness. Try to make each petal different to add vitality to the picture.

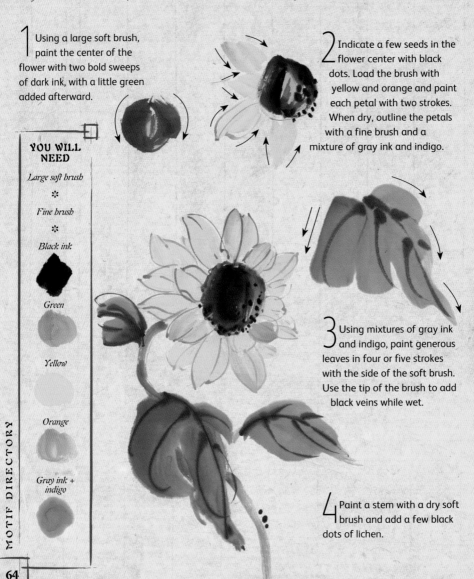

1 Using a large soft brush, paint the center of the flower with two bold sweeps of dark ink, with a little green added afterward.

2 Indicate a few seeds in the flower center with black dots. Load the brush with yellow and orange and paint each petal with two strokes. When dry, outline the petals with a fine brush and a mixture of gray ink and indigo.

3 Using mixtures of gray ink and indigo, paint generous leaves in four or five strokes with the side of the soft brush. Use the tip of the brush to add black veins while wet.

4 Paint a stem with a dry soft brush and add a few black dots of lichen.

YOU WILL NEED

Large soft brush

❖

Fine brush

❖

Black ink

Green

Yellow

Orange

Gray ink + indigo

MOTIF DIRECTORY

Poinsettia

Known as "Christmas Red" in China, the poinsettia is a symbol of Christmas worldwide, with its vivid flowers providing a joyous touch of color to the winter season.

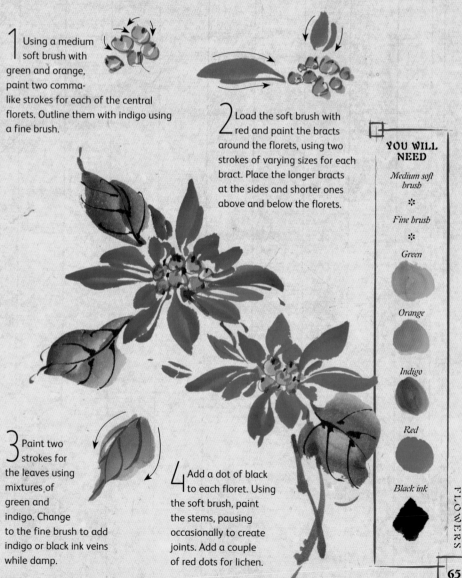

1 Using a medium soft brush with green and orange, paint two comma-like strokes for each of the central florets. Outline them with indigo using a fine brush.

2 Load the soft brush with red and paint the bracts around the florets, using two strokes of varying sizes for each bract. Place the longer bracts at the sides and shorter ones above and below the florets.

3 Paint two strokes for the leaves using mixtures of green and indigo. Change to the fine brush to add indigo or black ink veins while damp.

4 Add a dot of black to each floret. Using the soft brush, paint the stems, pausing occasionally to create joints. Add a couple of red dots for lichen.

YOU WILL NEED

Medium soft brush

❊

Fine brush

❊

Green

Orange

Indigo

Red

Black ink

FLOWERS

65

Purple-podded Pea

This pretty plant has pea-like flowers and lilac peapods. It looks good climbing bamboo canes.

YOU WILL NEED

Small firm brush

❊

Fine brush

❊

Lilac

Black ink

Pink

Yellow

Purple

Green

Burnt sienna

MOTIF DIRECTORY

1 Load a small firm brush with lilac. Paint a tapering zigzag for the peapod, then outline it using a fine brush and ink.

2 Load the firm brush with pink and paint a large and small petal. Press yellow at their base. Add purple petals below this, and two small dots in the yellow center.

3 Using a mixture of green and burnt sienna, paint a leaf stem. Add small leaves on each side of the stem, using two strokes for each leaf. Using a fine brush and ink, add veins while damp.

4 Assemble the elements around a bamboo cane (page 50). Use the fine brush to paint curling green tendrils.

Chinese Hibiscus

The hibiscus symbolizes fame and riches, and the scent of the flower recalls a beautiful girl.

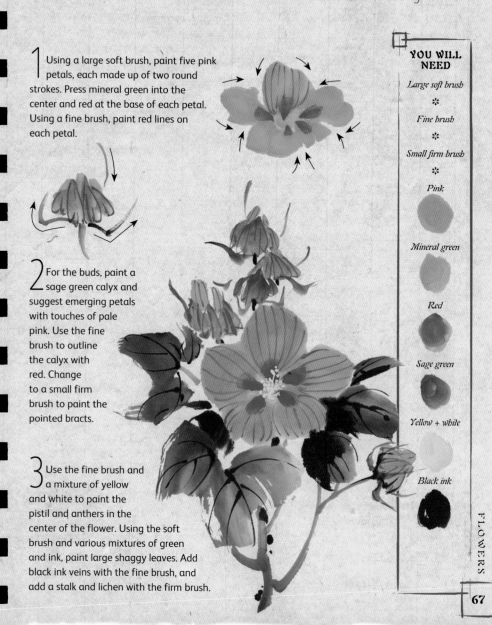

1 Using a large soft brush, paint five pink petals, each made up of two round strokes. Press mineral green into the center and red at the base of each petal. Using a fine brush, paint red lines on each petal.

2 For the buds, paint a sage green calyx and suggest emerging petals with touches of pale pink. Use the fine brush to outline the calyx with red. Change to a small firm brush to paint the pointed bracts.

3 Use the fine brush and a mixture of yellow and white to paint the pistil and anthers in the center of the flower. Using the soft brush and various mixtures of green and ink, paint large shaggy leaves. Add black ink veins with the fine brush, and add a stalk and lichen with the firm brush.

YOU WILL NEED

Large soft brush

❋

Fine brush

❋

Small firm brush

❋

Pink

Mineral green

Red

Sage green

Yellow + white

Black ink

FLOWERS

67

Hydrangea

With masses of tiny florets in shades of blue, hydrangea heads make a stunning picture.

1 Load a medium soft brush with various mixtures of mineral blue and pink. Twist the brush in a circle for each petal, trying to make each floret different in color and size.

2 Load the brush with various mixtures of green, indigo, and ink. Apply the whole ferrule in a fat stroke for the leaves, with two strokes per leaf. Add veins in indigo using a fine brush.

3 Paint the stems with the tip of the soft brush, pausing occasionally to create joints.

4 Add dots of indigo or black ink to the centers of the florets and as lichen on the stems.

YOU WILL NEED

Medium soft brush

✻

Fine brush

✻

Mineral blue

Pink

Green

Indigo

Black ink

MOTIF DIRECTORY

68

Pansy

A low-growing bushy plant with bright flowers that seem to have faces, the pansy is a delight to paint.

1 Using a medium soft brush and various colors, paint two strokes for each of the five petals. Press a contrasting color in the center of the damp petals. Paint a triangle and a few lines in the center using the tip of a fine brush and ink.

2 Load the soft brush with green and dip the tip in purple or red. Paint the leaves by pressing the heel of the brush into the center of the leaf, with the dark tip forming the edge.

3 Using a fine brush and green, paint the calyx and stem of the flower buds. When dry, add a splash of petal color.

4 Add indigo or ink veins to the leaves, outline the calyx of the flower bud, and add black ink dots for lichen.

YOU WILL NEED

Medium soft brush

❁

Fine brush

❁

Orange + yellow

Purple

Purple + blue

Red

Black ink

Green

Indigo

FLOWERS

Sweet Pea

The delicate, fragrant sweet pea provides the opportunity to splash around with large freestyle strokes; these can be outlined to contain them. This is an experiment in shapes.

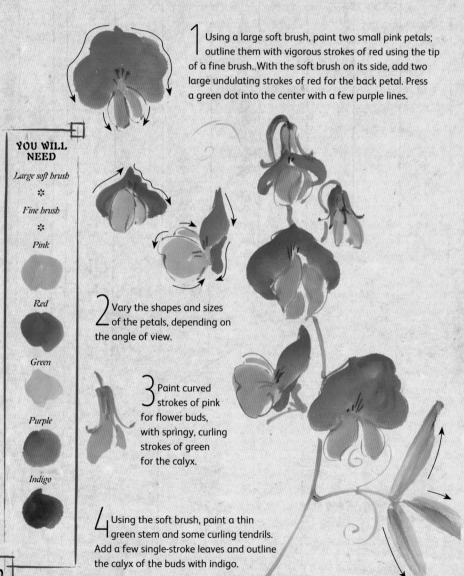

1 Using a large soft brush, paint two small pink petals; outline them with vigorous strokes of red using the tip of a fine brush. With the soft brush on its side, add two large undulating strokes of red for the back petal. Press a green dot into the center with a few purple lines.

2 Vary the shapes and sizes of the petals, depending on the angle of view.

3 Paint curved strokes of pink for flower buds, with springy, curling strokes of green for the calyx.

4 Using the soft brush, paint a thin green stem and some curling tendrils. Add a few single-stroke leaves and outline the calyx of the buds with indigo.

YOU WILL NEED

Large soft brush

❋

Fine brush

❋

Pink

Red

Green

Purple

Indigo

Magnolia This beautiful flower
symbolizes feminine beauty and spring.

1 Outline the petals using a fine brush and ink. Press lightly on the tip of the brush at the beginning of each stroke. Change to a medium soft brush to paint the inside of the petals white and ocher, and the outside purple.

2 Paint the petals of the buds in the same way. Add a green bract at the base of the petals and change to the fine brush to dot the bract with purple hairs.

3 Paint stamens in the center of the flowers with short fine strokes of orange. Add a little ink to the orange and paint smaller strokes in the center for pistils.

4 Load the soft brush with ink and paint the stems with vigorous strokes, pausing occasionally to create joints. Add dots of lichen.

YOU WILL NEED

Fine brush

❈

Medium soft brush

❈

Black ink

White + ocher

Purple

Green

Orange

FLOWERS

71

Pelargonium

A white pelargonium, or geranium, provides a great opportunity to put a wash on the back of your picture.

YOU WILL NEED

Small firm brush

❋

Fine brush

❋

Large soft brush

❋

Wash brush

❋

White

Yellow

Brown

Green

Dark ink

Red

Blue

1 Using a small firm brush, paint five small white petals for each flower and add a pale yellow dot in the center. Make the petals different sizes and shapes to add interest.

2 Using a fine brush, paint short brown and/or green stems joining the clusters of flowers. Dot the yellow centers. Add buds hanging down from the base of each flower head, using a dot of white for each bud.

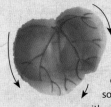

3 Load a large soft brush with various shades of green and ink; paint the rounded leaves with two or three strokes using the side of the brush. Add red veins using a fine brush.

4 Assemble the flower heads and leaves on a brown or green stalk painted with the firm brush. When the painting is dry, turn it over and use a wash brush to apply a blue wash to the back.

Bauhinia This delightful tropical flower grows in China and is a popular subject for paintings.

1 Load a medium soft brush with two shades of purple and paint five petals. Add a curl at the tip of the two lower petals and paint dark purple veins with a fine brush. Press yellow into the center and paint a green pistil.

2 Using the soft brush with mixtures of yellow and indigo, paint the kidney-shaped leaves. Add indigo veins with a fine brush and dot the center while damp.

3 Using a small firm brush, paint buds of two or three purple strokes held in a green calyx.

4 Use a fine brush to add white stamens and a green pistil; top them with yellow dots. Add a brown bract under the flower. Paint a vigorous branch using the firm brush and a mixture of yellow, indigo, and ink. Add dots to indicate mosses and lichens.

FLOWERS

73

Rose

Often fragrant, always beautiful, the rose can be painted in pretty combinations of colors. The large, penny-like leaves are distinctive.

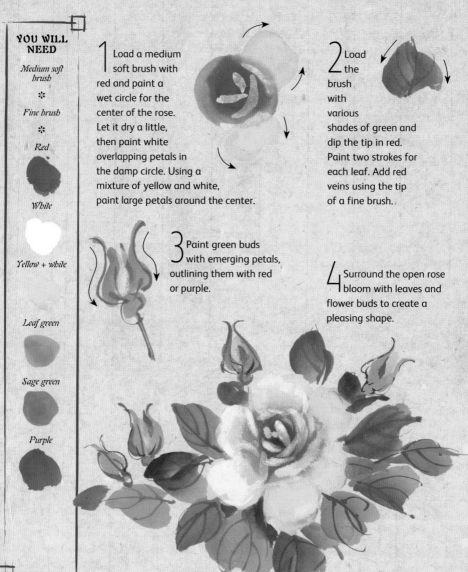

YOU WILL NEED

Medium soft brush

✳

Fine brush

✳

Red

White

Yellow + white

Leaf green

Sage green

Purple

1 Load a medium soft brush with red and paint a wet circle for the center of the rose. Let it dry a little, then paint white overlapping petals in the damp circle. Using a mixture of yellow and white, paint large petals around the center.

2 Load the brush with various shades of green and dip the tip in red. Paint two strokes for each leaf. Add red veins using the tip of a fine brush.

3 Paint green buds with emerging petals, outlining them with red or purple.

4 Surround the open rose bloom with leaves and flower buds to create a pleasing shape.

Waterlily

With its distinctive pointed petals, the waterlily can be painted in blue, yellow, white, or pink.

1 Load a medium soft brush with pink and paint the petals, using two strokes for the larger petals and one for the smaller ones. Paint the front petals first, then add the back ones, leaving space for stamens. Add purple lines with a fine brush just before the petals are dry.

2 Load the soft brush with two shades of green and paint a lobed circle for the leaf. Add lines with a fine brush while damp, using purple or purple mixed with ink.

3 Paint a couple of short pink strokes enclosed in a green calyx for a flower bud. Add lines as before.

4 Fill the space in the center of the open flower with leaf green and spots of yellow and white mixed. Add a few smaller floating green leaves.

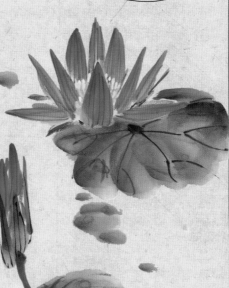

YOU WILL NEED

Medium soft brush

❁

Fine brush

❁

Pink

Purple

Leaf green

Sage green

Purple + ink

Yellow + white

FLOWERS

Poppy

With fragile petals in bold red and orange, the poppy is a delight to paint. Try painting the flower in lilac and deep purple, too.

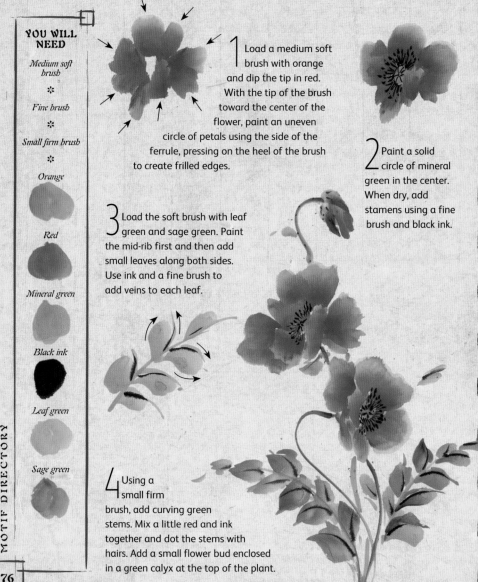

YOU WILL NEED

Medium soft brush

❈

Fine brush

❈

Small firm brush

❈

Orange

Red

Mineral green

Black ink

Leaf green

Sage green

1 Load a medium soft brush with orange and dip the tip in red. With the tip of the brush toward the center of the flower, paint an uneven circle of petals using the side of the ferrule, pressing on the heel of the brush to create frilled edges.

2 Paint a solid circle of mineral green in the center. When dry, add stamens using a fine brush and black ink.

3 Load the soft brush with leaf green and sage green. Paint the mid-rib first and then add small leaves along both sides. Use ink and a fine brush to add veins to each leaf.

4 Using a small firm brush, add curving green stems. Mix a little red and ink together and dot the stems with hairs. Add a small flower bud enclosed in a green calyx at the top of the plant.

Wisteria

The wisteria plant is said to symbolize all the stages of life. The strong knotty stem represents old age; the vigorous curling tendrils symbolize youth; and the buds and flowers childhood.

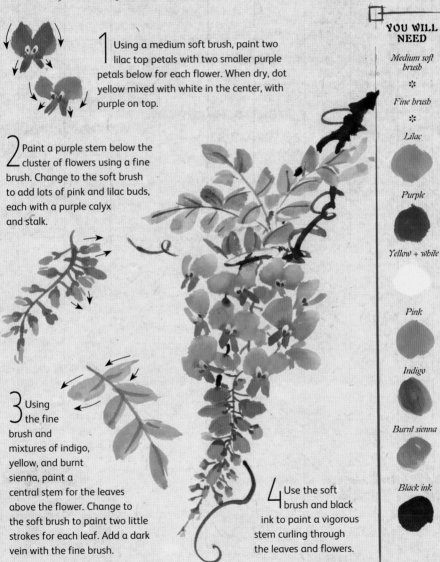

1. Using a medium soft brush, paint two lilac top petals with two smaller purple petals below for each flower. When dry, dot yellow mixed with white in the center, with purple on top.

2. Paint a purple stem below the cluster of flowers using a fine brush. Change to the soft brush to add lots of pink and lilac buds, each with a purple calyx and stalk.

3. Using the fine brush and mixtures of indigo, yellow, and burnt sienna, paint a central stem for the leaves above the flower. Change to the soft brush to paint two little strokes for each leaf. Add a dark vein with the fine brush.

4. Use the soft brush and black ink to paint a vigorous stem curling through the leaves and flowers.

FLOWERS

Lotus

The lotus, or sea rose, symbolizes purity because it emerges, spotless and beautiful, out of a muddy swamp. It also represents summer and fertility, and if accompanied by a fish, love.

1 Outline the petals using a small firm brush and ink, pressing lightly at the beginning of each stroke. You will need to outline both inner and outer petals, and turn up the edges of the front petals.

2 Outline the petals of the buds. Load a large soft brush with a mixture of green and ink to paint a stem and calyx. Add darker green hairs to the damp stem. Paint the petals orange with a little red. When dry, add red veins using the tip of the firm brush.

3 Load the soft brush with two different mixtures of green and ink and paint the leaves using sideways sweeps, varying their sizes. Dot the stems with dark green.

4 Paint the inside of the flower petals pink; paint the outside to match the bud. Press a pale green/orange mixture into the center and add mineral green oval seeds. Use the firm brush to outline the seeds and dot the centers with ink. Add a cluster of stamens using red mixed with ink.

YOU WILL NEED

Small firm brush

✽

Large soft brush

✽

Dark ink

Mineral green

Orange

Red

Pink

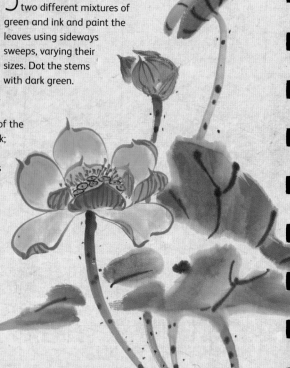

MOTIF DIRECTORY

Fuschia
Like ballerinas, fuschias have a stiff tutu with a soft petticoat underneath.

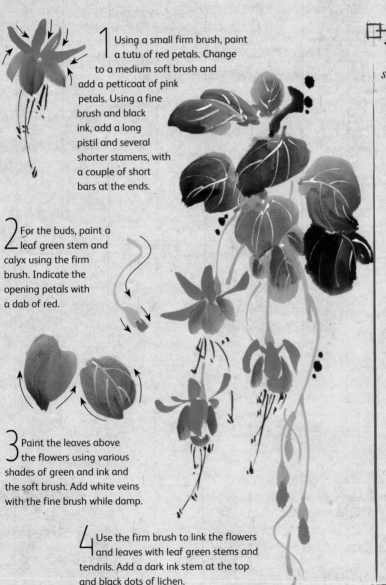

1 Using a small firm brush, paint a tutu of red petals. Change to a medium soft brush and add a petticoat of pink petals. Using a fine brush and black ink, add a long pistil and several shorter stamens, with a couple of short bars at the ends.

2 For the buds, paint a leaf green stem and calyx using the firm brush. Indicate the opening petals with a dab of red.

3 Paint the leaves above the flowers using various shades of green and ink and the soft brush. Add white veins with the fine brush while damp.

4 Use the firm brush to link the flowers and leaves with leaf green stems and tendrils. Add a dark ink stem at the top and black dots of lichen.

YOU WILL NEED

Small firm brush

❋

Medium soft brush

❋

Fine brush

❋

Red

Pink

Black ink

Leaf green

Sage green

White

FLOWERS

Hibiscus

Hibiscus is a joyful tropical flower that can be painted in many different colors. This is a very free painting with lots of spirit.

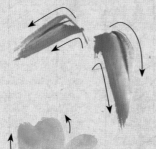

1 Load a large firm brush with burnt sienna and paint dry strokes for the leaves using the side of the brush. Add ink veins with the tip of the brush.

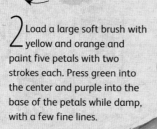

2 Load a large soft brush with yellow and orange and paint five petals with two strokes each. Press green into the center and purple into the base of the petals while damp, with a few fine lines.

3 Using the tip of the soft brush, paint a calyx and fill it with closed petals for the flower buds.

4 When the flower is dry, use a fine brush to add a white and purple stigma and yellow stamens. Line the petals with purple. Use the firm brush to add a short ink stem with dots of lichen.

Narcissus

A symbol of happiness, the narcissus is a popular painting subject, especially on silk and on cards to loved ones.

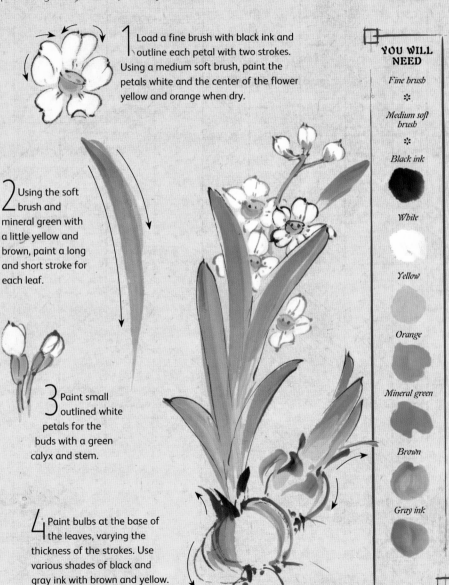

1 Load a fine brush with black ink and outline each petal with two strokes. Using a medium soft brush, paint the petals white and the center of the flower yellow and orange when dry.

2 Using the soft brush and mineral green with a little yellow and brown, paint a long and short stroke for each leaf.

3 Paint small outlined white petals for the buds with a green calyx and stem.

4 Paint bulbs at the base of the leaves, varying the thickness of the strokes. Use various shades of black and gray ink with brown and yellow.

YOU WILL NEED

Fine brush

✽

Medium soft brush

✽

Black ink

White

Yellow

Orange

Mineral green

Brown

Gray ink

FLOWERS

Exotic Orchid

With three slim petals and two large petals arranged around a trumpet made of modified petals, this is a truly exotic flower to paint.

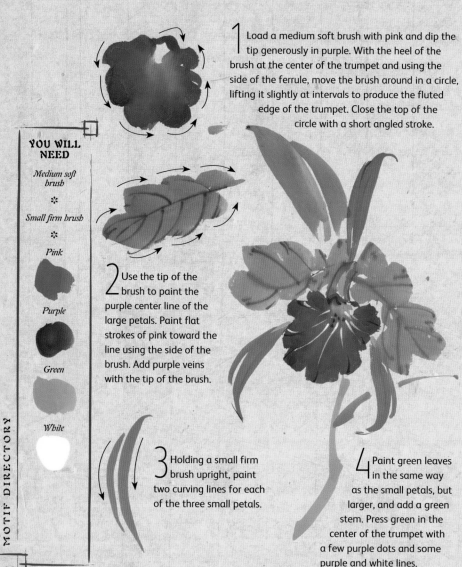

1 Load a medium soft brush with pink and dip the tip generously in purple. With the heel of the brush at the center of the trumpet and using the side of the ferrule, move the brush around in a circle, lifting it slightly at intervals to produce the fluted edge of the trumpet. Close the top of the circle with a short angled stroke.

2 Use the tip of the brush to paint the purple center line of the large petals. Paint flat strokes of pink toward the line using the side of the brush. Add purple veins with the tip of the brush.

3 Holding a small firm brush upright, paint two curving lines for each of the three small petals.

4 Paint green leaves in the same way as the small petals, but larger, and add a green stem. Press green in the center of the trumpet with a few purple dots and some purple and white lines.

Camellia

In southern China, a pretty young girl is often called "Mountain Tea Flower," the Chinese name for the camellia. The flower grows into a large shrub in acid soils, with glossy leaves and flowers that come in a wide variety of pinks, reds, and stripes.

YOU WILL NEED

Medium soft brush

❈

Fine brush

❈

Small firm brush

❈

Red

Leaf green

Black ink

Sage green + ink

White

Yellow

1 Load a medium soft brush with red and paint a circle of petals, using two strokes per petal. Press leaf green into the center.

2 Load the brush with leaf green and dip the tip in red. Paint the cup-shaped calyx and add a few red petals. Add a short ink stem. Mix a little red and ink and use a fine brush to outline a few calyx leaves.

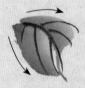

3 Load the soft brush with various shades of green and ink to paint the leaves. Add ink veins with the fine brush while damp.

4 Use a small firm brush and ink to paint a stem, with a few dots of lichen. When dry, paint short white lines for stamens and a long white line for the pistil using the fine brush. Dot the tips with yellow.

Iris

Known as the "Purple Butterfly," the iris, with its soft fluttering petals, reminds Chinese painters of butterfly wings. Irises come in many lovely colors—pinks, oranges, blues, and purples—and they bloom in early summer. This is a flower with a graceful, dancing spirit.

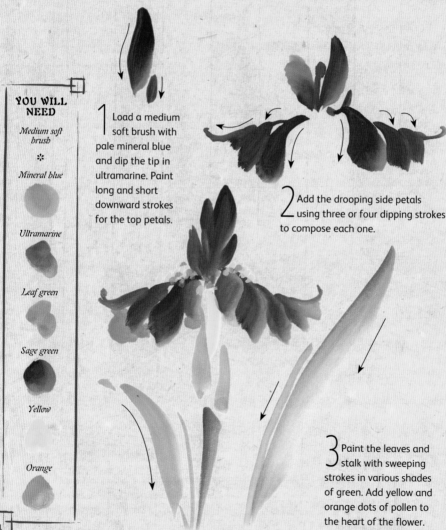

YOU WILL NEED

Medium soft brush

❈

Mineral blue

Ultramarine

Leaf green

Sage green

Yellow

Orange

1 Load a medium soft brush with pale mineral blue and dip the tip in ultramarine. Paint long and short downward strokes for the top petals.

2 Add the drooping side petals using three or four dipping strokes to compose each one.

3 Paint the leaves and stalk with sweeping strokes in various shades of green. Add yellow and orange dots of pollen to the heart of the flower.

Peony

Symbolizing spring, good fortune, and wealth, the peony is the king of flowers in China and is a popular decoration on ceramics, clothing, and silks. A large blowsy flower, it comes in myriad colors and has lots of petals.

1 Load a medium soft brush with pink and dip the tip in a mixture of pink and ink. Paint a row of three rounded petals.

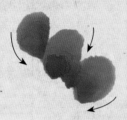

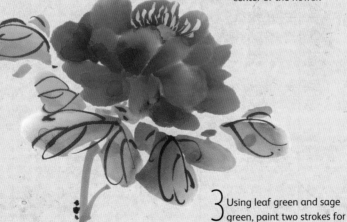

2 Paint a circle of petals around the first three. Add a small stroke of mineral green in the center of the flower.

3 Using leaf green and sage green, paint two strokes for each leaf. Add a short stem. Load a fine brush with a mixture of pink and ink and paint veins on the leaves. Dot the stem with lichen. Add stamens to the center of the flower using a mixture of yellow and white and the fine brush.

YOU WILL NEED

Medium soft brush

✽

Fine brush

✽

Pink

Pink + ink

Mineral green

Leaf green

Sage green

Yellow + white

FLOWERS

85

Pomegranate

The pomegranate is a symbol of abundance and plenty. A picture of an open pomegranate is a popular wedding present.

YOU WILL NEED

Medium soft brush

❊

Fine brush

❊

Burnt sienna + yellow

Light pink

Dark pink

Black ink

Leaf green

Indigo

Gray ink

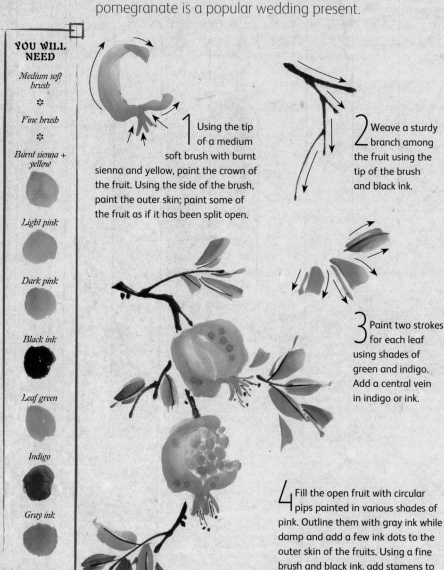

1 Using the tip of a medium soft brush with burnt sienna and yellow, paint the crown of the fruit. Using the side of the brush, paint the outer skin; paint some of the fruit as if it has been split open.

2 Weave a sturdy branch among the fruit using the tip of the brush and black ink.

3 Paint two strokes for each leaf using shades of green and indigo. Add a central vein in indigo or ink.

4 Fill the open fruit with circular pips painted in various shades of pink. Outline them with gray ink while damp and add a few ink dots to the outer skin of the fruits. Using a fine brush and black ink, add stamens to the crown of the fruits.

Loquat

With a shape resembling the *pi-pa*, a Chinese musical instrument, the loquat is also called *pi-pa* in China. It ripens early in the spring, which indicates good luck.

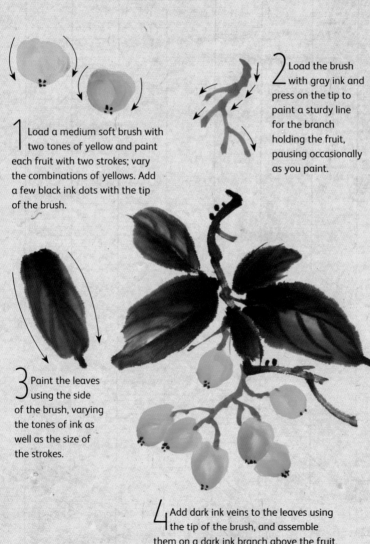

1 Load a medium soft brush with two tones of yellow and paint each fruit with two strokes; vary the combinations of yellows. Add a few black ink dots with the tip of the brush.

2 Load the brush with gray ink and press on the tip to paint a sturdy line for the branch holding the fruit, pausing occasionally as you paint.

3 Paint the leaves using the side of the brush, varying the tones of ink as well as the size of the strokes.

4 Add dark ink veins to the leaves using the tip of the brush, and assemble them on a dark ink branch above the fruit.

YOU WILL NEED

Medium soft brush

❋

Yellow

Yellow + burnt sienna

Yellow + orange

Black ink

Gray ink

FRUIT AND VEGETABLES

Cherry
The cherry represents feminine beauty. Cherries, painted in two tones of red, look especially good in a bowl.

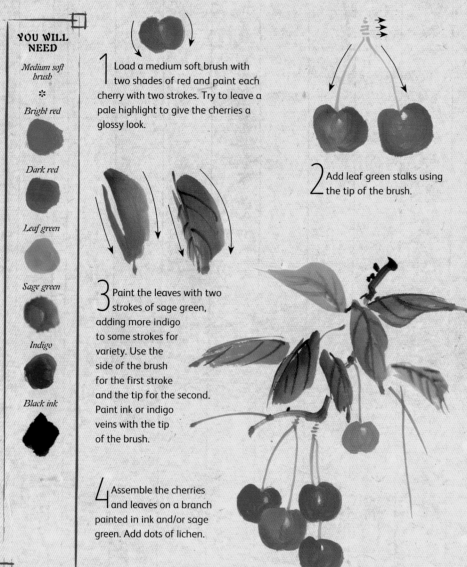

YOU WILL NEED

Medium soft brush

❋

Bright red

Dark red

Leaf green

Sage green

Indigo

Black ink

1 Load a medium soft brush with two shades of red and paint each cherry with two strokes. Try to leave a pale highlight to give the cherries a glossy look.

2 Add leaf green stalks using the tip of the brush.

3 Paint the leaves with two strokes of sage green, adding more indigo to some strokes for variety. Use the side of the brush for the first stroke and the tip for the second. Paint ink or indigo veins with the tip of the brush.

4 Assemble the cherries and leaves on a branch painted in ink and/or sage green. Add dots of lichen.

Peach

One of the most popular subjects in legends and paintings, the peach represents immortality, marriage, and spring. Its wood keeps demons at bay and its petals can cast spells. The god of long life was born from a peach.

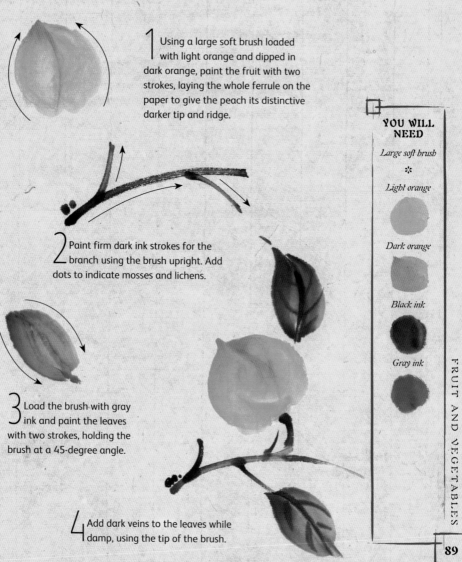

1 Using a large soft brush loaded with light orange and dipped in dark orange, paint the fruit with two strokes, laying the whole ferrule on the paper to give the peach its distinctive darker tip and ridge.

2 Paint firm dark ink strokes for the branch using the brush upright. Add dots to indicate mosses and lichens.

3 Load the brush with gray ink and paint the leaves with two strokes, holding the brush at a 45-degree angle.

4 Add dark veins to the leaves while damp, using the tip of the brush.

YOU WILL NEED

Large soft brush

❖

Light orange

Dark orange

Black ink

Gray ink

Grapes

Grapes can be painted in a variety of colors, from deep purples and reds to yellows and greens. They look wonderful painted in a basket or accompanied by birds and insects.

1 Load a medium soft brush with two shades of green and paint a circle with two curling strokes; vary the combinations of greens. Leave an unpainted highlight in the center. Add a dot of ink while wet.

2 A harder method is to paint a grape with a single curling stroke, using the brush upright. This is difficult but worth practicing, so try painting some of the grapes this way.

3 Paint the leaves in shades of ink. Use the side of the brush and five strokes for each leaf. Add dark veins with the tip of the brush.

4 Use the tip of the brush and ink to produce thin stems.

5 Assemble the elements on a thicker branch, with curling tendrils of ink weaving through them.

Strawberry

A delicious summer fruit, the strawberry makes a pretty addition to any picture of fruit and flowers.

1 Load a medium soft brush with orange and bright red, then dip the tip in dark red. Place the whole ferrule on the paper, with the tip of the brush at the tapering end of the fruit, then move the heel a little to create a triangular shape.

2 Repeat to add the second half of the strawberry. Add a couple of short strokes to indicate the back of the strawberry, leaving a space for the stalk. Dot with pale yellow while damp.

3 Use a fine brush to paint tiny green leaves at the top of the fruit, with each leaf composed of one large and one small stroke. Add a stalk.

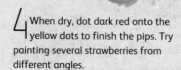

4 When dry, dot dark red onto the yellow dots to finish the pips. Try painting several strawberries from different angles.

YOU WILL NEED

Medium soft brush

❋

Fine brush

❋

Orange

Bright red

Dark red

Pale yellow

Green

FRUIT AND VEGETABLES

Persimmon

The persimmon symbolizes joy and good fortune at work. The tree was often planted in temple gardens because it gives shade, provides nesting space for birds, and lives a long time.

1 Load a large soft brush with two tones of red and paint the fruit with two semicircular strokes using the side of the brush. Draw a calyx and stalk using the tip of the brush and black ink.

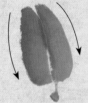

2 Using the side of the brush and gray ink, paint two flat strokes for each leaf.

3 Use the tip of the brush to add veins in black ink while the leaf is damp.

4 Assemble the fruits and leaves on a branch painted with a dry brush and ink. Add a few black dots of lichen. If wished, position a fruit as if it has fallen from the branch.

Plum

The plum is a very simple fruit to paint freestyle. There is a saying: "The plum tree puts forth many kernels [symbolizing children] and the green bamboo brings many grandchildren." This would be written on a picture of a plum and bamboo.

1 Using the side of a medium soft brush and purple or plum, paint a long stroke for the first half of each fruit.

2 Add a second long stroke, leaving an unpainted highlight in the center. Add a black ink dot at the tip of the fruit.

3 Load the brush with green and a touch of purple. Paint each leaf with two strokes, each a different size. Add purple veins to the leaves using the tip of the brush.

4 Assemble the plums and leaves hanging off a branch painted in green mixed with a little ink. Add dots of purple lichen.

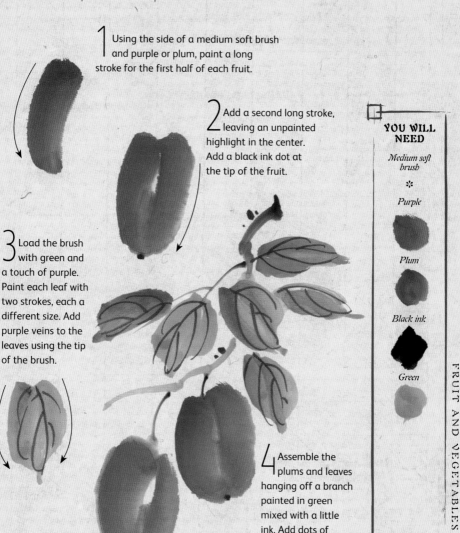

FRUIT AND VEGETABLES

93

Pear

Pear trees live for many years, so pears can be used to symbolize longevity. However, friends and families should avoid cutting up and sharing pears because this could lead to separation. The Chinese word for pear, *li*, also means separation.

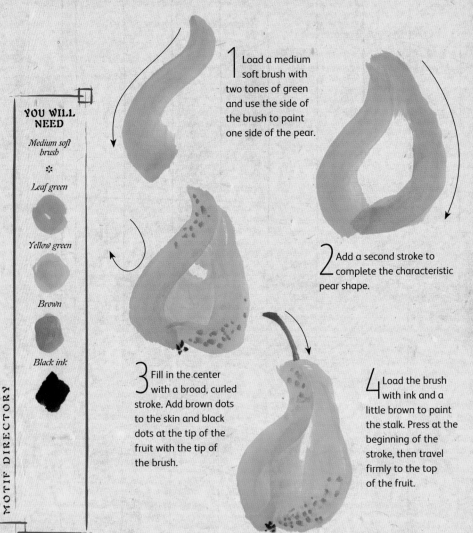

YOU WILL NEED

Medium soft brush

✻

Leaf green

Yellow green

Brown

Black ink

1 Load a medium soft brush with two tones of green and use the side of the brush to paint one side of the pear.

2 Add a second stroke to complete the characteristic pear shape.

3 Fill in the center with a broad, curled stroke. Add brown dots to the skin and black dots at the tip of the fruit with the tip of the brush.

4 Load the brush with ink and a little brown to paint the stalk. Press at the beginning of the stroke, then travel firmly to the top of the fruit.

Banana

Although rarely painted, with banana leaves being much more popular with artists, the banana is a fun addition to a still life. It is a symbol for self-discipline in China.

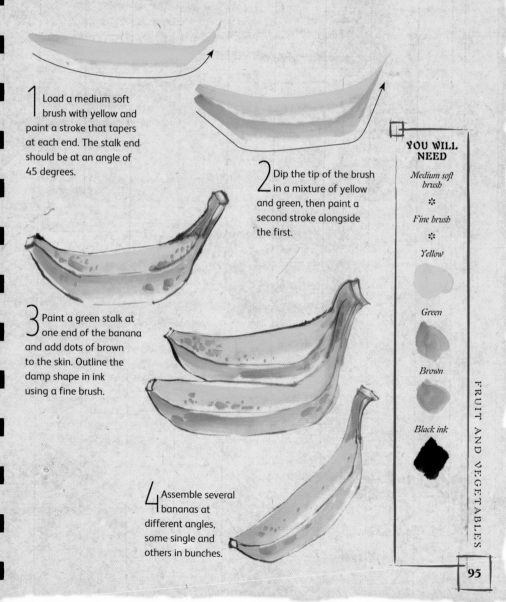

1 Load a medium soft brush with yellow and paint a stroke that tapers at each end. The stalk end should be at an angle of 45 degrees.

2 Dip the tip of the brush in a mixture of yellow and green, then paint a second stroke alongside the first.

3 Paint a green stalk at one end of the banana and add dots of brown to the skin. Outline the damp shape in ink using a fine brush.

4 Assemble several bananas at different angles, some single and others in bunches.

YOU WILL NEED

Medium soft brush

❉

Fine brush

❉

Yellow

Green

Brown

Black ink

FRUIT AND VEGETABLES

Pumpkin and Bell Pepper

Pumpkin is a favorite vegetable in China and is often planted around the house. The bell pepper is painted in the same way as a pumpkin, but with a different shape.

YOU WILL NEED

Large soft brush

*

Yellow

Orange

Olive green

Sage green

Leaf green

Gray ink

MOTIF DIRECTORY

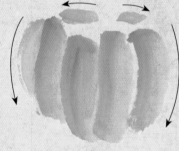

1 Load a large soft brush with yellow and dip the tip generously in orange. Use the side of the brush to paint a series of long strokes. Add two or three small ones at the back of the pumpkin.

2 Paint a stroke of olive green for the stalk and add fine lines of gray ink and olive green using the tip of the brush.

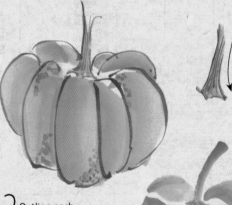

3 Outline each segment of the pumpkin with gray ink and add a few dots of ink to its surface.

4 Load a medium soft brush with leaf green and dip the tip generously in sage green. Paint the pepper in the same way as the pumpkin, but more tapered, and add a blunt-ended stalk.

Bitter Gourd
This decorative gourd is a symbol of mystery and necromancy, and represents the universe in total.

1 Outline the warty skin of the gourd using a fine brush and gray ink. Add ovals in different sizes to indicate bumps on the skin.

2 Load a small firm brush with orange and red. Holding the brush upright, paint the fruits by turning the brush in a circle for each one.

3 Load the firm brush with a pale mixture of mineral green and ink, then dip the tip generously in sage green. Form each leaf from four or five strokes using the side of the brush; vary the colors, perhaps painting some leaves purely in shades of ink. Add black ink veins.

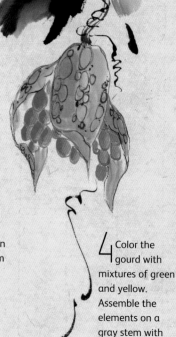

4 Color the gourd with mixtures of green and yellow. Assemble the elements on a gray stem with black tendrils.

FRUIT AND VEGETABLES

Cauliflower

With its combination of wet and fine strokes, the cauliflower is an attractive addition to a still life.

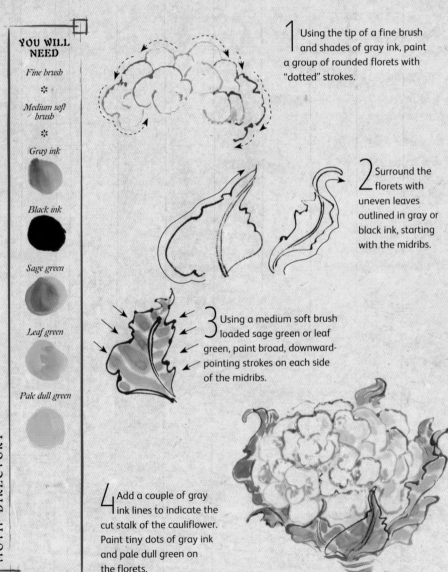

YOU WILL NEED

Fine brush

❊

Medium soft brush

❊

Gray ink

Black ink

Sage green

Leaf green

Pale dull green

1 Using the tip of a fine brush and shades of gray ink, paint a group of rounded florets with "dotted" strokes.

2 Surround the florets with uneven leaves outlined in gray or black ink, starting with the midribs.

3 Using a medium soft brush loaded sage green or leaf green, paint broad, downward-pointing strokes on each side of the midribs.

4 Add a couple of gray ink lines to indicate the cut stalk of the cauliflower. Paint tiny dots of gray ink and pale dull green on the florets.

Eggplant

An eggplant in a picture symbolizes a job as an official and is sent as a gift to someone who needs that job. The eggplant has a large calyx and looks like a man wearing a hat—or an official with a cap of office.

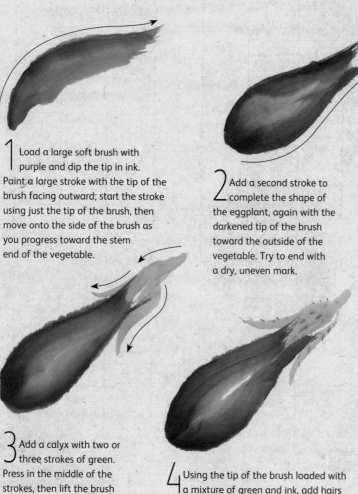

1 Load a large soft brush with purple and dip the tip in ink. Paint a large stroke with the tip of the brush facing outward; start the stroke using just the tip of the brush, then move onto the side of the brush as you progress toward the stem end of the vegetable.

2 Add a second stroke to complete the shape of the eggplant, again with the darkened tip of the brush toward the outside of the vegetable. Try to end with a dry, uneven mark.

3 Add a calyx with two or three strokes of green. Press in the middle of the strokes, then lift the brush to taper to a point.

4 Using the tip of the brush loaded with a mixture of green and ink, add hairs to the calyx.

YOU WILL NEED

Large soft brush

❋

Purple

Black ink

Green

FRUIT AND VEGETABLES

99

Radish

Usually painted in a still life with other vegetables, the radish gives a wonderful splash of color to a painting.

1 Load a medium soft brush with diluted red and dip the tip in a more concentrated red. Paint a semicircular stroke.

2 Add a second semicircle to complete the radish.

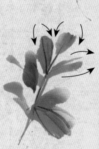

3 Add curly red roots using the tip of a fine brush.

MOTIF DIRECTORY

YOU WILL NEED

Medium soft brush

�die

Fine brush

�die

Red

Leaf green

Sage green

4 Use the fine brush to paint a fine leaf green line or two issuing from the top of the radish. Add tiny leaves using two strokes per leaf and two shades of green. Add sage green veins.

5 Vary the angle of the radishes if painting several.

Lettuce

The humble lettuce is one of the nicest subjects to paint and always looks good in a picture with other vegetables. It is painted in the same way as a peony flower, but in greens instead of reds and pinks.

1 Load a large soft brush with leaf green and dip the tip generously in sage green. Place the whole ferrule on the paper, with the tip pointing toward the base of the vegetable. Leaving the tip in one place, press the heel of the brush in a semicircle.

2 Paint more leaves in the same way.

3 Continue building up rows of overlapping leaves, adding a sage green central vein to each one.

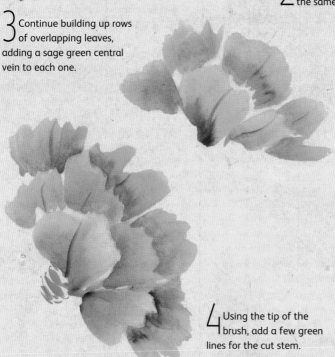

4 Using the tip of the brush, add a few green lines for the cut stem.

YOU WILL NEED

Large soft brush

✳

Leaf green

Sage green

FRUIT AND VEGETABLES

Chinese Cabbage

The Chinese cabbage is very distinctive, with its pale stems and dark leaves. It is an exciting subject, especially if painted in ink, providing a chance to make contrasts work well.

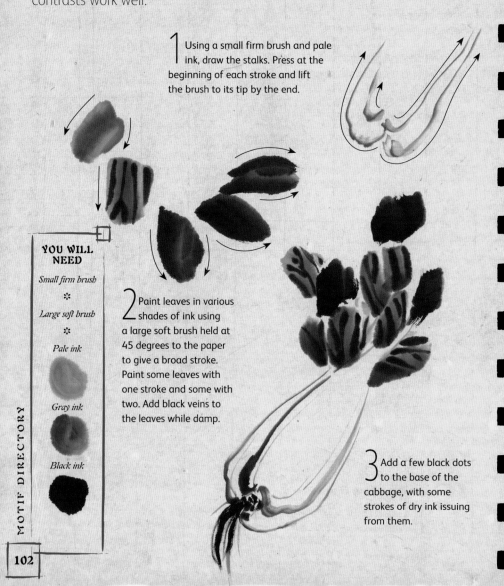

1 Using a small firm brush and pale ink, draw the stalks. Press at the beginning of each stroke and lift the brush to its tip by the end.

2 Paint leaves in various shades of ink using a large soft brush held at 45 degrees to the paper to give a broad stroke. Paint some leaves with one stroke and some with two. Add black veins to the leaves while damp.

3 Add a few black dots to the base of the cabbage, with some strokes of dry ink issuing from them.

YOU WILL NEED

Small firm brush

❖

Large soft brush

❖

Pale ink

Gray ink

Black ink

MOTIF DIRECTORY

Onion

The onion is thought of as a symbol for cleverness; perhaps it has many layers of learning. One special kind of onion, the stag onion, should be tied to the waist of any expectant mother who would like a son.

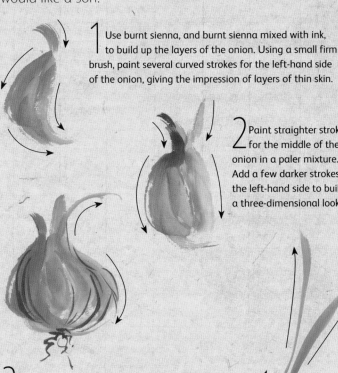

1 Use burnt sienna, and burnt sienna mixed with ink, to build up the layers of the onion. Using a small firm brush, paint several curved strokes for the left-hand side of the onion, giving the impression of layers of thin skin.

2 Paint straighter strokes for the middle of the onion in a paler mixture. Add a few darker strokes to the left-hand side to build a three-dimensional look.

3 Paint the right-hand side in the same way as the left side, extending the stroke with the tip of the brush at the top. Emphasize the roundness with fine dark lines. Use the tip of the brush to scribble the roots.

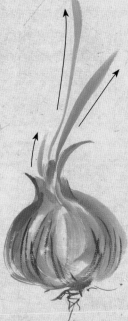

4 Add a few green shoots coming out of the top of the onion.

YOU WILL NEED

Small firm brush

❋

Burnt sienna

Burnt sienna + ink

Green

Celery

Celery is rich in mineral salts, vitamins, and iron. It is becoming more widely grown for use in cooking because of its medicinal diuretic properties, lack of calories, and wonderful taste.

YOU WILL NEED

Fine brush

✳

Medium soft brush

✳

Gray ink

Pale dull green

Leaf green

Sage green

1 Using a fine brush and gray ink, draw a rough circle. Add separate leaf stalks composed of darker, thicker lines at the edges of each stalk and fine lines in the middle. Emphasize the different stalks with a little pale dull green.

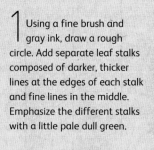

2 Load a medium soft brush with leaf green and dip the tip in sage green. Paint the leaves by placing the tip of the brush facing toward the base of the vegetable and then pressing down the whole ferrule and moving it to the side to broaden the leaf. Vary the sizes and colors of the leaves.

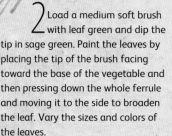

3 Add veins using a fine brush and ink while the leaves are damp.

Carrot

Great fun to paint because of its simplicity, the carrot can be added to any still life. It is usually pictured lying on a table.

1 Load a medium soft brush with two shades of orange and paint a large stroke using the side of the brush.

 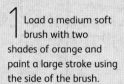

2 Repeat with progressively smaller strokes all down the carrot. End with a wavy line using the tip of the brush.

3 Change to a fine brush and paint sage green stems at the top of the carrot. Dip a splayed medium soft brush into leaf green and sage green. Dab the brush at the top of long stems to give frilly leaves.

4 Using the fine brush and bright orange, paint a semicircle at the top of the carrot and outline the segments if you wish. For variety, paint some carrots with cut stems and add little orange roots along the length of the carrot.

YOU WILL NEED

Medium soft brush

❋

Fine brush

❋

Pale orange

Bright orange

Leaf green

Sage green

FRUIT AND VEGETABLES

Mushroom

The mushroom is important in Chinese cuisine and is often painted in a still life arrangement with other fruit and vegetables. There is a famous mushroom, known as the "Miraculous Mushroom," that confers immortality, but the mushroom painted in this motif is an edible one.

1 Load a small firm brush with a mixture of burnt sienna and ink, then dip the tip in a slightly darker mixture. Paint a semicircle with the tip of the brush pointing toward the stalk end of the mushroom. Begin with just the tip of the brush on the paper, then press down on the heel for the top of the mushroom. Lift the brush back onto the tip to complete the shape.

2 Dip the brush in blue and use the side of the brush to paint a stalk, with the tip of the brush pointing toward the outside of the stalk.

3 Outline the stalk in blue using the tip of the brush.

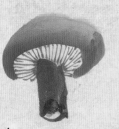

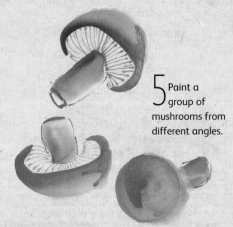

4 Change to a fine brush and purple to add lines radiating out from the stalk.

5 Paint a group of mushrooms from different angles.

YOU WILL NEED

Small firm brush

❖

Fine brush

❖

Burnt sienna + ink

Blue

Purple

MOTIF DIRECTORY

Maize

A popular vegetable originating in America, maize kernels can be painted in ochers, purples, browns, and blues. An outline is used to simplify the shape here, but you could use large freestyle strokes and round kernels instead.

YOU WILL NEED

Fine brush

❋

Medium soft brush

❋

Gray ink

Pale dull green

Leaf green

Sage green

Yellow

Orange

1 Using a fine brush and gray ink, draw a small circle, then paint several lively strokes to give form to the outer husk. Add uneven wavy strokes in any shade of green mixed with a little ink to give a papery feel to the husk.

2 Load a medium soft brush with yellow and dip the tip in orange. Add dabs of paint in rows between the husk bracts for the kernels. Outline the kernels with ink using the fine brush.

3 When dry, use the soft brush with various shades of green and a dash of orange to overpaint the husk with broad strokes. Add long silky strands of yellow, green, and ink to the tip of the cob using the fine brush.

FRUIT AND VEGETABLES

107

Chili Pepper

The chili pepper is a popular vegetable worldwise. Its shape and color lend themselves perfectly to Chinese brush strokes. A bowl of chilis makes a lovely picture.

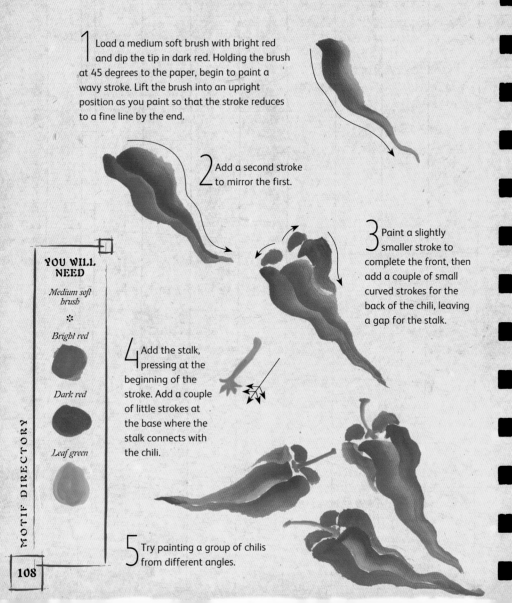

1 Load a medium soft brush with bright red and dip the tip in dark red. Holding the brush at 45 degrees to the paper, begin to paint a wavy stroke. Lift the brush into an upright position as you paint so that the stroke reduces to a fine line by the end.

2 Add a second stroke to mirror the first.

3 Paint a slightly smaller stroke to complete the front, then add a couple of small curved strokes for the back of the chili, leaving a gap for the stalk.

4 Add the stalk, pressing at the beginning of the stroke. Add a couple of little strokes at the base where the stalk connects with the chili.

5 Try painting a group of chilis from different angles.

YOU WILL NEED

Medium soft brush

✳

Bright red

Dark red

Leaf green

Scallion

Popular the world over, and used in stir frying every day, the scallion is very simple to paint and adds color to a still life.

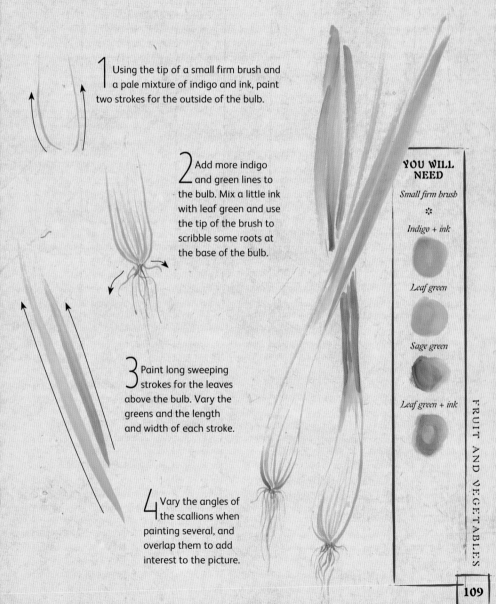

1 Using the tip of a small firm brush and a pale mixture of indigo and ink, paint two strokes for the outside of the bulb.

2 Add more indigo and green lines to the bulb. Mix a little ink with leaf green and use the tip of the brush to scribble some roots at the base of the bulb.

3 Paint long sweeping strokes for the leaves above the bulb. Vary the greens and the length and width of each stroke.

4 Vary the angles of the scallions when painting several, and overlap them to add interest to the picture.

YOU WILL NEED

Small firm brush

❋

Indigo + ink

Leaf green

Sage green

Leaf green + ink

FRUIT AND VEGETABLES

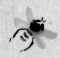

Bee

An industrious insect, the bee is very easy to paint and always adds interest to flower paintings.

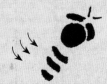

1 Using a fine brush and black ink, paint a dot for the thorax and add two lines for the eyes.

2 Paint three black lines behind the thorax for the abdomen. Add two very fine black lines above the eyes for antennae.

3 When dry, load a medium soft brush with yellow and paint an oval over the three ink lines to complete the abdomen.

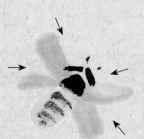

4 Load the soft brush with gray ink and paint wings attached to the thorax.

5 Paint two legs running each side of the body with the fine brush and black ink.

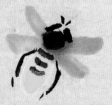

MOTIF DIRECTORY

Ant

The ant lives in a colony and is thought of as a virtuous, tidy insect in China. Ants are simple and fun to paint.

1 Using a medium soft brush, paint a spot of gray ink for the abdomen. Add black lines with a fine brush while the ink is still damp.

2 Using the soft brush, add a triangle and two lines of differing lengths to represent the head and thorax. Indicate the eyes and mouthparts with black dots using the fine brush, then add the antennae.

3 Using the fine brush, paint six legs issuing from the thorax. Add a white dot to give the abdomen a sheen.

4 Try drawing several ants at different angles.

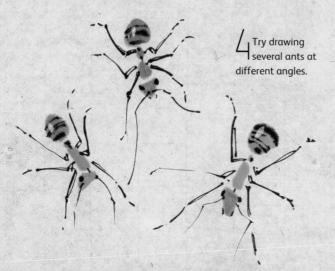

YOU WILL NEED

Medium soft brush

❀

Fine brush

❀

Gray ink

Black ink

White

INSECTS AND MOLLUSCS

Cicada

A cicada sings at night, filling the evening with sound. In China it represents eternal youth, happiness, and resurrection. In the hope of this last quality, a jade cicada is often placed in the mouth of a dead person.

1 Using a small firm brush and black ink, paint a rectangle, making one of the strokes wide.

2 Add a long triangle for the head, and outline the wing.

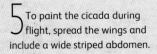
3 Complete the wings and abdomen, adding gray ink lines and black stripes respectively. Paint a dot and two fine lines for the eye and antennae.

4 Color the body with burnt sienna mixed with a little ink, using various dilutions. Change to a fine brush to add legs in black ink. Paint a green leaf beneath the legs using the firm brush.

5 To paint the cicada during flight, spread the wings and include a wide striped abdomen.

Praying Mantis

A praying mantis will enliven any flower painting. It is almost comical in appearance (although small insects may not agree).

1 Using a small firm brush, paint a sage green triangle for the head.

2 Load the brush with leaf green and dip the tip in sage green. Add two strokes for the thorax, one using the tip of the brush and the other pressing and then lifting the brush for a wider stroke.

3 Paint the wings in the same way, but longer and wider. Paint yellow dots for the eyes; when dry, add a spot of black ink.

4 Using a mixture of burnt sienna and ink, paint a line under the wings to form the abdomen. Load a fine brush with any green mixture and paint the legs, paying special attention to the shape of the forelegs with its barbs. Add two long fine lines for antennae using burnt sienna and ink, and paint short black ink lines on the abdomen.

INSECTS AND MOLLUSCS

113

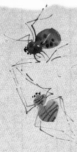

Spider

Always present in the garden, spiders add a charming touch to any plant picture.

1 Using a small firm brush, paint two small strokes of burnt sienna to create a small, almost circular thorax. Paint a larger, almost circular abdomen in the same way.

2 Using a fine brush, add black ink stripes to both the thorax and abdomen while damp.

3 Paint eight legs and indicate eyes and mouthparts at the head end with black dots.

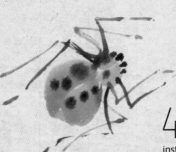

4 Try painting a spider using gray ink with black dots instead of stripes.

Dragonfly
A fluttering dragonfly adds a symbol of summer to a picture. However, it also represents fickleness and weakness.

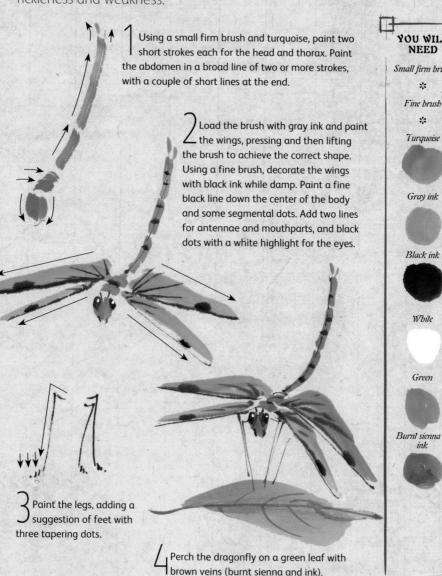

1 Using a small firm brush and turquoise, paint two short strokes each for the head and thorax. Paint the abdomen in a broad line of two or more strokes, with a couple of short lines at the end.

2 Load the brush with gray ink and paint the wings, pressing and then lifting the brush to achieve the correct shape. Using a fine brush, decorate the wings with black ink while damp. Paint a fine black line down the center of the body and some segmental dots. Add two lines for antennae and mouthparts, and black dots with a white highlight for the eyes.

3 Paint the legs, adding a suggestion of feet with three tapering dots.

4 Perch the dragonfly on a green leaf with brown veins (burnt sienna and ink).

YOU WILL NEED

Small firm brush

❀

Fine brush

❀

Turquoise

Gray ink

Black ink

White

Green

Burnt sienna + ink

INSECTS AND MOLLUSCS

Cricket

Chirruping away on warm evenings, the cricket symbolizes summer and courage in China. You could paint it in brown instead of green.

1 Using a small firm brush and sage green, paint a few short lines and a couple of dots to indicate the head and mouthparts.

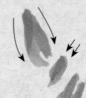

2 Add two strokes to create the thorax and two strokes for a short, stubby wing.

3 Add a second wing behind the first, then paint a leaf green oval for the abdomen using two strokes. Change to a fine brush and paint indigo lines on the abdomen. Add dark ink dots at the base of the wings and to indicate eyes.

4 Add fine indigo lines to the wings, then paint the legs and antennae in ink. Add a few small dots along the hindlegs to indicate spines.

5 Try painting the insect from a different angle.

Water Beetle

This is a male of the tiger water beetle species, with stripes on his back. A voracious predator, this insect lives in ponds and pools, and flies in the evening.

1 Load a small firm brush with sage green and paint the head using a sideways stroke with the whole ferrule.

2 Leave a gap and then add the abdomen.

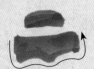

3 Leave another gap, then paint two broad wing cases.

4 Outline the head, thorax, and sides of the wing cases with a dull brown mixture of yellow ocher and green, filling in all the gaps and adding two dots for eyes. Add some white highlights to give the beetle a glossy appearance. Using a fine brush, paint a few ink lines on the beetle's back.

5 Using the fine brush and dull brown, add the legs, eyes, and antennae. Add fine black hairs to the hind legs and dot the eyes.

YOU WILL NEED

Small firm brush

❖

Fine brush

❖

Sage green

Yellow ocher + green

White

Black ink

INSECTS AND MOLLUSCS

Beetle

This exotic beetle has very long antennae and spots on its back. It is a longicorn beetle, which lives in forests.

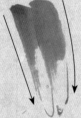

1 Load a small firm brush with a mixture of burnt sienna and gray ink and paint the wings. Press and lift the brush to give a dry end to each stroke. Use the tip of the brush to draw the rounded ends.

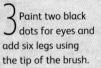

2 Paint two broad strokes for the head and thorax, and outline the top of the wings to create an angular shape. Add black ink dots to the thorax, and black and white dots to the wings.

3 Paint two black dots for eyes and add six legs using the tip of the brush.

4 Using a fine brush, paint a curling black line for each antenna, pausing at intervals to leave a spot of ink.

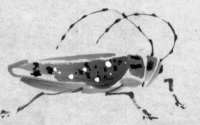

5 Add a lighter gray underbelly below the wings if painting a sideview of the beetle.

Ladybug

The ladybug's beautiful red color makes this insect perfect for flower pictures. The number of spots varies. The ladybug eats plant lice and is useful in the control of this pest.

1 Using a small firm brush and black ink, paint two strokes side by side to indicate the thorax.

2 Using a fine brush, add two ink dots for eyes and two dashes for antennae, above the thorax.

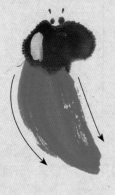

3 Load the firm brush with red and paint two curving strokes to form each wing case. Add a pale green dot to each side of the damp thorax.

4 When the red has almost dried, paint the required number of inky black dots onto the wing cases using the tip of the firm brush. Using the fine brush and ink, paint six legs.

5 Practice painting the ladybug from different angles. Add a white highlight to a wing case if wished.

INSECTS AND MOLLUSCS

Stag Beetle
An inhabitant of forests, the stag beetle flies in the evening and likes to lay its eggs in rotting wood.

1 Load a small firm brush with black ink and paint a sideways stroke for the head using the side of the brush.

2 Add a slightly larger sideways stroke for the thorax.

3 Add a black dot at each side of the head for the eyes and add mouthparts at the top. Load the brush with a mixture of burnt sienna and ink and paint the wings. Press and lift the brush to give a dry end to each stroke. Use the tip of the brush to draw the rounded ends.

YOU WILL NEED

Small firm brush

❊

Fine brush

❊

Black ink

Burnt sienna + ink

4 Using a fine brush and black ink, add the horns, antennae, and legs.

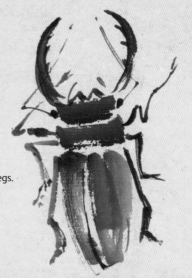

Wasp

Painting wasps flying around perfumed flowers, in and out of grapevines, or in a still life with fruit will add interest to the picture. The wasp has a longer abdomen and legs than the bee.

1 Using a small firm brush, paint two dark ink dots for eyes. Add two bigger yellow dots to indicate the head and thorax.

2 Paint a couple of gray spots on the thorax, then add a long yellow oval for the abdomen using two overlapping, tapering strokes.

3 Load the firm brush with gray ink and paint the wings, pressing at the beginning of the stroke and lifting as the brush tip travels to the thorax. Using a fine brush and dark ink, add six long jointed legs and two tiny antennae. Add dark lines on the abdomen to give the wasp its distinctive coloring.

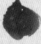

YOU WILL NEED

Small firm brush

❋

Fine brush

❋

Dark ink

Yellow

Gray ink

4 Vary the wasp by painting it with its wings up or its body bent or viewed from the side.

INSECTS AND MOLLUSCS

121

Grasshopper This delightful garden insect is a lively addition to any flower or fruit picture.

1 Load a small firm brush with green and paint three short lines for the head and thorax, making the thorax slightly triangular. Paint the wing, pressing the brush at the beginning of the stroke and lifting it at the end.

2 Use the tip of the brush to draw the edge of the folded wings. Add a small line of burnt sienna mixed with ink below the wings for the abdomen. Using a fine brush and dark ink, add dots to the head for eyes and mouthparts. Link the thorax to the wings with a short, tapering stroke.

MOTIF DIRECTORY

3 Using a fine brush and ink, paint the antennae and legs, adding dots to the two long hind legs.

4 Try painting the grasshopper from a different angle, and swapping the use of colors so that the wings are brown and the abdomen green.

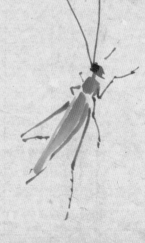

Snail
The snail is a delightful addition to any picture. Its shell can be outlined and then decorated, or painted freestyle.

1 Using the tip of a small firm brush and gray ink, paint a curl for the outline of the shell, starting in the center and spiraling outward.

2 Add another broader curl to the center of the shell immediately, using a very dilute mixture of burnt sienna and ink. Decorate the shell with broken stripes using a stronger brown mixture.

3 Add a tapering stroke under the shell for the body, with a tiny curve for the head. Using the tip of the brush, add two black eyes on antennae.

4 Try painting a freestyle shell with a thick curl of burnt sienna and ink. Paint it in the same way as the outlined shell, but press the brush more firmly into the paper to produce a broad stroke.

5 Decorate the shell with black dots while damp, then add a body, eyes, and antennae as before.

INSECTS AND MOLLUSCS

Cat

The cat protects against evil spirits and represents good wishes for a long life. It is an auspicious motif to give as a gift, and fun and easy to paint freestyle.

1 Load a large soft brush with black ink and paint a large circle for the lower body of the cat.

2 Add a half-moon slightly off-center above the first circle to indicate the cat's upper body.

YOU WILL NEED

Large soft brush

❉

Fine brush

❉

Black ink

3 Paint a smaller half-moon, again off-center, for the head.

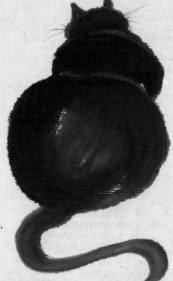

4 Add a curling tail, and change to a fine brush to add ears and whiskers.

MOTIF DIRECTORY

Kitten

In contrast to the adult cat, this kitten is painted using the outline method. Looking sheepishly over its shoulder, the kitten knows it has been naughty, playing with a ball of yarn.

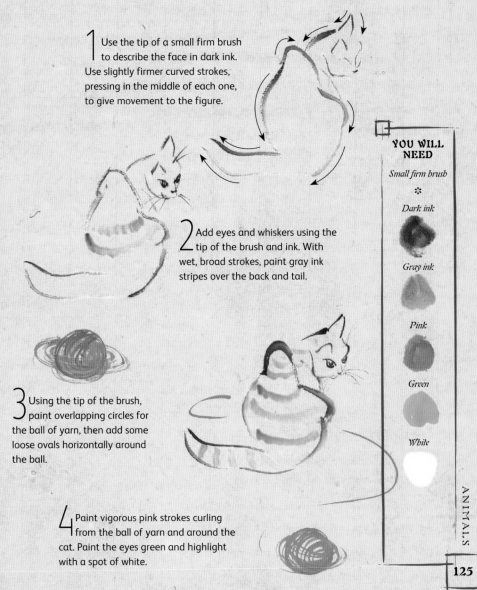

1 Use the tip of a small firm brush to describe the face in dark ink. Use slightly firmer curved strokes, pressing in the middle of each one, to give movement to the figure.

2 Add eyes and whiskers using the tip of the brush and ink. With wet, broad strokes, paint gray ink stripes over the back and tail.

3 Using the tip of the brush, paint overlapping circles for the ball of yarn, then add some loose ovals horizontally around the ball.

4 Paint vigorous pink strokes curling from the ball of yarn and around the cat. Paint the eyes green and highlight with a spot of white.

YOU WILL NEED

Small firm brush

❖

Dark ink

Gray ink

Pink

Green

White

Bear

The bear symbolizes man and stands for strength and courage. Here, the bear is painted with two layers of freestyle strokes

YOU WILL NEED

Medium soft brush

✽

Fine brush

✽

Dark ink

Gray ink

Pale ink

1 Using a medium soft brush and various tones of gray ink, paint the head, body, and legs of the bear in large strokes.

2 While damp, use a dry brush to add strokes of darker gray to give the bear a shaggy coat. Using a fine brush and dark ink, add ears, eye, nose, and mouth.

3 Continue adding strokes of fur over the shoulders, back, and legs, keeping the legs on the far side lighter to suggest more distance.

Deer

The deer is a symbol of long life in China because it is adept at finding the mushrooms that give longevity. It is a shy, elegant creature.

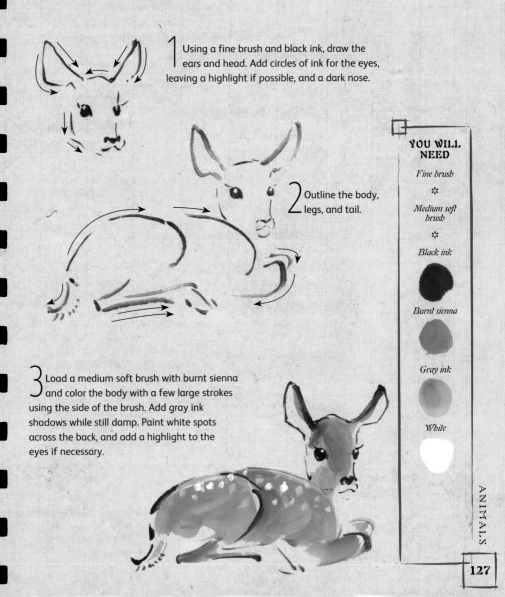

1 Using a fine brush and black ink, draw the ears and head. Add circles of ink for the eyes, leaving a highlight if possible, and a dark nose.

2 Outline the body, legs, and tail.

3 Load a medium soft brush with burnt sienna and color the body with a few large strokes using the side of the brush. Add gray ink shadows while still damp. Paint white spots across the back, and add a highlight to the eyes if necessary.

YOU WILL NEED

Fine brush

❊

Medium soft brush

❊

Black ink

Burnt sienna

Gray ink

White

ANIMALS

127

Goat
Sheep and goats both symbolize the love of children, and have been important through the ages for food and wool production.

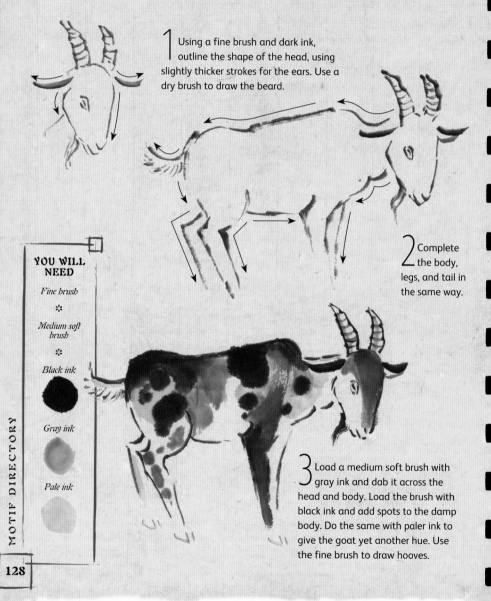

1 Using a fine brush and dark ink, outline the shape of the head, using slightly thicker strokes for the ears. Use a dry brush to draw the beard.

2 Complete the body, legs, and tail in the same way.

3 Load a medium soft brush with gray ink and dab it across the head and body. Load the brush with black ink and add spots to the damp body. Do the same with paler ink to give the goat yet another hue. Use the fine brush to draw hooves.

YOU WILL NEED

Fine brush

❖

Medium soft brush

❖

Black ink

Gray ink

Pale ink

Bush Baby

A bush baby, with its huge eyes and lovely soft fur, is delightful to paint. It lends itself perfectly to wet strokes with a soft brush.

1 Using the tip of a small firm brush and dark ink, draw large circular eyes. Add two small lines for the nose and two upward curling lines for the ears.

2 Load a medium soft brush with gray blue, then paint around the eyes and reinforce the ear strokes. Leave the muzzle unpainted, with a semicircle of tiny strokes for a beard. Paint the eyes with dark ink, leaving unpainted highlights.

3 Color the eyes with burnt sienna. Use wet gray blue strokes for the arms and shoulders.

4 Paint a branch in dark ink, then add the hands and tail. Use light strokes in alternating directions for the tail, going over them several times with various grays and blues until it looks fluffy, adding a few dryer strokes at the end. Go over the bush baby with strokes of gray ink and light blue to indicate dense fur.

YOU WILL NEED

Small firm brush

❖

Medium soft brush

❖

Dark ink

Gray blue

Burnt sienna

Gray ink

Light blue

ANIMALS

Elephant

Once abundant in China, elephants are regarded as having high moral standards and symbolize strength and astuteness. Deities and emperors rode on elephants, and the animals were trained to work much as they are in India.

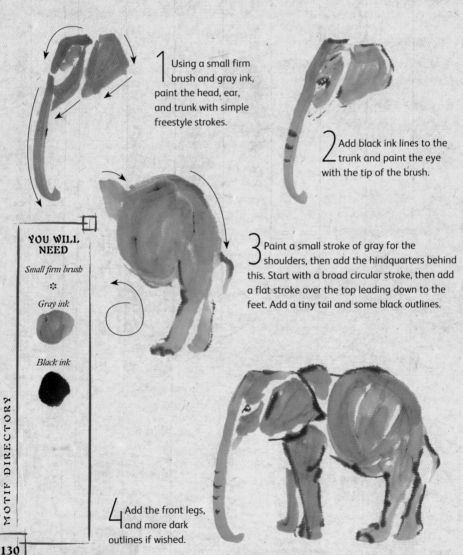

1 Using a small firm brush and gray ink, paint the head, ear, and trunk with simple freestyle strokes.

2 Add black ink lines to the trunk and paint the eye with the tip of the brush.

3 Paint a small stroke of gray for the shoulders, then add the hindquarters behind this. Start with a broad circular stroke, then add a flat stroke over the top leading down to the feet. Add a tiny tail and some black outlines.

4 Add the front legs, and more dark outlines if wished.

YOU WILL NEED

Small firm brush

❋

Gray ink

Black ink

Lion

The golden lion is a wise animal symbolizing valor and strength. Pairs of stone lions often stand as guardians outside temples and official buildings. The right-hand male holds an ornamental ball under his left paw; the left-hand female holds a cub under her right paw.

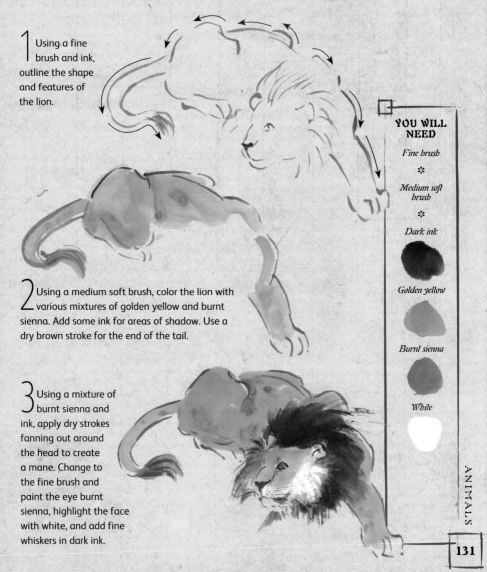

1 Using a fine brush and ink, outline the shape and features of the lion.

2 Using a medium soft brush, color the lion with various mixtures of golden yellow and burnt sienna. Add some ink for areas of shadow. Use a dry brown stroke for the end of the tail.

3 Using a mixture of burnt sienna and ink, apply dry strokes fanning out around the head to create a mane. Change to the fine brush and paint the eye burnt sienna, highlight the face with white, and add fine whiskers in dark ink.

ANIMALS

Fox

The fox is a magical animal, symbolizing supernatural strength, cunning, and practical joking. It also has the ability to change—into a woman when it is 50 years old, a girl at 100, and a celestial fox after 1,000 years. A celestial fox has nine tails and is beguiling and sensual.

1 Using a fine brush and black ink, outline the face, ears, eye, and nose. Add short strokes for whiskers.

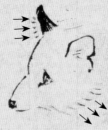

2 Load a medium soft brush with burnt sienna and paint the face. Add sweeping strokes with the side of the brush for the body. Paint a long stroke for the tail, adding shorter strokes with a dry brush to make the tail fluffy.

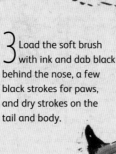

YOU WILL NEED

Fine brush

❊

Medium soft brush

❊

Black ink

Burnt sienna

3 Load the soft brush with ink and dab black behind the nose, a few black strokes for paws, and dry strokes on the tail and body.

Water Buffalo

Found all over China, the water buffalo is used extensively to plough the wet rice fields. It is a popular subject in paintings, often depicted with a child riding on it to show the gentle side of this powerful animal.

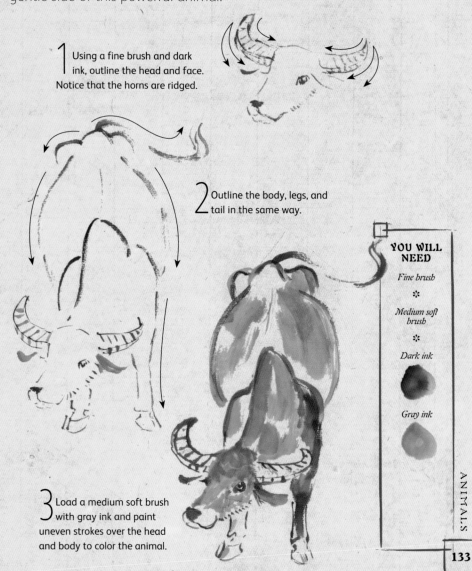

1 Using a fine brush and dark ink, outline the head and face. Notice that the horns are ridged.

2 Outline the body, legs, and tail in the same way.

3 Load a medium soft brush with gray ink and paint uneven strokes over the head and body to color the animal.

YOU WILL NEED

Fine brush

✼

Medium soft brush

✼

Dark ink

Gray ink

ANIMALS

Panda

The panda is China's living treasure. It feeds on bamboo, which is so low in nutrients that the panda has to spend most of the day eating.

1 Using the tip of a large soft brush and gray ink, paint a broken circle, leaving space for the ears and muzzle. Add black ears with a curving stroke, then paint the eye patches in the lower half of the face. Add a black line for the nose and gray lines for the mouth.

2 Using black ink, paint a thick U-shaped stroke for the forelegs, pressing at the elbows. Lift the brush at the end of the stroke to produce a dry mark to indicate claws.

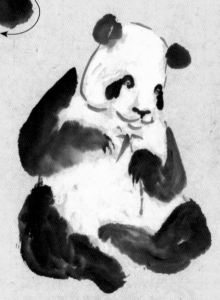

3 Paint the hind legs with one or two thick strokes, ending with a dry mark for the toes.

4 Paint the face and body cream, the eyes blue, and give the panda a green bamboo shoot to eat.

Donkey

Regarded as a stupid animal in China, only poorer people and minor officials rode on donkeys. The donkey is a humble, biddable animal, useful for transporting packs and produce.

1 Load a medium soft brush with gray ink and paint two ears, pressing a little in the middle of each stroke.

2 Paint two strokes for the forehead, one for the cheek, lightly draw the eye, and add a stroke for the front of the body. Hold the brush on its side when painting the back and at 45 degrees to the paper for the hindquarters.

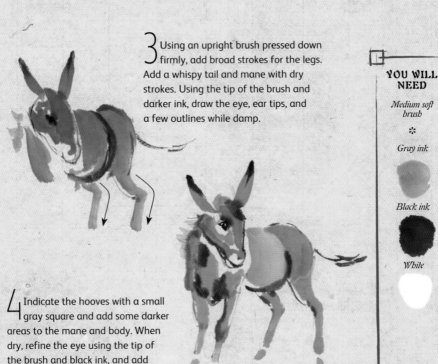

3 Using an upright brush pressed down firmly, add broad strokes for the legs. Add a whispy tail and mane with dry strokes. Using the tip of the brush and darker ink, draw the eye, ear tips, and a few outlines while damp.

4 Indicate the hooves with a small gray square and add some darker areas to the mane and body. When dry, refine the eye using the tip of the brush and black ink, and add a white highlight if necessary.

ANIMALS

135

Lizard

The lizard varies in color and decoration, but is always a mysterious addition to a picture. The viewer wonders what the lizard is doing, where it has come from, and where it is going.

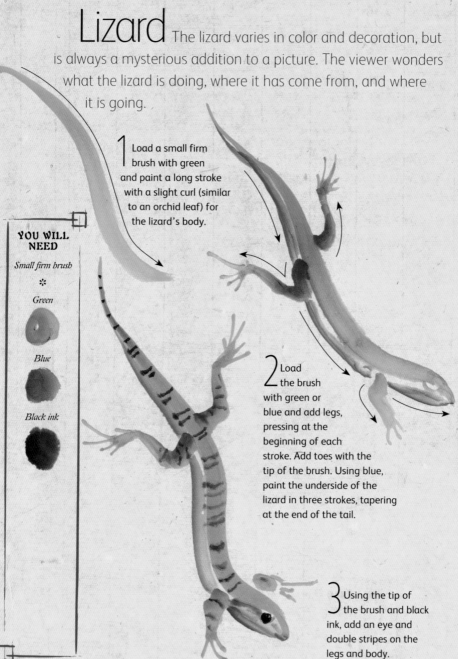

1 Load a small firm brush with green and paint a long stroke with a slight curl (similar to an orchid leaf) for the lizard's body.

YOU WILL NEED

Small firm brush
✻
Green

Blue

Black ink

2 Load the brush with green or blue and add legs, pressing at the beginning of each stroke. Add toes with the tip of the brush. Using blue, paint the underside of the lizard in three strokes, tapering at the end of the tail.

3 Using the tip of the brush and black ink, add an eye and double stripes on the legs and body.

Otter

The otter is a symbol of sexual activity and there are many tales of otters in female guise seducing men. In captivity, the otter was often trained to catch fish for its owner.

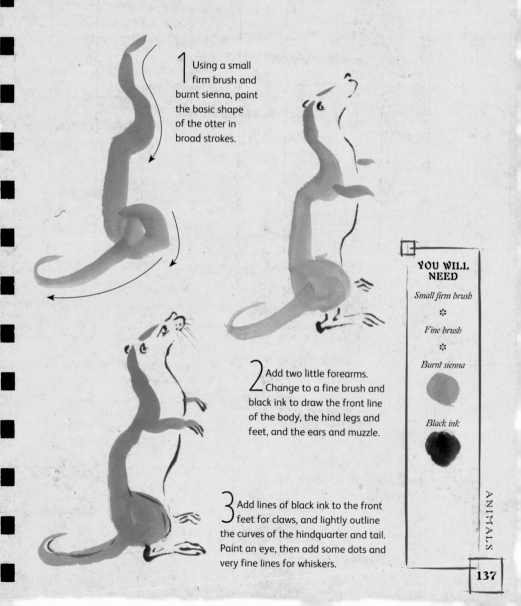

1 Using a small firm brush and burnt sienna, paint the basic shape of the otter in broad strokes.

2 Add two little forearms. Change to a fine brush and black ink to draw the front line of the body, the hind legs and feet, and the ears and muzzle.

3 Add lines of black ink to the front feet for claws, and lightly outline the curves of the hindquarter and tail. Paint an eye, then add some dots and very fine lines for whiskers.

YOU WILL NEED

Small firm brush

❊

Fine brush

❊

Burnt sienna

Black ink

ANIMALS

Lemur

An unusual animal to paint, the ring-tailed lemur lends itself beautifully to the free and fine strokes of the Chinese brush.

1 Using a fine brush and black ink, paint the eyes and nose. Change to a medium soft brush and gray ink to paint three short strokes for the ears and head.

2 Use the tip of the brush to outline a furry face with fine gray lines. When the nose and eyes are dry, dab dark ink around the eyes and a gray spot over the nose.

YOU WILL NEED

Fine brush

❖

Medium soft brush

❖

Black ink

Gray ink

3 Paint four gray strokes for the body, hindquarters, and front legs. Outline them using a fine brush and black ink while wet. Add fingers.

4 Add hind legs in the same way. Load the soft brush with clean water and paint a large wet stroke for the tail. Paint bands of black ink across the wet stroke, letting them bleed to simulate fur.

Squirrel

The squirrel is often painted with a pine tree, its favorite haunt. Give it a pinecone or acorn to hold for added interest.

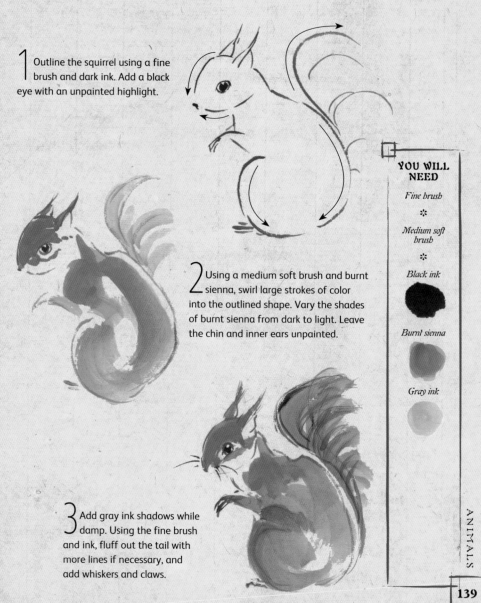

1 Outline the squirrel using a fine brush and dark ink. Add a black eye with an unpainted highlight.

2 Using a medium soft brush and burnt sienna, swirl large strokes of color into the outlined shape. Vary the shades of burnt sienna from dark to light. Leave the chin and inner ears unpainted.

3 Add gray ink shadows while damp. Using the fine brush and ink, fluff out the tail with more lines if necessary, and add whiskers and claws.

YOU WILL NEED

Fine brush

❉

Medium soft brush

❉

Black ink

Burnt sienna

Gray ink

ANIMALS

139

Mouse

A quiet, shy animal, the mouse usually appears to be timid and wary. It can be painted in brown, black, or gray, using the outline or freestyle method.

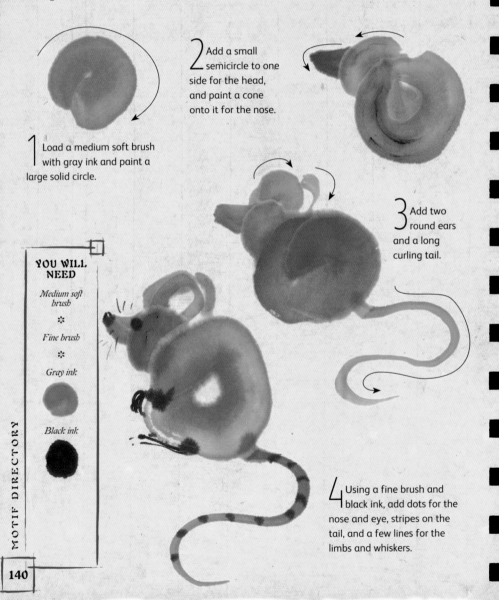

1 Load a medium soft brush with gray ink and paint a large solid circle.

2 Add a small semicircle to one side for the head, and paint a cone onto it for the nose.

3 Add two round ears and a long curling tail.

4 Using a fine brush and black ink, add dots for the nose and eye, stripes on the tail, and a few lines for the limbs and whiskers.

YOU WILL NEED

Medium soft brush

❋

Fine brush

❋

Gray ink

Black ink

Frog

In China, the frog represents the unattainable and is also the symbol of earning money.

1 Load a small firm brush with two shades of green. Paint the head and body of the frog with small strokes, pressing gently down during the strokes to give muscle to the limbs.

2 Using a fine brush, add the feet, fingers, and belly, and a little more color to the eyes.

3 Load the fine brush with ink and add stripes on the limbs and spots on the back. Define the eye, leaving an unpainted highlight.

YOU WILL NEED

Small firm brush

✻

Fine brush

✻

Sage green

Olive green

Black ink

Rat

The clever rat managed to sit on the ox's back when the animals lined up to be chosen for the zodiac. The ox was at the front of the line, but the rat jumped down at the last moment and was selected first. The rat symbolizes money.

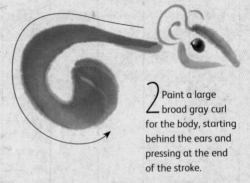

1 Using a fine brush and gray ink, outline the ears. Using the tip of a medium soft brush and black ink, add a round eye, leaving an unpainted highlight. Paint gray lines for the head and jaw.

2 Paint a large broad gray curl for the body, starting behind the ears and pressing at the end of the stroke.

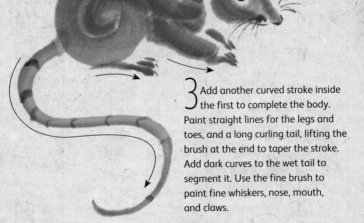

3 Add another curved stroke inside the first to complete the body. Paint straight lines for the legs and toes, and a long curling tail, lifting the brush at the end to taper the stroke. Add dark curves to the wet tail to segment it. Use the fine brush to paint fine whiskers, nose, mouth, and claws.

Ox

Taoists regard the ox as a symbol of spiritual strength. Houses in some areas are decorated with ox heads to show wealth and power, but the ox is normally employed in agricultural labors to pull plows and harrows.

1 Load a small firm brush with ink and draw the head, horns, and eye using hesitant strokes with the dry brush. The relationship between brush and paper is emphasized in this motif.

2 Outline the body, legs, hooves, and tail in the same way.

3 Load a medium soft brush with a mixture of burnt sienna and ink, and color the ox while the outlines are slightly damp. Use burnt sienna on its own to give three-dimensional form to the ox. Leave an area around the eye unpainted as a highlight.

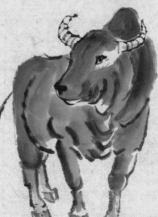

Tiger

The king of wild animals, the tiger is a symbol of courage and bravery, a god of prosperity, and possesses military prowess and masculine strength. Stone tigers are placed on graves to drive away evil spirits.

YOU WILL NEED

Fine brush

�֍

Small firm brush

�֍

Medium soft brush

✷

Gray ink

Black ink

Burnt sienna

Amber

Pink

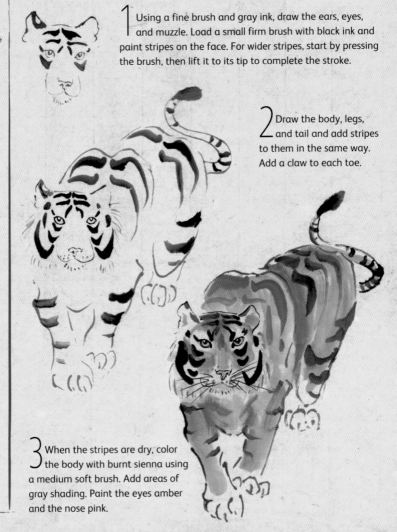

1 Using a fine brush and gray ink, draw the ears, eyes, and muzzle. Load a small firm brush with black ink and paint stripes on the face. For wider stripes, start by pressing the brush, then lift it to its tip to complete the stroke.

2 Draw the body, legs, and tail and add stripes to them in the same way. Add a claw to each toe.

3 When the stripes are dry, color the body with burnt sienna using a medium soft brush. Add areas of gray shading. Paint the eyes amber and the nose pink.

MOTIF DIRECTORY

144

Rabbit

The rabbit is a charming motif and is easy to depict with a few well-placed strokes. You can use a range of colors, from gray and brown to black and white.

1 Using a small firm brush and gray ink, paint the inner ears, pressing in the middle of each stroke, then add a finer stroke for the outer ears.

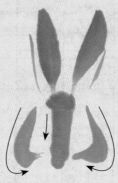

2 Paint a vertical stroke for the middle of the face, pressing the brush onto the paper at the beginning to create a forehead. Add two angled cheek strokes.

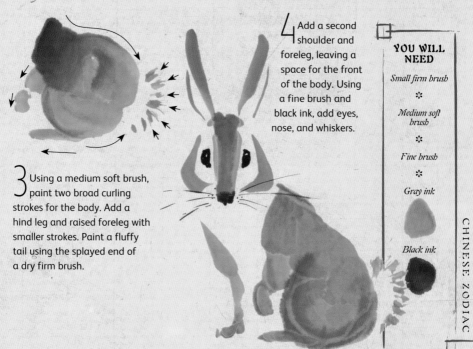

3 Using a medium soft brush, paint two broad curling strokes for the body. Add a hind leg and raised foreleg with smaller strokes. Paint a fluffy tail using the splayed end of a dry firm brush.

4 Add a second shoulder and foreleg, leaving a space for the front of the body. Using a fine brush and black ink, add eyes, nose, and whiskers.

YOU WILL NEED

Small firm brush

❋

Medium soft brush

❋

Fine brush

❋

Gray ink

Black ink

145

Dragon

Symbol of the emperor, the dragon represents strength, alertness, the ability to change, protection, good luck, and fertility. This dragon, painted on meticulous paper, is chasing a pearl of wisdom through the clouds.

YOU WILL NEED

Fine brush

❖

Two medium soft brushes

❖

Black ink

Indigo

Gray ink

Orange

Red

Yellow

1 Using a fine brush and black ink, draw the head. Use a medium soft brush to paint indigo onto the head; use another soft brush loaded with clean water to blend the color softly.

2 Draw and color the body, tail, clawed feet, and pearl in the same way, leaving areas blank for the clouds. For the scales, paint a little indigo at the base and blend it backward. Allow to dry, then paint a second and third layer of indigo, each time a little bigger.

3 Using a soft brush, wet the cloud area and drop in diluted indigo. Repeat two or three times with gray ink, letting the cloud dry between each painting.

4 Complete the coloring of the dragon and pearl using orange, red, and yellow.

Snake
Snakes used to be objects of worship in China. However, it is a noxious creature and is often regarded as treacherous and wicked, so it can symbolize malice and cunning.

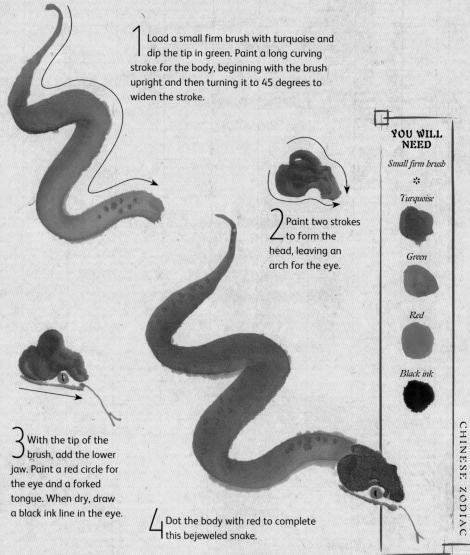

1 Load a small firm brush with turquoise and dip the tip in green. Paint a long curving stroke for the body, beginning with the brush upright and then turning it to 45 degrees to widen the stroke.

2 Paint two strokes to form the head, leaving an arch for the eye.

3 With the tip of the brush, add the lower jaw. Paint a red circle for the eye and a forked tongue. When dry, draw a black ink line in the eye.

4 Dot the body with red to complete this bejeweled snake.

CHINESE ZODIAC

Horse

Symbolizing speed and endurance, horses were very important and expensive in ancient China. A picture showing a monkey riding a horse, given as a gift, expresses the wish that the recipient will become a noble.

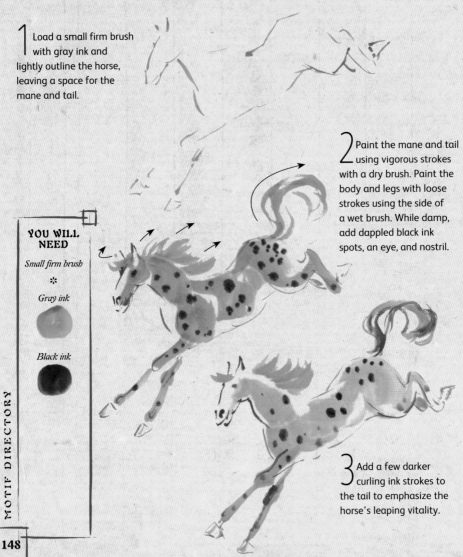

1 Load a small firm brush with gray ink and lightly outline the horse, leaving a space for the mane and tail.

2 Paint the mane and tail using vigorous strokes with a dry brush. Paint the body and legs with loose strokes using the side of a wet brush. While damp, add dappled black ink spots, an eye, and nostril.

3 Add a few darker curling ink strokes to the tail to emphasize the horse's leaping vitality.

MOTIF DIRECTORY

Sheep

The sheep represents filial piety. The Chinese word for sheep is *yang*, so it can also symbolize the male principle.

1 With a fine brush and black ink, draw the face and ears of the sheep. Add a horizontal bar for the pupil of the eye.

2 Using a small firm brush and gray ink, paint little curled strokes for the wool. Paint a gray spot inside the ears, then dot black on top while still damp.

3 Add some pale ink circles of wool between the gray ones. Continue adding circles of wool to form the body of the sheep, varying the shades of ink to give depth and variety. Add some gray shading to the face, then indicate the hooves with a couple of short curved strokes of gray ink.

YOU WILL NEED

Fine brush

❖

Small firm brush

❖

Black ink

Gray ink

Pale ink

CHINESE ZODIAC

Monkey

The monkey is known for its skill and sense of fun. Many Chinese temples were built to the monkey god Sun Wu-Kong, known for his tantrums and practical jokes.

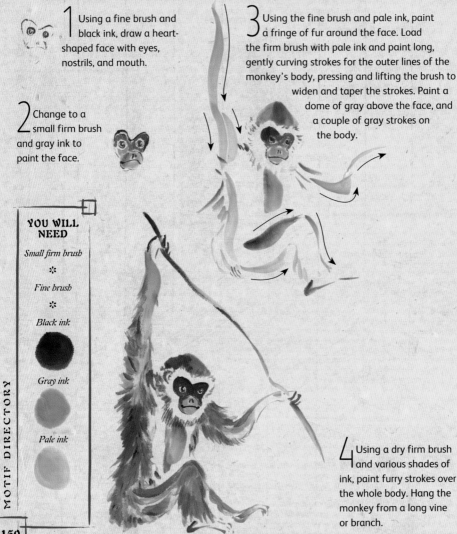

1 Using a fine brush and black ink, draw a heart-shaped face with eyes, nostrils, and mouth.

2 Change to a small firm brush and gray ink to paint the face.

3 Using the fine brush and pale ink, paint a fringe of fur around the face. Load the firm brush with pale ink and paint long, gently curving strokes for the outer lines of the monkey's body, pressing and lifting the brush to widen and taper the strokes. Paint a dome of gray above the face, and a couple of gray strokes on the body.

4 Using a dry firm brush and various shades of ink, paint furry strokes over the whole body. Hang the monkey from a long vine or branch.

YOU WILL NEED

Small firm brush

❀

Fine brush

❀

Black ink

Gray ink

Pale ink

Rooster

The rooster symbolizes the five virtues of being literary, benevolent but warlike, courageous, and faithful. A crowing cock represents achievement and fame.

1 Using a fine brush and black ink, paint the eye and beak. Load a small firm brush with red and paint the wattle with two short flat strokes. Paint a lively zigzag for the comb and a circle to indicate the eardrum.

2 Add short gray ink strokes behind the head with the tip of the firm brush.

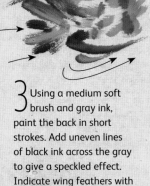

3 Using a medium soft brush and gray ink, paint the back in short strokes. Add uneven lines of black ink across the gray to give a speckled effect. Indicate wing feathers with two dark curved lines. Use a large firm brush to paint fat feather strokes for the tail, ending in a dry mark.

4 Change to the fine brush and outline the feet and claws in ink, then use the small firm brush to color the feet, beak, and eye with yellow ocher.

CHINESE ZODIAC

Dog

The dog is a faithful companion. In the folk tales of southern China, the dog brings rice to humankind.

1 Load a large firm brush with black ink and use the tip to paint the eyes with two strokes. Add U shapes for the irises.

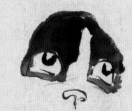

2 Paint black ink around the eyes, leaving an unpainted flash between them. Add a nose.

3 Paint the ears with black ink using a dry brush.

4 Add a fringe of fur around the face, then paint the body with black and gray ink and large strokes. Add the legs and paws, and sweeping gray strokes for the tail.

MOTIF DIRECTORY

Pig

The pig represents virility. A knuckle of pork is traditionally given to expectant mothers because it is so nourishing. A picture of a pig betokens good luck in examinations and makes an ideal greeting card.

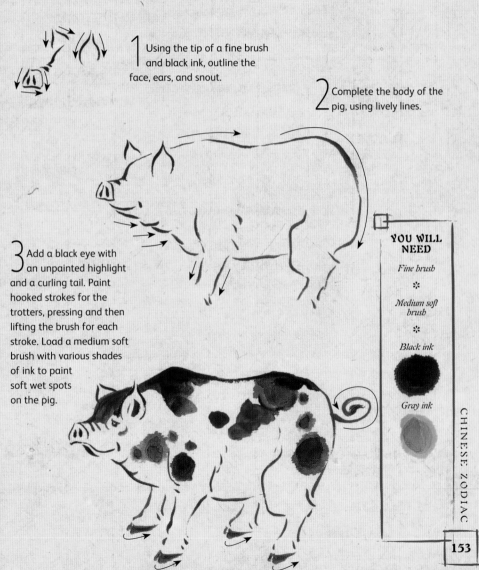

1 Using the tip of a fine brush and black ink, outline the face, ears, and snout.

2 Complete the body of the pig, using lively lines.

3 Add a black eye with an unpainted highlight and a curling tail. Paint hooked strokes for the trotters, pressing and then lifting the brush for each stroke. Load a medium soft brush with various shades of ink to paint soft wet spots on the pig.

YOU WILL NEED

Fine brush

❋

Medium soft brush

❋

Black ink

Gray ink

CHINESE ZODIAC

YOU WILL NEED

Fine brush

❈

Small firm brush

❈

Black ink

Indigo

Mineral green

Gray ink

Dark orange

Light orange

Pale green

White

Kingfisher

The kingfisher, with its glorious colors, symbolizes beauty. Having "kingfisher eyebrows" was a compliment to a beautiful woman in China. The birds often fly in pairs, so they represent married love.

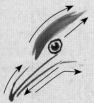

1 Using a fine brush and black ink, draw the beak and eye. Change to a small firm brush and add two strokes of indigo for the crown of the head.

2 When dry, add lines of mineral green to the crown. Paint the beak gray, the eye and brow dark orange, and the face black. Load the brush with light orange and dip the tip in dark orange. Put the tip just under the beak and press the heel of the brush around in a fan shape to create the breast.

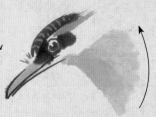

3 Add black and gray wing and tail feathers, flattening the firm brush to give a blunt end to the strokes.

4 Add some fluffy black ink strokes to the chest with a dry firm brush. Load the firm brush with shades of green to paint the bird's back, and add a stroke of white to the cheek. Using a fine brush and bright orange, paint the feet and toes.

Rosybill

The rosybill is a pretty duck that lends itself to freestyle strokes. A black duck is used to suppress evil in Taiwan on New Year's Eve, with the blood of a sacrificed duck being burned with a paper tiger by the city gates to rid the town of evil.

1 Load a small firm brush with black ink and paint a deep semicircle for the head, pressing the brush into the paper as you go. Paint around the eye, then add another semicircle for the breast.

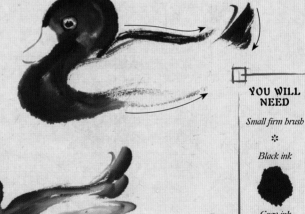

2 Using a dry firm brush and black ink, paint the body. Press inky strokes into the paper for the tail and outline the bill.

3 Paint wet strokes of gray ink for the wing, adding a row of dark dots while damp. Color the bill and eye red. Indicate the water surface with gray swirls.

Goose

The goose is one of several birds that symbolize married bliss, so a painting of a goose makes a perfect engagement gift. Migrating geese are regarded as messengers bringing good news from distant partners.

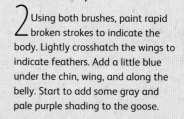

YOU WILL NEED

Fine brush

❋

Medium soft brush

❋

Gray ink

Black ink

Orange

Blue

Pale purple

1 Using a fine brush and gray ink, outline the head and beak, adding a black eye. Change to a medium soft brush and color the beak orange.

2 Using both brushes, paint rapid broken strokes to indicate the body. Lightly crosshatch the wings to indicate feathers. Add a little blue under the chin, wing, and along the belly. Start to add some gray and pale purple shading to the goose.

3 Add a touch of orange to the body, then outline the feet in ink and paint them orange. Add a stripe of orange across the eye, and a black nostril to the beak. Add footprints in gray ink mixed with a tiny amount of the other colors.

Eagle

A picture of an eagle in a pine tree makes a great gift. The eagle is a symbol of strength and the pine tree signifies longevity.

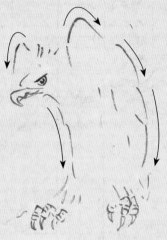

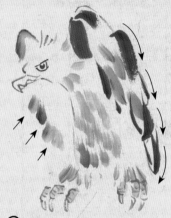

1 Using a fine brush and dark ink, outline the eagle with lively lines. Add an eye and feet with large claws.

2 Load a medium soft brush with gray ink and paint dry feathers on the breast using upward strokes. Change to a small firm brush and paint larger wing feathers with downward strokes of gray and burnt sienna. Color the beak mineral blue and the talons ocher.

3 Color the eye yellow and build up the feathers with more burnt sienna and gray ink, adding a crest of feathers over the head. Using green and black ink, paint a sturdy branch beneath the bird, then add a black tail with an upward dry stroke.

BIRDS

157

Peacock

Representing dignity and high rank, the beautifully colored peacock is a valued bird. It is believed to ward off evil with the eyes on its tail.

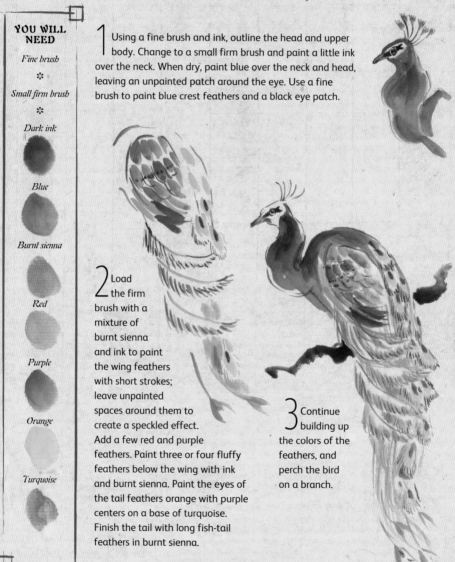

1 Using a fine brush and ink, outline the head and upper body. Change to a small firm brush and paint a little ink over the neck. When dry, paint blue over the neck and head, leaving an unpainted patch around the eye. Use a fine brush to paint blue crest feathers and a black eye patch.

2 Load the firm brush with a mixture of burnt sienna and ink to paint the wing feathers with short strokes; leave unpainted spaces around them to create a speckled effect. Add a few red and purple feathers. Paint three or four fluffy feathers below the wing with ink and burnt sienna. Paint the eyes of the tail feathers orange with purple centers on a base of turquoise. Finish the tail with long fish-tail feathers in burnt sienna.

3 Continue building up the colors of the feathers, and perch the bird on a branch.

Mute Swan

Swans are symbols of grace, elegance, and serenity worldwide, and they are strong and powerful, too. Although the mute swan is white, pale gray ink is used to give form to the neck and feathers.

1 Using a fine brush and gray ink, outline the shape of the swan with lively strokes.

2 Load a medium soft brush with gray and sweep the brush through the graceful U of the neck. Add a few long feathers at the end of the wing and scale-like feathers at the top of the wing.

3 Enhance the eye with black ink and paint a black circle at the top of the beak. Color the beak red. Add a few swirling gray lines to indicate water.

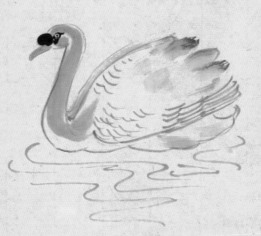

YOU WILL
NEED

Fine brush

❉

Medium soft brush

❉

Gray ink

Black ink

Red

BIRDS

Robin

This is an ideal bird to paint on a Christmas card, perhaps with a pine tree and snow.

YOU WILL NEED

Fine brush

�֍

Small firm brush

✤

Black ink

Burnt sienna

Red

Pale yellow

Gray ink

Pale blue

1 Establish a bird shape using two egg shapes, small for the head and large for the body. Using a fine brush and black ink, paint the shape of the bird around the eggs, putting in the beak, eye, and tail. Indicate a branch for the bird to perch on.

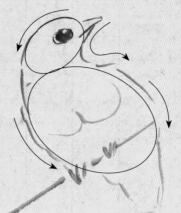

2 Using a small firm brush and burnt sienna, repeat the bird shape. Paint a red breast, leaving an unpainted rim running between the head and chest. Strengthen the branch.

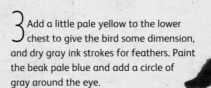

3 Add a little pale yellow to the lower chest to give the bird some dimension, and dry gray ink strokes for feathers. Paint the beak pale blue and add a circle of gray around the eye.

Magpie

The call of the magpie heralds good news or the arrival of a guest, and it is known as a bird of good omen as a result. It is often referred to as the joy-bringing magpie in China.

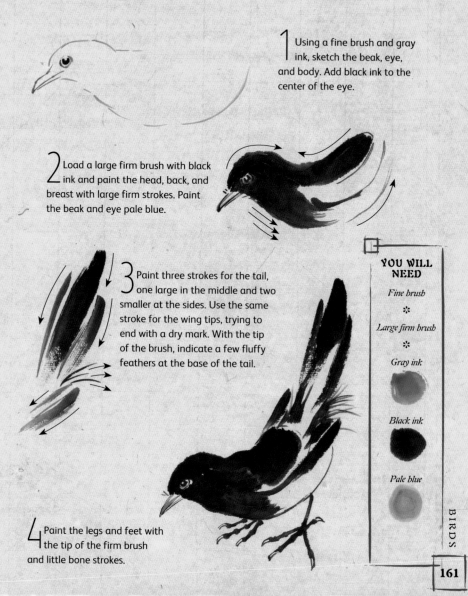

1 Using a fine brush and gray ink, sketch the beak, eye, and body. Add black ink to the center of the eye.

2 Load a large firm brush with black ink and paint the head, back, and breast with large firm strokes. Paint the beak and eye pale blue.

3 Paint three strokes for the tail, one large in the middle and two smaller at the sides. Use the same stroke for the wing tips, trying to end with a dry mark. With the tip of the brush, indicate a few fluffy feathers at the base of the tail.

4 Paint the legs and feet with the tip of the firm brush and little bone strokes.

YOU WILL NEED

Fine brush

❖

Large firm brush

❖

Gray ink

Black ink

Pale blue

Cormorant

The cormorant is often used by Chinese fishermen to catch fish. The bird, secured to the boat with a long rope, dives for fish and then returns to the boat. A neck band prevents the bird from swallowing the fish—until it has caught a few.

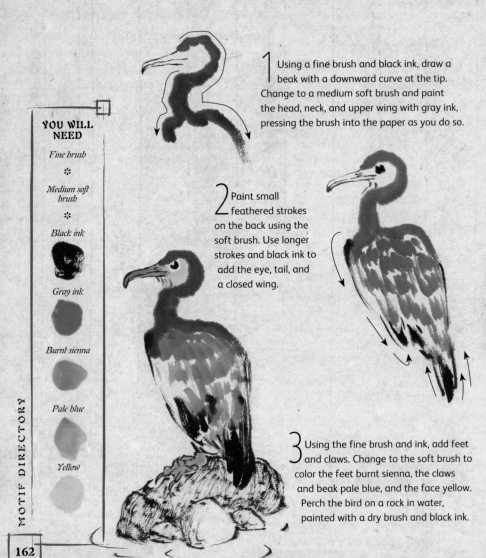

YOU WILL NEED

Fine brush

❖

Medium soft brush

❖

Black ink

Gray ink

Burnt sienna

Pale blue

Yellow

1 Using a fine brush and black ink, draw a beak with a downward curve at the tip. Change to a medium soft brush and paint the head, neck, and upper wing with gray ink, pressing the brush into the paper as you do so.

2 Paint small feathered strokes on the back using the soft brush. Use longer strokes and black ink to add the eye, tail, and a closed wing.

3 Using the fine brush and ink, add feet and claws. Change to the soft brush to color the feet burnt sienna, the claws and beak pale blue, and the face yellow. Perch the bird on a rock in water, painted with a dry brush and black ink.

Parrot

The parrot is native to China and is prized for its ability to talk. Now and again, a parrot is given to wives as a warning to be faithful to their husbands.

1 Using a fine brush and gray ink, outline the curved beak and eye.

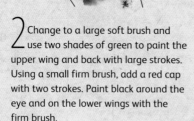

2 Change to a large soft brush and use two shades of green to paint the upper wing and back with large strokes. Using a small firm brush, add a red cap with two strokes. Paint black around the eye and on the lower wings with the firm brush.

3 Add a long black, yellow, and leaf green tail with the firm brush. Using yellow and leaf green, indicate the throat, chest, and legs. Paint the beak gray and add a flash of white to the cheek. Use the firm brush and ink mixed with burnt sienna to paint a branch, with black claws gripping it.

YOU WILL NEED

Fine brush

❊

Large soft brush

❊

Small firm brush

❊

Gray ink

Sage green

Leaf green

Red

Black ink

Yellow

White

Burnt sienna

BIRDS

Owl

The Chinese regard the owl as a bird of ill omen, believing that when an owl appears, disaster is not far behind. However, in ancient China, owls were regarded with less dislike, and small sculptural owls were placed on the roof to shelter the family from thunder and fire.

YOU WILL NEED

Fine brush

❊

Small firm brush

❊

Gray ink

Black ink

Burnt sienna

Yellow

White

1 Using a fine brush and gray ink, paint a circle of short strokes to indicate a fluffy face. Add round eyes and a V-shaped beak.

2 Using a small firm brush, paint the eyes black, leaving some unpainted highlights. Load the brush with burnt sienna, then splay the hairs and paint feathered dry strokes over the ink marks around the face. Add gray ink strokes around the eyes in the same way. Add short burnt sienna strokes for the chest feathers. Using the tip of the brush and dark ink, paint the wings and feet. Use the fine brush to indicate black claws.

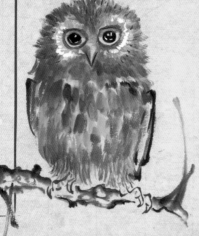

3 Continue building up the feathers with layers of burnt sienna and ink strokes. Add yellow and burnt sienna to the eye, and a circle of short white strokes around the eyes when all the colors are dry. Perch the owl on a branch painted with ink.

MOTIF DIRECTORY

164

Black Swan

Native to Australia, the black swan is a wonderful subject for freestyle strokes and makes a dramatic addition to a picture.

1 Load a small firm brush with black ink and paint the top of the head and neck with one firm stroke, pressing lightly on the brush to give the correct thickness. Add a chin.

2 Keeping the brush a little dryer than before, paint the wing feathers with the bristles splayed. Using a fine brush and ink, paint the eye and lightly indicate the beak. Color them both red.

3 Continue building up the wing feathers as before, then add a couple of curving gray ink strokes to indicate the surface of the water.

YOU WILL NEED

Small firm brush

❖

Fine brush

❖

Black ink

Red

Gray ink

Mallard

The mallard is the largest and most common of the surface-feeding ducks. This one is a brightly colored male; the brown female needs to remain inconspicuous while incubating eggs.

1 Using a fine brush and gray ink, draw a simple duck shape with lively lines.

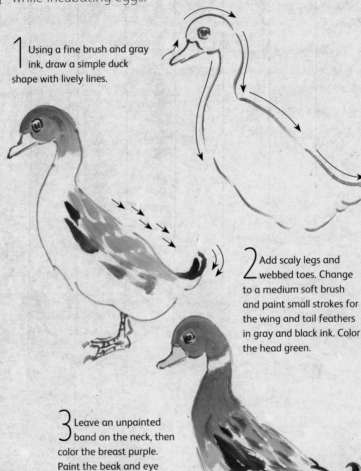

2 Add scaly legs and webbed toes. Change to a medium soft brush and paint small strokes for the wing and tail feathers in gray and black ink. Color the head green.

3 Leave an unpainted band on the neck, then color the breast purple. Paint the beak and eye yellow and the legs orange. Shade the belly with a dilute mixture of burnt sienna and ink.

Duckling

Ducks are often used as a motif in embroidery, and when painted with a lotus, are said to give a feeling of contentment. This duckling should give a feeling of contentment, too, because it is very easy to paint.

1 Using a fine brush and gray ink, outline a circular head and curved bill. Add a circle for the eye with a black dot in the center, then complete the outline of the body and feet with lively ink lines.

2 Load a small firm brush with black ink and paint a semicircle for the head, then a curve for the back and tail, ending in a dry feathered stroke in a lighter gray. The wing is almost calligraphic; press the tip of the brush into the paper at the beginning and end of the stroke. Color the feet and beak orange.

3 Color the body yellow and the face orange and yellow. Add a few feathered dry gray strokes to the chest and belly.

YOU WILL NEED

Fine brush

❊

Small firm brush

❊

Gray ink

Black ink

Orange

Yellow

Oriole

The oriole sings beautifully, so it is known as the bird of joy and music. It also symbolizes friendship. This is an example of the black-naped oriole.

MOTIF DIRECTORY

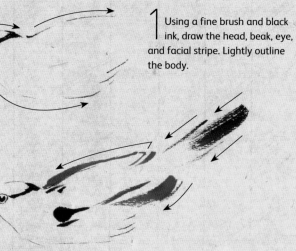

1 Using a fine brush and black ink, draw the head, beak, eye, and facial stripe. Lightly outline the body.

2 Using a small firm brush with black and gray ink, paint dry strokes for the wing feathers and a long dry stroke in the center of the tail with two smaller ones each side.

3 Outline the scaly legs and feet.

4 Change to a medium soft brush to paint the head and body yellow and orange. Color the legs, feet, beak, and eye red. Perch the bird on a green branch.

Moorhen

The moorhen is a fascinating bird, with a jerky, hesitant way of moving. Wonderfully adaptable, it swims well without webbed feet, can climb trees and run on hard ground, and can wade and clamber through reeds.

YOU WILL NEED

Fine brush

❋

Medium soft brush

❋

Black ink

Red

Yellow

Gray ink

Purple

Ocher

1 Using a fine brush and black ink, outline the beak and eye. When dry, color them with red and yellow.

2 Load a medium soft brush with gray ink and paint the head and body with large strokes. When dry, repeat with purple.

3 Outline the wings using the fine brush and gray ink. Dab gray ink feathers onto the wings with the soft brush. When dry, add gray mixed with purple. Using a dry soft brush, paint feathered strokes at the top of the legs. Outline the bird's shape with a fine brush and dark ink if wished.

4 Outline the long legs and large feet using a fine brush and black ink. Indicate a few scales with little lines. When dry, paint them with a mixture of yellow and ocher.

Egret

The snowy white egret is a very popular subject in Chinese paintings, especially on silk, perhaps with lotus blossoms and fish.

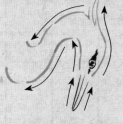

1 Using a fine brush and black ink, draw the eye and beak. Outline the head and graceful curved neck in gray ink, with a few fine feathers at the back of the head.

2 Outline the rest of the body and wings. Load a medium soft brush with white and paint the bird. Paint the beak and eye yellow ocher.

3 Reinforce the shape of the egret with pale blue and a little purple. Outline the legs and feet in ink, then color them yellow ocher. Use the tip of the soft brush to indicate a water surface with swirls of blue and purple.

Mandarin Duck

The glorious mandarin duck is a symbol for marital happiness because the birds live in pairs and mate for life. Pillows, coverlets, and drapes for marriage bedrooms are decorated with mandarin ducks and given as wedding gifts.

YOU WILL NEED

Small firm brush
❈
Fine brush
❈
Pale indigo

Purple

Black ink

Red

Orange

Bright blue

White

Yellow

Green

1 Load a small firm brush with pale indigo and purple. Beginning with the tip of the brush, sweep back in a semicircle to form the head, ending with a feathered dry stroke. Paint the eye using a fine brush and black ink.

2 Outline the beak in red mixed with purple. Using a small firm brush, add a beard of feathered orange strokes.

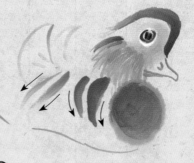

3 Paint a large, wet purple circle framed by two lines for the chest, with two bright blue lines behind this. Using the fine brush and ink, outline the body and wings. Add a white circle around the eye.

4 Finish coloring the duck, with a red beak, orange wings, yellow belly, and pale indigo back and tail. Add a few black ink strokes to the tail and indicate a watery surface with dots of green.

Chick Chicks make delightful subjects, and can be painted in speckled grays, browns, pale yellows, and ochers.

1 Using a fine brush and black ink, paint a large eye and small angled beak.

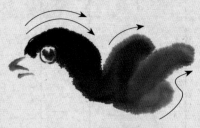

2 Load a medium soft brush with black ink and paint a wide semicircle over the top of the eye. Paint a similar stroke just above the last to give a rounded head. Add another two, slightly paler strokes for wings.

3 Paint slightly wet gray ink strokes in a V shape underneath the wings for a fluffy body.

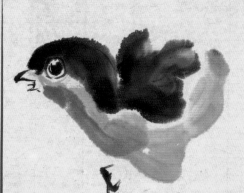

4 Using a fine brush and black ink, paint the legs and feet, pressing the brush into the paper to give a joint to each toe. Add claws.

Hen

The hen drives away evil spirits. Folklore in south China says that there were two hens at the beginning of time, one black and one white. They each laid nine eggs, and out of those eggs came good people and bad people to populate the world.

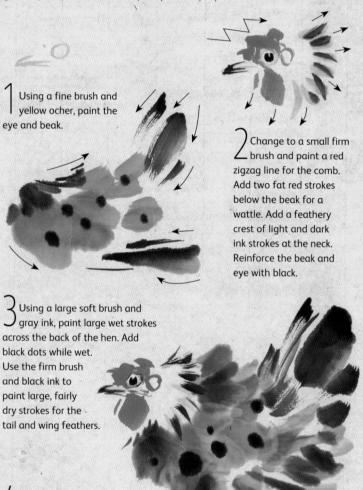

1 Using a fine brush and yellow ocher, paint the eye and beak.

2 Change to a small firm brush and paint a red zigzag line for the comb. Add two fat red strokes below the beak for a wattle. Add a feathery crest of light and dark ink strokes at the neck. Reinforce the beak and eye with black.

3 Using a large soft brush and gray ink, paint large wet strokes across the back of the hen. Add black dots while wet. Use the firm brush and black ink to paint large, fairly dry strokes for the tail and wing feathers.

4 Use the fine brush and ink to outline the scaly feet, then color them yellow ocher.

YOU WILL NEED

Fine brush

❈

Small firm brush

❈

Large soft brush

❈

Yellow ocher

Black ink

Red

Gray ink

BIRDS

173

Crane

The magnificent crane is a symbol of longevity. It is seen as a bird of mythical powers and a messenger from the immortals. Often portrayed with the pine tree (also a symbol of longevity), the crane is one of the most popular motifs in China.

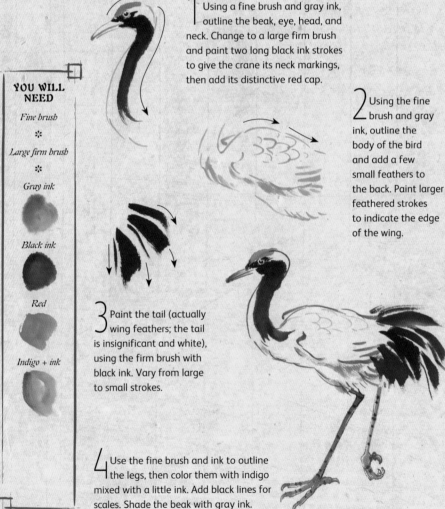

YOU WILL NEED

Fine brush

❖

Large firm brush

❖

Gray ink

Black ink

Red

Indigo + ink

1 Using a fine brush and gray ink, outline the beak, eye, head, and neck. Change to a large firm brush and paint two long black ink strokes to give the crane its neck markings, then add its distinctive red cap.

2 Using the fine brush and gray ink, outline the body of the bird and add a few small feathers to the back. Paint larger feathered strokes to indicate the edge of the wing.

3 Paint the tail (actually wing feathers; the tail is insignificant and white), using the firm brush with black ink. Vary from large to small strokes.

4 Use the fine brush and ink to outline the legs, then color them with indigo mixed with a little ink. Add black lines for scales. Shade the beak with gray ink.

Sparrow

The sparrow represents sensuality, and eating it will increase potency. In south China, mahjong players are known as "sparrow schools." This freestyle sparrow is fun to paint and looks cute in a picture.

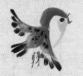

1 Flatten the end of a small firm brush and paint a broad semicircle of burnt sienna mixed with ink for the head.

2 Add three strokes in the same color for the back and wings. Dot the sparrow's back with black ink. Paint a gray belly and black eye. Add black wing and tail feathers, sweeping the strokes inward and making them larger for the tail.

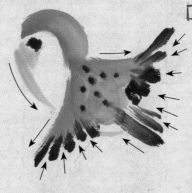

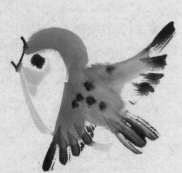

3 Using a fine brush and black ink, add an open beak.

4 Finish the sparrow with two dangling feet.

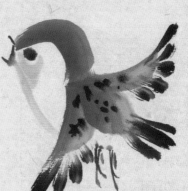

YOU WILL NEED

Small firm brush

❋

Fine brush

❋

Burnt sienna + ink

Black ink

Gray ink

Angel Fish

A pretty subject for a picture, the angel fish can be painted in lots of different color combinations.

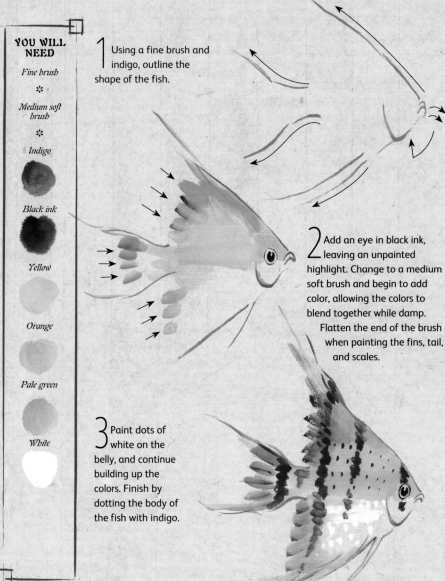

1 Using a fine brush and indigo, outline the shape of the fish.

2 Add an eye in black ink, leaving an unpainted highlight. Change to a medium soft brush and begin to add color, allowing the colors to blend together while damp. Flatten the end of the brush when painting the fins, tail, and scales.

3 Paint dots of white on the belly, and continue building up the colors. Finish by dotting the body of the fish with indigo.

MOTIF DIRECTORY

176

Carp

Carp are very long-lived and symbolize soldiery, endurance, and youth. They are also thought of as quarrelsome, although a pair of fish (any fish) is a symbol of harmony and married bliss in China.

1 Load a medium soft brush with pale indigo and dip the tip in gray ink. Paint the body of the fish so that the brush tip runs along the top of the stroke. Press the heel of the brush down initially, then lift the brush to taper the stroke.

2 Add the head using two strokes of black ink, with dots for eyes. Using a fine brush and gray ink, crosshatch the back.

3 Add the mouthparts and whiskers using the fine brush and dark ink.

4 Using the soft brush with pale indigo and gray ink, add a tail and six fins. Indicate the dorsal fin with a line of dark ink along the center of the back.

YOU WILL NEED

Medium soft brush

❁

Fine brush

❁

Pale indigo

Gray ink

Black ink

FISH AND CRUSTACEANS

Goldfish
The Chinese name for goldfish means "gold in abundance," so these fish make a very acceptable gift. They are kept in bowls in the home or ponds in the garden, and are much admired.

MOTIF DIRECTORY

YOU WILL NEED

Fine brush

❊

Large soft brush

❊

Orange

Yellow + orange

Red

Mineral blue + white

White

Black ink

1 Using a fine brush and orange, paint the eye, lips, and gill. Load a large soft brush with a mixture of yellow and orange and paint the top of the fish using the side of the brush.

2 Paint the tail in three strokes, starting with the brush on its side and lifting it to its tip for the whispy ends. Add dorsal fins to the back in the same way. Paint the fins underneath, outline the belly, and emphasize the gill.

3 Add red lines to the damp fins. Paint the belly mineral blue and white. Dot red scales across the back and white on the belly. Using a fine brush and black ink, paint the eye.

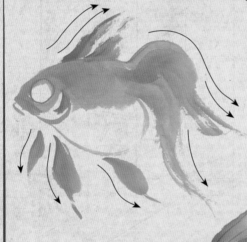

178

Chaetodon
Often painted with other fish in a tank, there are many different kinds of colorful chaetodon.

1 Using a medium soft brush, paint two large blobs of black ink.

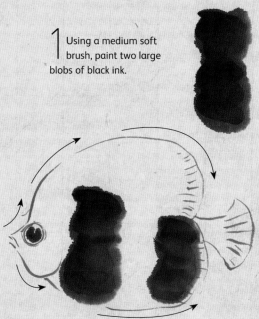

2 Change to a fine brush and gray ink to outline the shape of the fish. Add fine lines to the tail and fins, and a couple of circles for the eye. Finish the eye with a black center, leaving an unpainted highlight.

3 Using the soft brush, add various mixtures of yellow and green to the fish. Add a black stripe to the face and two black fins below the gills.

YOU WILL NEED

Medium soft brush

❉

Fine brush

❉

Black ink

Gray ink

Yellow

Green

FISH AND CRUSTACEANS

Bubble Eye
There are many varieties of goldfish, and the bubble eye is a very popular one. It makes a fun addition to a picture.

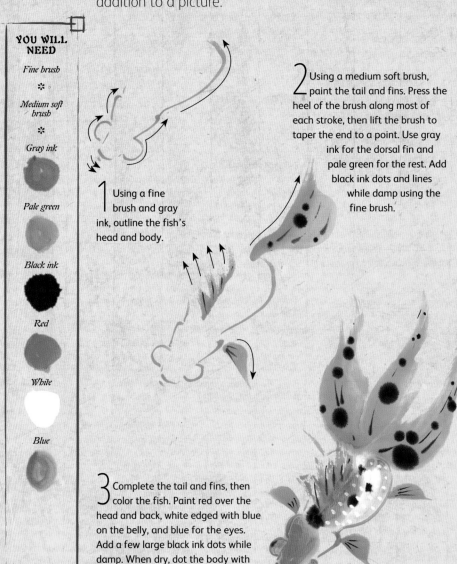

YOU WILL NEED

Fine brush

❋

Medium soft brush

❋

Gray ink

Pale green

Black ink

Red

White

Blue

1 Using a fine brush and gray ink, outline the fish's head and body.

2 Using a medium soft brush, paint the tail and fins. Press the heel of the brush along most of each stroke, then lift the brush to taper the end to a point. Use gray ink for the dorsal fin and pale green for the rest. Add black ink dots and lines while damp using the fine brush.

3 Complete the tail and fins, then color the fish. Paint red over the head and back, white edged with blue on the belly, and blue for the eyes. Add a few large black ink dots while damp. When dry, dot the body with white scales.

Grass Carp

The grass carp is related to the common carp, and is native to northern China and central Asia. It is often used for aquatic weed control.

1 Using a fine brush with a mixture of indigo and ink, outline the eye, head, body, and tail.

2 Using the side of a medium soft brush and the same color, paint the top half of the fish. Paint the tail and fins with the brush upright and a stronger indigo mixture. Add a little white across the center of the fish.

3 Paint a U shape for the eye in dark ink, adding a little yellow once dry. Paint a streak of yellow on the lower belly and a couple of the fins. Use the fine brush to dot scales over the body, white for the top of the fish and blue for the belly.

YOU WILL NEED

Fine brush

❖

Medium soft brush

❖

Indigo + ink

Dark ink

White

Yellow

Minnow

The minnow is a simple fish to paint, and is a useful addition to pictures of waterlilies and lotuses. A shoal of little minnows makes a delightful picture.

1 Load a medium soft brush with brown and paint a tapering stroke, pressing the brush in the middle.

2 Using a fine brush and indigo, crosshatch the lower section and add a dark line down the center to indicate the dorsal fin.

3 Paint the eye, lips, and gill using the fine brush and dark ink. Add a fine line for the belly and tail.

4 Using the soft brush and brown, paint two fins behind the gills with a side sweep of the brush. Add two more fins and a tail. Using the fine brush, add fine lines of indigo to the tail and fins. Vary the angles of the fish when painting a shoal.

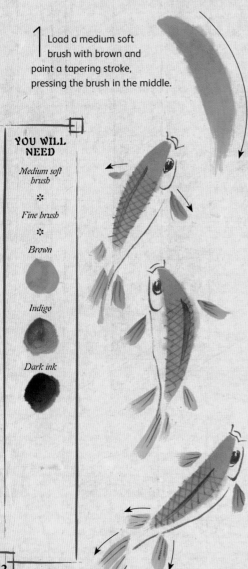

YOU WILL NEED

Medium soft brush

❋

Fine brush

❋

Brown

Indigo

Dark ink

Red Cap Oranda

This variety of goldfish has been bred for its warty red cap. It was a mutation, initially, from the carp family. There is also a variety with a warty red nose.

YOU WILL NEED

Fine brush

✽

Medium soft brush

✽

Gray ink

Red

Yellow

Blue

White

Black ink

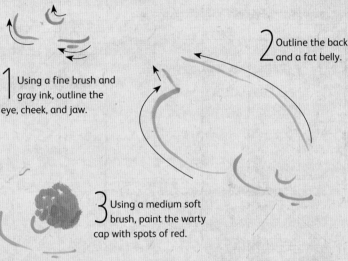

1 Using a fine brush and gray ink, outline the eye, cheek, and jaw.

2 Outline the back and a fat belly.

3 Using a medium soft brush, paint the warty cap with spots of red.

4 Load the soft brush with gray ink and paint the tail and fins, pressing the heel of the brush for most of the strokes and then lifting it to taper the ends. Color the body and head with yellow, red, and blue. Dot the body with white scales. Use the fine brush to paint the eye black.

Crab

The reputation of the crab varies according to where you are in China. In Sichuan, the jade crab of legend is a plague-bringing demon. In Shanxi and Henan, however, dried crabs or pictures of crabs hung over a doorway repel bad magic.

1 Load a large soft brush with green and paint a thick stroke with the side of the brush for the middle of the carapace.

2 Add two smaller strokes for each side of the carapace, lifting the brush slightly at the end of the strokes to taper them.

3 Change to a small firm brush and paint the jointed legs, pressing the brush firmly on the upward bone stroke, and more lightly on the downward tapering stroke. Paint two claw legs using the side of the brush. Load the brush with brown and add two pincers to the claw legs, two eyes on stalks, and dots on the carapace.

4 Mix a little brown into the green and add a single claw to each of the eight jointed legs.

Shrimp

A very popular subject, the shrimp is fun to paint. A shoal of shrimp in different shades of ink looks wonderful swimming across the page.

1 Using a medium soft brush and a pale mixture of indigo and ink, paint two long strokes to create an oval-shaped head.

2 Add three lines for the mouthparts, then use the side of the brush to paint five short fat body segments, ending with two flat strokes for the tail. Add a little more ink to the indigo mixture and use the tip of the brush to paint the legs. Add a line of black ink on the head while damp.

3 Using a fine brush and black ink, paint short lines with a dot at the tip for eyes. Paint two legs with claws, then three pairs of feelers, facing forward, to the side, and backward. Paint a black line down the body, and vary the angles of the shrimp when painting several together.

YOU WILL NEED

Medium soft brush

❖

Fine brush

❖

Indigo + ink

Black ink

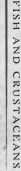

FISH AND CRUSTACEANS

185

Rocks

Rocks symbolize longevity, so giving a picture with a rock in it to an older person is auspicious. A picture in which a rock juts out of the sea represents paradise. Rocks were sometimes regarded as sacred in China and prayers for rain were said to them.

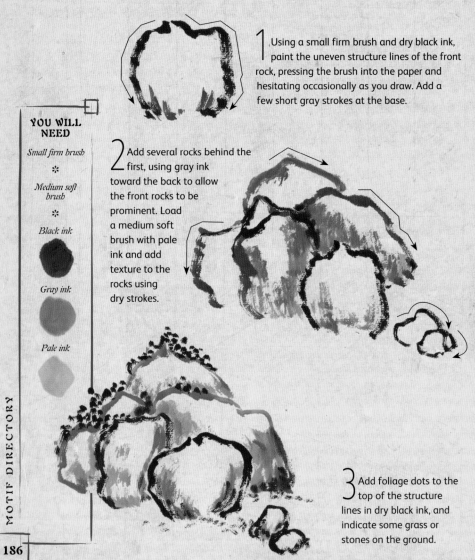

1 Using a small firm brush and dry black ink, paint the uneven structure lines of the front rock, pressing the brush into the paper and hesitating occasionally as you draw. Add a few short gray strokes at the base.

YOU WILL NEED

Small firm brush

❄

Medium soft brush

❄

Black ink

Gray ink

Pale ink

2 Add several rocks behind the first, using gray ink toward the back to allow the front rocks to be prominent. Load a medium soft brush with pale ink and add texture to the rocks using dry strokes.

3 Add foliage dots to the top of the structure lines in dry black ink, and indicate some grass or stones on the ground.

Mountain

Mountains were venerated, special places in ancient China. Mountain gods inhabited them and many temples were built in them. A row of peaks is known as the "dragon's back."

1 Using a small firm brush and gray ink, establish the outline of the closest outcrop with hesitant strokes. This is the "nose" of the painting.

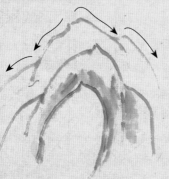

2 Load a medium soft brush with gray and add some marks behind each structure line to give the mountains texture and substance.

3 Paint the front outcrop and peaks with a dilute mixture of burnt sienna and ink. Do the same with an indigo and ink mixture on the lower slopes. Add black ink dots for shrubbery while damp. These are the "eyes" of the painting and bring it to life.

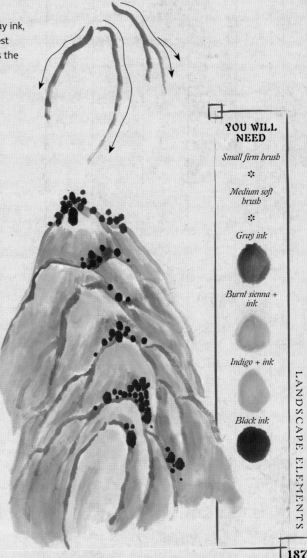

YOU WILL NEED

Small firm brush

❖

Medium soft brush

❖

Gray ink

Burnt sienna + ink

Indigo + ink

Black ink

LANDSCAPE ELEMENTS

Cloud

Clouds symbolize good fortune and happiness. If clouds are painted with more than one color, their good fortune ratio increases. This stylized, outlined cloud is most often seen in the ornamentation of Chinese fabrics and pottery.

YOU WILL NEED

Small firm brush

❀

Medium soft brush

❀

Gray ink

Black ink

Mineral blue

Mineral green

Pale blue

1 Paint lively swirls of smooth, scalloped strokes in gray ink using a small firm brush. Alter the pressure on the tip of the brush so that the lines look varied and more attractive.

2 Outline a mountain behind the cloud in black ink (page 187).

3 When the ink is dry, color the mountain with mineral blue peaks, mineral green lower slopes, and add black dots of foliage. Add a wet stroke of pale blue around some of the internal lines of the cloud.

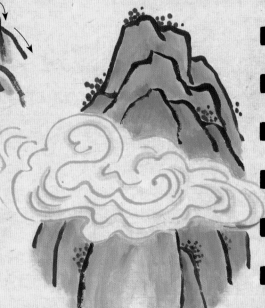

Waterfall

Water, whether trickling, flowing, spraying, foaming, splashing, or in rivers or oceans, is the very blood and marrow of heaven and earth according to the ancient painting manual *The Mustard Seed Garden*. Water sculpts the rocks and mountains, so pay careful attention when painting waterfalls.

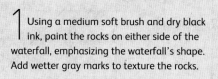

1 Using a medium soft brush and dry black ink, paint the rocks on either side of the waterfall, emphasizing the waterfall's shape. Add wetter gray marks to texture the rocks.

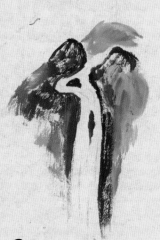

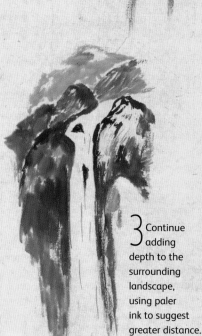

2 Add rocks behind the waterfall in paler ink. Paint a few dark rocks in the middle of the waterfall. Indicate the flowing water with a few pale lines painted with the brush tip.

3 Continue adding depth to the surrounding landscape, using paler ink to suggest greater distance.

YOU WILL NEED

Medium soft brush

❖

Black ink

Gray ink

Pale ink

Water
Water symbolizes *yin*, the female principle, and is usually painted as soft, pliant, and rippling.

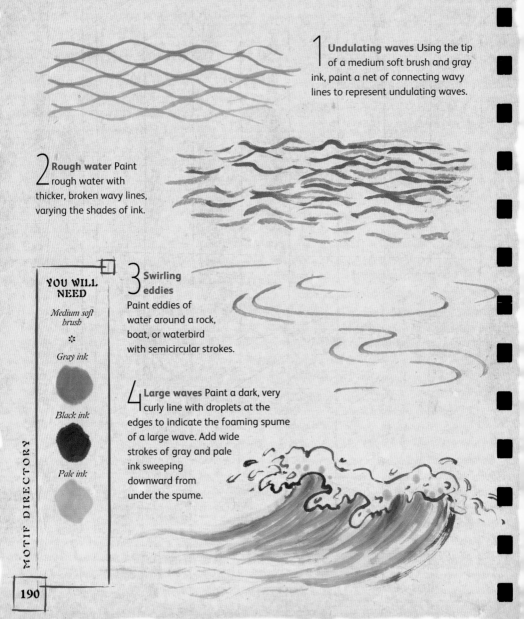

1 Undulating waves Using the tip of a medium soft brush and gray ink, paint a net of connecting wavy lines to represent undulating waves.

2 Rough water Paint rough water with thicker, broken wavy lines, varying the shades of ink.

3 Swirling eddies Paint eddies of water around a rock, boat, or waterbird with semicircular strokes.

4 Large waves Paint a dark, very curly line with droplets at the edges to indicate the foaming spume of a large wave. Add wide strokes of gray and pale ink sweeping downward from under the spume.

YOU WILL NEED

Medium soft brush

✳

Gray ink

Black ink

Pale ink

Boats

Boats come in all shapes and sizes in China. Shallow rivers require flat-bottomed boats; heavy seas are best tackled in the swift and stable junk. A large empty space with a boat in it indicates water.

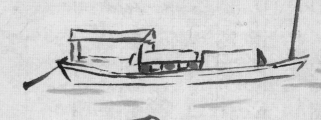

1 Distant boats Using a small firm brush and gray ink, paint distant boats with a couple of lines for the boat and a large sail.

2 Houseboats Begin a houseboat with a black ink line that curves slightly upward. Add a shorter, flatter line below. Join these at each end to form the bottom of the boat. Add cabins, a rudder, and mast head. Indicate the water with a few strokes of pale ink.

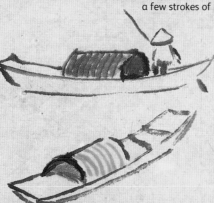

3 Fishing boats Paint shallow-bottomed fishing boats in the same way as a houseboat, adding hatched or crosshatched strokes of pale ink for a bamboo shelter. Sketch in a fisherman with a pole.

LANDSCAPE ELEMENTS

Bridges

Bridges connect areas of a picture together. They can be constructed from all sorts of materials: flexible bamboo; thin rope; wood; brick, stone, and rock. The god of bridges prevents evil demons from crossing them.

1 Stone humpback bridge
Using the tip of a small firm brush and black ink, outline the shape of a humpback bridge with uneven, hesitant strokes. Load the brush with gray ink and flatten the tip to paint rectangles in staggered rows to indicate stones.

2 Log-and-rope bridge
Paint wooden poles using the tip of the firm brush and black ink. Add logs of wood in gray ink, and curved strokes for a supporting rope. You could also add swirls of water around each pole if you wish.

YOU WILL NEED

Small firm brush

❖

Black ink

Gray ink

3 Rock-and-plank bridge
Outline some rocks supporting planks of wood using uneven lines to give the bridge an organic look. Color the rocks with ink and add swirls of water around them, varying the shades of ink to give depth to the picture.

MOTIF DIRECTORY

Rushes

Rushes and reeds appear at the mouth of a river, around a boat yard, or in any painting with large expanses of water. Each stage of this sequence could be used in a picture, from a few stalks to a colored bank of rushes.

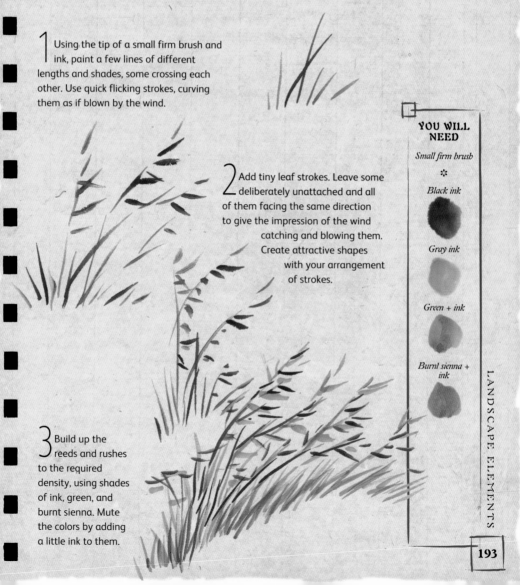

1 Using the tip of a small firm brush and ink, paint a few lines of different lengths and shades, some crossing each other. Use quick flicking strokes, curving them as if blown by the wind.

2 Add tiny leaf strokes. Leave some deliberately unattached and all of them facing the same direction to give the impression of the wind catching and blowing them. Create attractive shapes with your arrangement of strokes.

3 Build up the reeds and rushes to the required density, using shades of ink, green, and burnt sienna. Mute the colors by adding a little ink to them.

YOU WILL NEED

Small firm brush

❋

Black ink

Gray ink

Green + ink

Burnt sienna + ink

Teasel

 The dry seed head of a teasel is great fun to paint and always looks good in a landscape. Place it in fields, along roadsides, or near riverbanks.

1 Load a large soft brush with a mixture of gray ink and burnt sienna. Paint a fuzzy oval shape for the seed head. Let the ink run at the edges by painting slowly. Add black spots while damp.

2 Add a spiky calyx below the seed head, pressing at the beginning of the stroke, then lifting to the tip. Paint the stalk with a dry soft brush. Change to a fine brush and a darker ink mixture to paint fine lines coming out of the seed head.

3 Add tiny prickles to the stem with a fine brush. Vary the angles of the teasels and vary the proportions of ink and burnt sienna used for each element.

Pine Needles

There are several different ways of painting pine needles; three are shown here. Try them in different colors—indigo, blue, and mineral green, for example.

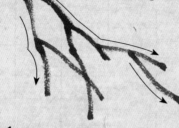

2 Single-layer needles Using the tip of the brush, paint lines along the side branches in black and gray ink. Enliven the branch with dark dots of lichen.

1 Basic branch Using a small firm brush and slightly dry black ink, paint a branch, pressing the brush into the paper at the beginning and end of each stroke. Each side branch must be firmly begun from the one before.

3 Bushy needles For a bushy effect, paint longer needles, then go over them twice more, changing the direction of the brush a little to give a crosshatched effect.

4 Star-shaped needles Paint star-shaped needles with the upper needles coming inward to a point. Paint the needles for the lower half of the star from the point outward.

LANDSCAPE ELEMENTS

Pine Tree

The evergreen pine tree symbolizes long life and faithfulness. It is the favorite tree of landscape painters and, along with the cedar, epitomizes self-discipline. Old, gnarled pine trees are admired, and are often attributed with human qualities.

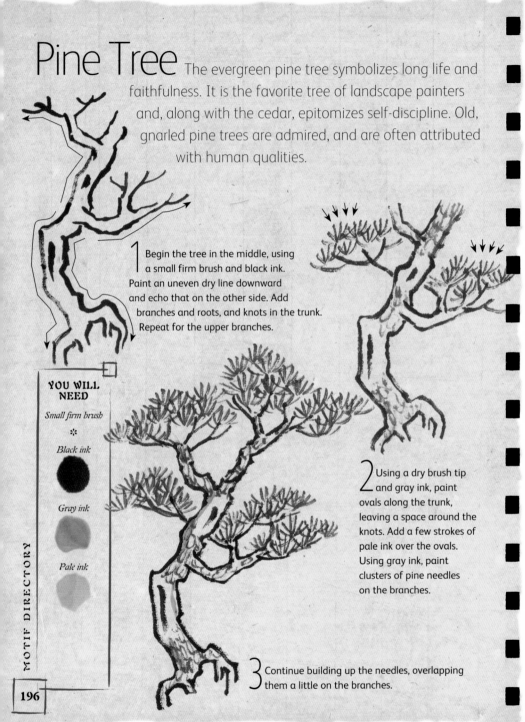

1 Begin the tree in the middle, using a small firm brush and black ink. Paint an uneven dry line downward and echo that on the other side. Add branches and roots, and knots in the trunk. Repeat for the upper branches.

YOU WILL NEED

Small firm brush

❖

Black ink

Gray ink

Pale ink

2 Using a dry brush tip and gray ink, paint ovals along the trunk, leaving a space around the knots. Add a few strokes of pale ink over the ovals. Using gray ink, paint clusters of pine needles on the branches.

3 Continue building up the needles, overlapping them a little on the branches.

Willow

The willow tree is a symbol of spring and is reputed to repel demons. This graceful tree is also associated with romantic desire. The waist of a beautiful woman can be compared to a willow, and the delicate curve of her eyebrows to willow leaves.

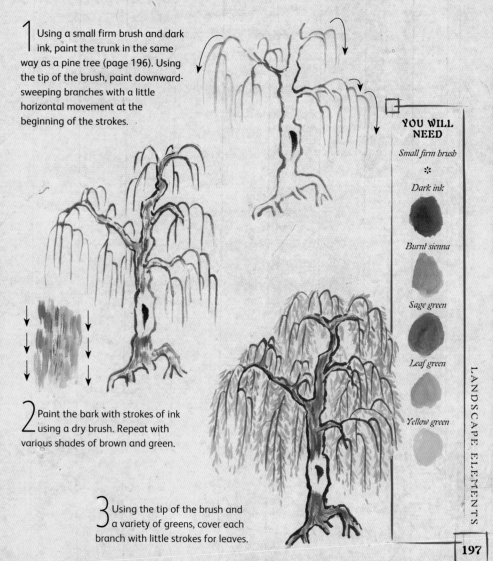

1 Using a small firm brush and dark ink, paint the trunk in the same way as a pine tree (page 196). Using the tip of the brush, paint downward-sweeping branches with a little horizontal movement at the beginning of the strokes.

2 Paint the bark with strokes of ink using a dry brush. Repeat with various shades of brown and green.

3 Using the tip of the brush and a variety of greens, cover each branch with little strokes for leaves.

LANDSCAPE ELEMENTS

197

Round-leaved Tree

Reminiscent of the tree on willow-patterned crockery, this is a lovely addition to any landscape. The contrast of outlined trunk and branches with freestyle round leaves always looks pleasing.

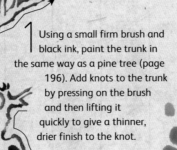

1 Using a small firm brush and black ink, paint the trunk in the same way as a pine tree (page 196). Add knots to the trunk by pressing on the brush and then lifting it quickly to give a thinner, drier finish to the knot.

(page 196)

2 Add bark to the trunk using a dry medium soft brush and pale ink. Avoid putting any marks around the knots. Hold the soft brush upright and turn the tip on the paper to produce the round leaves using gray ink.

3 Vary the shades of ink used for the leaves as well as the sizes. Arrange them in clusters to create a pleasing shape on the page.

Group of Trees

A landscape usually begins with a group of trees. Make the tree at the front the darkest one; background trees should be paler.

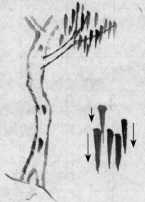

1 Using a small firm brush and black ink, paint the trunk of the foreground tree in the same way as a pine tree (page 196). Add nail-shaped foliage using the tip of the brush, pressing it into the paper at the beginning of each stroke, then lifting it to taper the end.

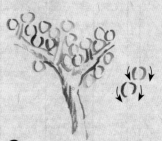

2 Paint a tree with circular foliage behind the first one, using two strokes with the tip of the brush for each circle and gray ink.

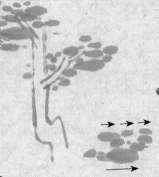

3 Using the palest ink, paint a third tree behind the other two. Dab pale wet ink onto the branches with the tip of the brush to add foliage.

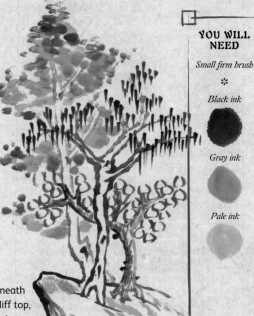

4 Add some ground beneath the trees, such as a cliff top, making sure the roots of the trees are firmly anchored to it.

LANDSCAPE ELEMENTS

Pagoda

The pagoda is a sacred building and is usually a tower in pyramidal form. It can be round, square, or many-cornered, and have a single or several roofs.

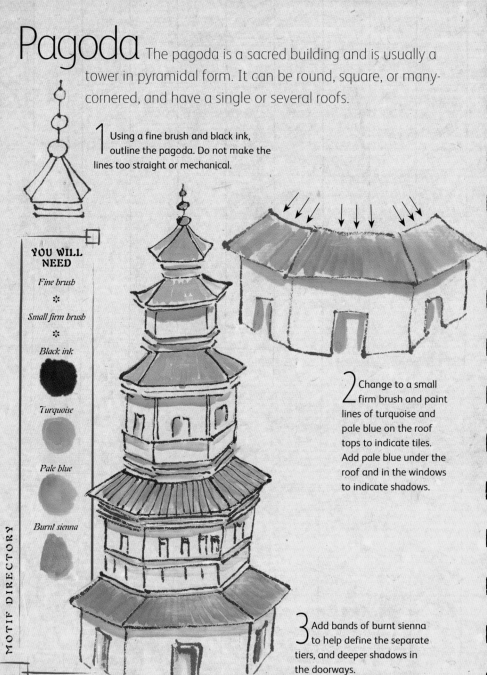

1 Using a fine brush and black ink, outline the pagoda. Do not make the lines too straight or mechanical.

2 Change to a small firm brush and paint lines of turquoise and pale blue on the roof tops to indicate tiles. Add pale blue under the roof and in the windows to indicate shadows.

3 Add bands of burnt sienna to help define the separate tiers, and deeper shadows in the doorways.

MOTIF DIRECTORY

200

Pavilions

A pavilion is an open building used as a shelter. Three styles of pavilion are shown here: a many-cornered tiled pavilion; one with a straw roof; and a round wooden one with a tiled roof.

1 Many-cornered pavilion
Using a small firm brush and shades of ink, outline the pavilion. Make the tip of the brush contact well with the paper, so that the lines are not too straight or mechanical. Color the main building with burnt sienna and the roof with yellow ocher. Add stripes of gray ink to indicate the tiled roof and slatted wooden sides.

2 Thatched pavilion Outline the roof of the pavilion in dark ink, adding dry strokes of gray to create a straw edge. Color with yellow ocher and paint firm strokes for the legs, using darker ink for the foreground legs.

3 Round pavilion Outline the pavilion in dark ink and add gray lines of texture to the roof. Paint turquoise over the lines, giving a glazed tile effect. Paint the wooden supports red.

YOU WILL NEED

Small firm brush

✳

Dark ink

Gray ink

Burnt sienna

Yellow ocher

Turquoise

Red

LANDSCAPE ELEMENTS

Scholar

The old and wise scholar is a respected person. He is often painted walking through a landscape, thinking and meditating, or sitting under a pine tree writing poetry or sketching.

1 Using the tip of a small firm brush and black and gray ink, paint two curving lines with a triangle on top for the hat. Add lines inside the triangle to imitate straw.

2 Add a face, eyes, and nose in pale ink. Using a dry brush to indicate age, paint a wispy moustache and beard.

3 Paint the garments with lively lines, using the tip of the brush and pressing a little in the middle of each stroke to give his robe a flowing feeling. Paint a bold black line to depict an old tree branch for the scholar's cane.

YOU WILL NEED

Small firm brush

❋

Black ink

Gray ink

Pale ink

Farmer

A freestyle figure is often more interesting than an outlined one. Movement and texture are captured in a few broad strokes and contrast is provided by wet and dry, fine and wide, or dark and light work.

1 Using the tip of a small firm brush and pale ink, paint the farmer's bald head, cheeks, and chin with lively strokes. Add eyes, ears, nose, and mouth with gray ink, and then paint short strokes of black ink above the ears for hair.

2 Using a medium soft brush and gray ink, paint broad strokes with the side of the brush. These show the direction of the farmer's sweeping movement as well as the clothes he is wearing.

3 Complete the clothes and outline the feet. Shade the chest and cheeks with pale ink. Paint a long, curling dry stroke of black ink to indicate a wooden rake.

PEOPLE

Wood Collector

The little wood collector is an interesting character to add to a scene. He can be painted on a mountain path or entering a village. An attractive contrast is created between the dark, dry sticks of wood and his light, fine clothing.

1 Using the tip of a small firm brush and dark ink, paint a circle for the round face. Add facial features and black hair.

2 Paint the clothes in gray ink with lively lines, using the tip of the brush and pressing a little in the middle of each stroke. Add a gray pole threading behind the neck and through the hand, a black belt, and dark feet.

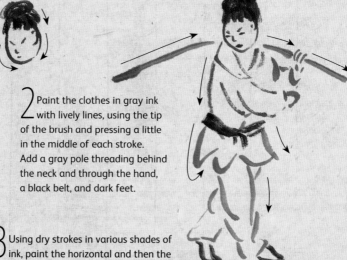

3 Using dry strokes in various shades of ink, paint the horizontal and then the vertical lines of the wood piles. Make sure they look attached to the pole.

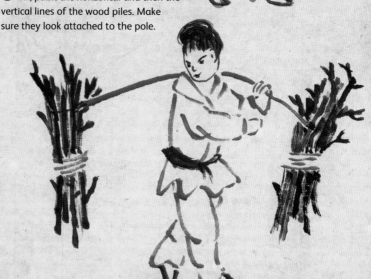

MOTIF DIRECTORY

Outdoorsman

This man could be placed in a snowy scene under dark skies, or would look good in a mountain landscape with frozen lakes and skeleton trees. His figure is painted freestyle and contrasted with an outlined face.

1 Using the tip of a small soft brush and pale ink, outline the face. Use black ink for the hat, eyes, moustache, and mouth. Add a few dry lines of gray to indicate hair under the hat.

2 Load a medium soft brush with pale ink and dip the tip in gray ink. Paint sweeping, lively strokes with the brush held a little sideways to form the garments of this wintry figure.

3 Paint uneven strokes of dry black and gray ink to create twigs for the fire. Splay the brush tip and paint smoke with curly lines of dry pale and gray ink.

PEOPLE

205

Traveler
This traveler is painted in outline. He should be small in a landscape, with a path or road to travel on, or an animal to ride. He could be returning to his village, especially as he looks slightly hunched and tired.

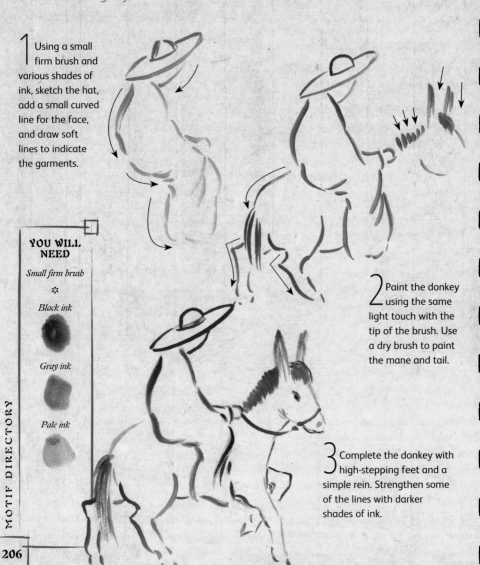

1 Using a small firm brush and various shades of ink, sketch the hat, add a small curved line for the face, and draw soft lines to indicate the garments.

2 Paint the donkey using the same light touch with the tip of the brush. Use a dry brush to paint the mane and tail.

3 Complete the donkey with high-stepping feet and a simple rein. Strengthen some of the lines with darker shades of ink.

Musician

This female musician can be used in a painting of an interior. Place her in an informal family setting in a Chinese home, or as part of an orchestra giving a recital to the Emperor.

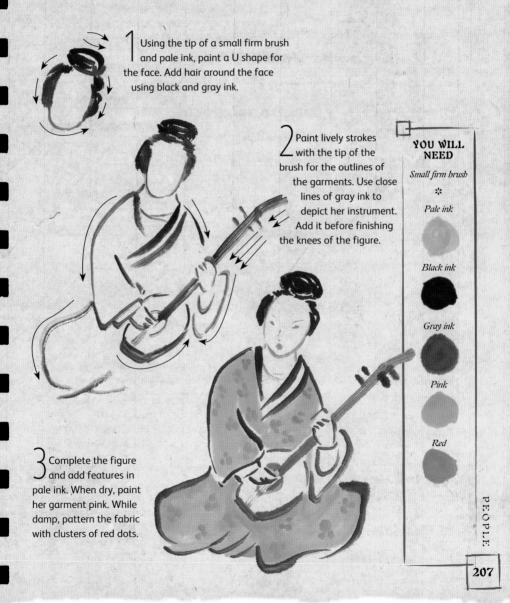

1 Using the tip of a small firm brush and pale ink, paint a U shape for the face. Add hair around the face using black and gray ink.

2 Paint lively strokes with the tip of the brush for the outlines of the garments. Use close lines of gray ink to depict her instrument. Add it before finishing the knees of the figure.

3 Complete the figure and add features in pale ink. When dry, paint her garment pink. While damp, pattern the fabric with clusters of red dots.

PEOPLE

Relaxing Woman
This lounging figure will give a landscape a sunny, summer's day feeling. She could be painted in a park, beside a stream, on a mountain plateau, or as part of a group at a picnic.

1 Using the tip of a small firm brush, paint two curving strokes of gray ink for the face and add an ear. Load the brush with black ink and paint short strokes for the hair.

2 Paint her garment in gray ink with lively strokes using the tip of the brush to give the fabric a soft, light, flowing feeling. Add her arm and book, and leave a gap where her back will rest against the rock.

3 Outline the rock using dark dry ink. Add texture strokes with a dry brush and gray ink.

4 Add some darker texture to the rock, and reinforce the soles of her shoes to ground the figure.

Couple in Conversation

Two people talking on a summer's day after a picnic is an ideal, simple motif to paint in the foreground of a landscape. The couple are relaxed and enjoying their chat.

1 Using the tip of a small firm brush and pale ink, paint an oval for the gentleman's face. Add three lines of black ink to indicate hair and use the tip of the brush to describe his features.

2 Paint soft, flowing garments with lively strokes of pale ink. Press the tip of the brush in the middle of each stroke.

3 Paint the lady's face and garments in the same way as her companion, adding a black belt.

YOU WILL NEED

Small firm brush

Pale ink

Black ink

Gray ink

4 Paint a rock between the couple with dry, uneven lines of black ink. Add texture to the rock in gray and black. Add feet and shoes with dark ink.

Nasturtiums in a Bowl

Bright, gaudy nasturtiums in a large ceramic bowl are a cheerful subject. Use them on greeting cards or include them in a picture with lettuce and vegetables; nasturtiums are good to eat, after all.

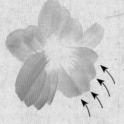

1 Using a small firm brush and various mixtures of yellow and orange, paint each petal with three or four overlapping strokes. Arrange the petals in a circle.

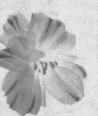

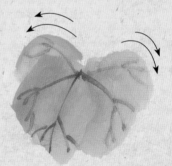

2 Add a dot of leaf green in the center of the flower. Using the tip of the brush, paint purple stamens and a few tiny lines at the edge of each petal.

3 Load a large soft brush with two shades of green and paint four large strokes for each leaf using the side of the brush. Add indigo veins with the tip of the firm brush.

4 Load the soft brush with blue and diluted indigo. Paint the bowl with large sideways sweeps of the brush. Outline the bowl with black ink while wet.

百花盛放

5 Use black ink to add some calligraphy if wished. This writing says "a hundred flowers in full bloom" and is balanced by the artist's seal in the lower right corner of the painting.

6 Add some flower buds, painting a green calyx with two strokes, the top one larger, and a few orange strokes emerging from the calyx for the unopened flower. Add indigo veins to the calyx. Paint curly green stems with the firm brush.

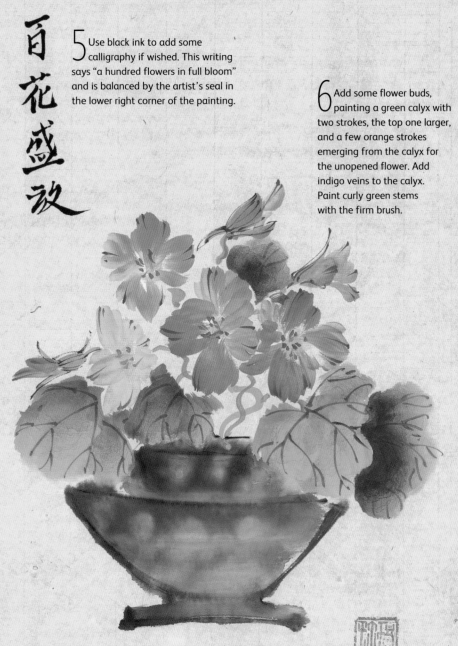

Basket of Cherries

The cherry represents feminine beauty in China. In the West, "life is a bowl of cherries" when all is going well. Perhaps this image would make a pretty Valentine card, with all its hidden meanings.

YOU WILL NEED

Small firm brush

❋

Black ink

Red

Pink

Gray ink

1 Using a small firm brush, paint the handle of the basket with a vigorous dry stroke of black ink.

2 Draw a horizontal line for the top of the basket, with two smaller ones for the base. Join the sides with angled lines and fill the basket with a lively zigzag. Use the tip of the brush to swirl ties at each joint of the handle.

3 Using various shades of red and pink, paint each cherry in the top of the pile with two curved strokes, leaving a little unpainted highlight if possible. Hold the brush upright and fill in the center if too big a highlight is left. Paint a couple of cherries outside of the basket as if they had fallen out.

4 Using the tip of the brush and gray ink, add stalks to a few cherries, with three or four horizontal strokes at the top.

5 Add dots of red between the zigzags of the basket to fill it with cherries. Paint a black line to show the back rim of the basket if it can be seen.

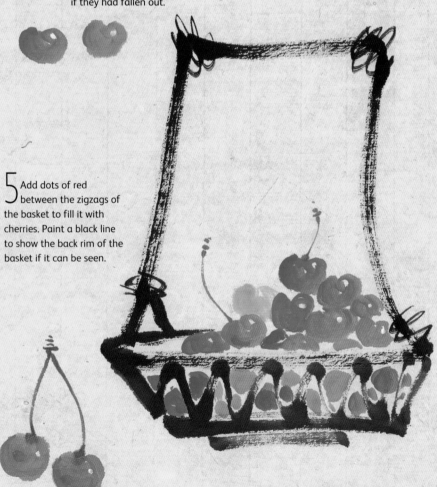

Teapot and Roses

These motifs are painted on fully sized meticulous paper. This is nonabsorbent paper and allows the paint to sit on the surface, so the paint can be blended easily as well as overpainted.

2 Use two medium soft brushes to color the rose, one to apply the color and the other to blend it. Start with little areas of burnt sienna behind each petal, blending it outward with clear water. There should be no hard lines to the edge of the paint. Apply two or three layers.

1 Using a fine brush and gray ink, outline the rose with fine, clear lines with definite beginnings and endings. The lines should have a calligraphic feel. Start from the center of the rose and work outward.

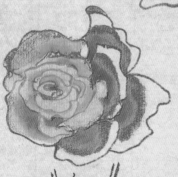

3 When dry, paint a layer of yellow over the whole rose.

4 Outline the stem with dark ink and then add branches and leaves. Color each leaf with indigo in the center, blending it outward as before.

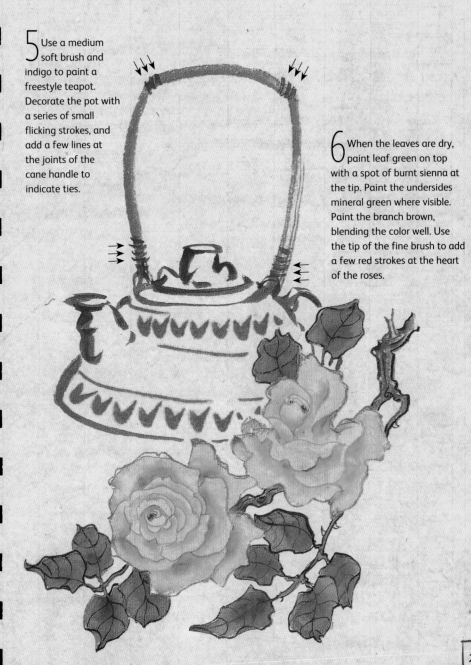

5 Use a medium soft brush and indigo to paint a freestyle teapot. Decorate the pot with a series of small flicking strokes, and add a few lines at the joints of the cane handle to indicate ties.

6 When the leaves are dry, paint leaf green on top with a spot of burnt sienna at the tip. Paint the undersides mineral green where visible. Paint the branch brown, blending the color well. Use the tip of the fine brush to add a few red strokes at the heart of the roses.

Grapes in a Basket

Paint the main bunch of grapes and large leaf first, then add the basket. Finish off the painting with more grapes and leaves among the wickerwork.

1 Using a medium soft brush and various shades of purple, paint each grape with two curving strokes. Add a dot of black ink at the bottom of each grape.

2 Using a large soft brush, paint two large strokes with the side of the ferrule for the central lobe of the leaves, with two smaller strokes on each side. Paint veins on the leaves with the tip of the brush. Vary the colors of the leaves, adding burnt sienna or purple for contrast.

3 Using a dry soft brush and gray ink, paint the basket. Alternate several rows of short strokes to simulate woven wickerwork. Add the handle, then use the tip of the brush to paint swirling ties around the joints.

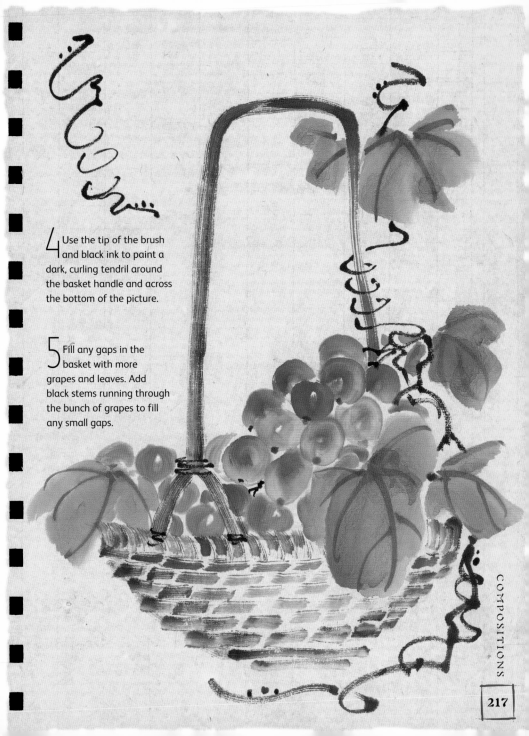

4 Use the tip of the brush and black ink to paint a dark, curling tendril around the basket handle and across the bottom of the picture.

5 Fill any gaps in the basket with more grapes and leaves. Add black stems running through the bunch of grapes to fill any small gaps.

Seafood Supper

A bowl of cooked crab and some whelks makes a simple supper. To vary the picture, you could paint fish on the plate, or clams and winkles. The writing says "Seafood Supper."

YOU WILL NEED

Medium soft brush

❅

Fine brush

❅

Orange

Red

Black ink

Pink

Indigo

Gray ink

Burnt sienna

MOTIF DIRECTORY

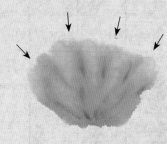

1 Load a medium soft brush with orange and dip the tip in red. Paint the crab carapace with four strokes using the side of the brush, tapering the bottom of each stroke.

2 Use the tip of the brush to paint the legs, four on each side. The legs are tucked under the crab, so you can only see a couple of complete ones. Add the claws, with black dots inside the gripping edges.

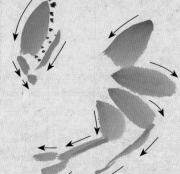

3 Paint the bowl in pink and indigo, using the tip of the soft brush to draw the lip of the bowl, then turning the brush on its side for the next two strokes, giving the bowl its depth. Add two small straight lines for the base. Decorate the rim with a V-shaped pattern of short strokes.

4 Outline the whelk in black ink using a fine brush. When dry, use the tip of the soft brush and a dilute mixture of indigo and gray ink to add shadows under the lines.

5 Using a dry soft brush and burnt sienna, color the shell with curving strokes.

6 Use black ink to add some calligraphy if wished. This writing says "Seafood Supper" and is balanced by the artist's seal in the lower left corner of the painting. Add two dots and lines for eyes and antennae, and outline the carapace of the crab a little to define the body.

海鮮饕

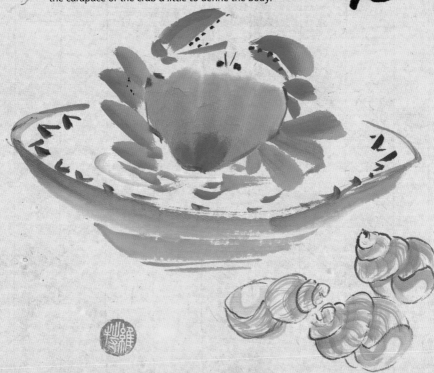

Goldfish and Weeds

These simple motifs could be painted on tiles in a bathroom, or on a glass or lampshade. Pond weeds, called elodea, are great fun to paint, weaving among the fish.

1 Load a small firm brush with dark orange. Holding it upright, paint four short firm strokes for the face of the fish, shortest at the sides. Add a short stroke for the mouth. Load the brush with pale orange and paint two longer and larger strokes for the body and four short strokes for the fins.

2 Add a three-pronged tail using the side of the brush. Depict the eye with fine black lines and a dot, with a little blue behind the dot. Using the tip of the brush and red, paint fine lines on the tail and fins and a few spots on the back.

3 Paint a wavy leaf green line using the tip of the brush. Add two small curved strokes on each side, ending at the wavy line. Continue adding pairs of longer curved lines, ending at the same spot, until you reach the required width. Taper some of the weeds, and alter the shade of green occasionally.

4 Indicate the bottom of the tank with sage green pebbles. Paler ones higher in the water could be bubbles or algae.

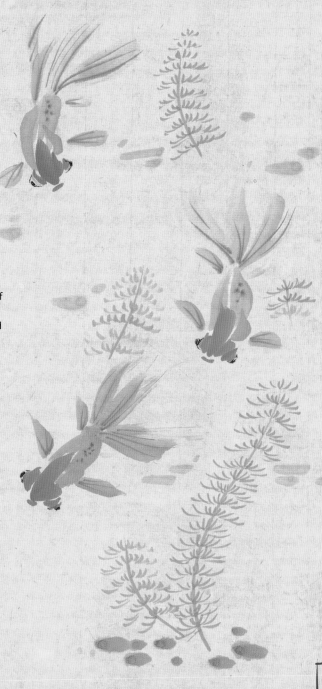

5 Vary the angle of the fish as they are swimming in and out of the weeds. Add an artist's seal and calligraphic signature if wished.

Pekinese and Butterfly

The idea for this painting could be adapted to other animals and insects, such as a cat and bee, a mouse and wasp, or a squirrel and dragonfly.

YOU WILL NEED

Fine brush

✤

Small firm brush

✤

Black ink

Mineral blue

Sky blue

Orange

Gray ink

Yellow

Burnt sienna

White

1 Using a fine brush and black ink, outline the head, thorax, and abdomen of the butterfly. Attach six legs to the thorax. Use a series of short dashes ending in dots for the antennae. Draw the wing shapes and add a pattern of lines.

2 Using a small firm brush, color the inner wings mineral blue and the outer wings sky blue. Add a series of ink dots for decoration. Color the body orange.

3 Using the fine brush and ink, outline the dog's ears and face. Make the nose and eyes darker.

4 Use the tip of the firm brush to reinforce the ears with long, flowing strokes of ink, pressing in the middle of each stroke. Splay the brush and add soft, short gray strokes all over the forehead and around the eyes and muzzle. Add yellow, burnt sienna, and a few white highlights to the eyes.

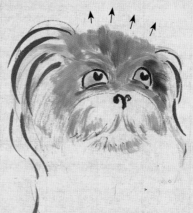

5 Complete the coat of the dog with short dry strokes of gray ink using a splayed firm brush. Add the feet, then paint the tail with large sweeps of gray ink.

6 Load the brush with ink, then dip generously in burnt sienna. Press the brush onto the paper to create a pattern of footprints below the dog.

COMPOSITIONS

This is the flag iris. It makes a lovely bright picture and could be used on a greeting card to great effect. Although a mantis is painted here, any insect would complement the iris.

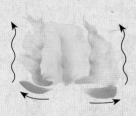

1 Load a medium soft brush with yellow and dip the tip in burnt sienna. Press the whole of the ferrule onto the paper with the tip facing downward; do this twice to produce the central petal. Paint the curvy side petals by moving the tip up each edge of the first petal. Add two short pink strokes beneath.

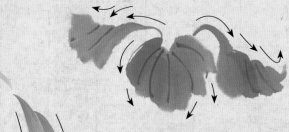

2 Paint the lower three petals with broad strokes of pink. Use the tip of the soft brush to add purple veins.

3 Load a large firm brush with leaf green and dip the tip in sage green. Paint two curving strokes for each leaf, starting with the tip and then pressing the brush as you go. Color some of the leaves by dipping the green-loaded brush into pink.

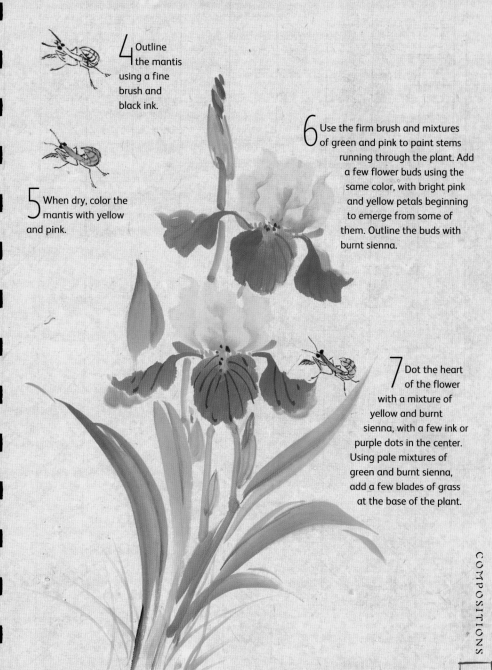

4 Outline the mantis using a fine brush and black ink.

5 When dry, color the mantis with yellow and pink.

6 Use the firm brush and mixtures of green and pink to paint stems running through the plant. Add a few flower buds using the same color, with bright pink and yellow petals beginning to emerge from some of them. Outline the buds with burnt sienna.

7 Dot the heart of the flower with a mixture of yellow and burnt sienna, with a few ink or purple dots in the center. Using pale mixtures of green and burnt sienna, add a few blades of grass at the base of the plant.

Cucumber and Bumble Bee

The bee may indicate industriousness and thrift. In this picture, a bumble bee is about to collect honey from the luscious cucumber flowers.

YOU WILL NEED

Medium soft brush

❈

Fine brush

❈

Small firm brush

❈

Sage green

Black ink

Blue

Yellow

Burnt sienna

Gray ink

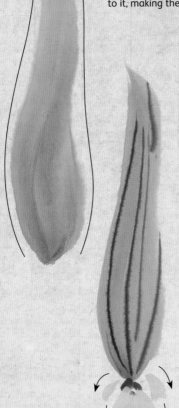

1 Using a medium soft brush and sage green, press quite firmly to paint a large upward stroke for the cucumber. Paint another next to it, making the lower end a little fatter.

2 Use the tip of the brush and black ink to paint lines along the cucumber while damp. Add a little blue to the ink and paint a couple of dots at the base of the cucumber, than add four or five short fat yellow strokes for the flower.

3 Using a fine brush and black ink, draw the antennae and eyes of the bee. Change to a small firm brush and paint a large yellow dot for the thorax and a blue half-moon for the abdomen.

4 Dot the yellow thorax with ink. Using a mixture of burnt sienna and gray ink, add pale wings; paint burnt sienna lines on them. Add tiny ink lines for the bee's back legs.

MOTIF DIRECTORY

226

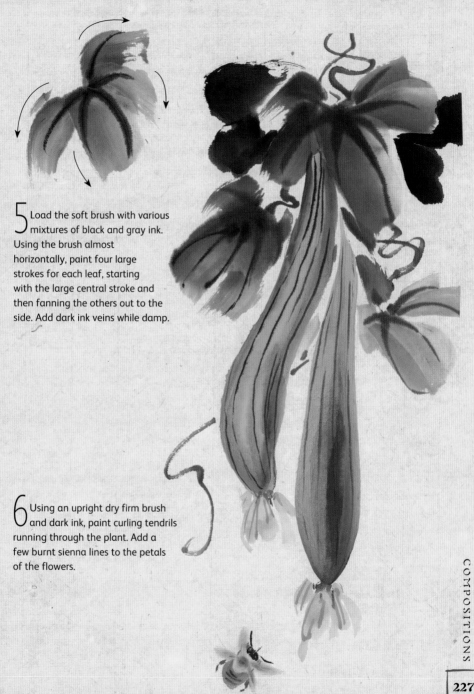

5 Load the soft brush with various mixtures of black and gray ink. Using the brush almost horizontally, paint four large strokes for each leaf, starting with the large central stroke and then fanning the others out to the side. Add dark ink veins while damp.

6 Using an upright dry firm brush and dark ink, paint curling tendrils running through the plant. Add a few burnt sienna lines to the petals of the flowers.

YOU WILL NEED

Large firm brush

❊

Fine brush

❊

Large soft brush

❊

Light red

Dark red

Sage green

Black ink

Yellow

Leaf green

Burnt sienna

Lotus and Frog

There are good contrasts in this composition. The finely outlined frog contrasts with the freestyle leaf. Thin, willowy reeds contrast with the thick, fleshy lotus. Fine dots on the frog and stem contrast with splashy dots on the leaf.

1 Load a large firm brush with light red and dip the tip in dark red. Start with the tip of the brush at the top of each petal and press down firmly to give a fat stroke. Place a second stroke beside it.

2 Add dark red lines using the tip of the brush. Paint a thick stroke of sage green mixed with ink for the stem, and dot with black. Use a fine brush to draw green circles in the center of the flower; fill these with yellow and a black dot. Add curving black stamens.

3 Use a resist technique to paint the leaves. First, splash a few drops of light cream (the kind you eat) onto the paper. When dry, paint broad strokes of sage green over the cream with the side of the soft brush.

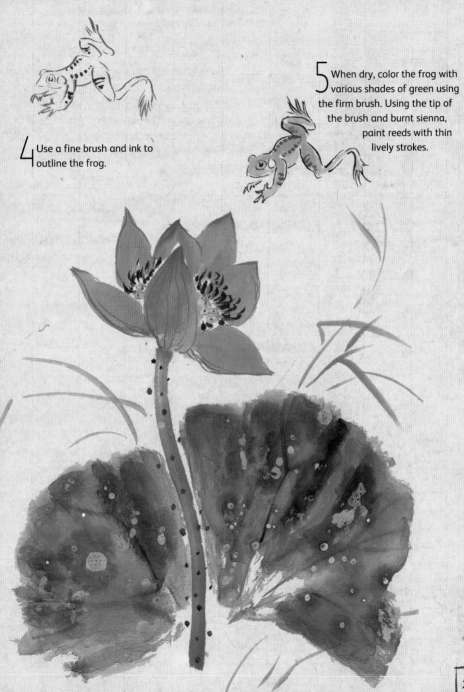

4 Use a fine brush and ink to outline the frog.

5 When dry, color the frog with various shades of green using the firm brush. Using the tip of the brush and burnt sienna, paint reeds with thin lively strokes.

Squirrel and Lychee

This finely painted squirrel is looking up at a snail crawling on the twig of a lychee tree.

MOTIF DIRECTORY

YOU WILL NEED

Fine brush

❋

Small firm brush

❋

Large soft brush

❋

Black ink

Brown + gray ink

Pink

Red

Mineral green

Indigo

1 Using a fine brush and black ink, paint the nose, eyes, and ears of the squirrel. Using a dry fine brush, paint the body with lots of tiny fine lines to give a fluffy appearance.

2 Change to a small firm brush, splayed at the end and loaded with a mixture of brown and gray ink. Paint lots of short dry strokes all over the squirrel; leave the chest, stomach, inner ear, and a circle around the eye unpainted. When dry, add wet strokes, avoiding the unpainted highlights.

3 Use the firm brush to paint a sturdy black branch with dots for mosses and lichens.

4 Load a large soft brush with gray ink and dip the tip in black ink. Paint two strokes with the side of the brush for each leaf. Add black veins.

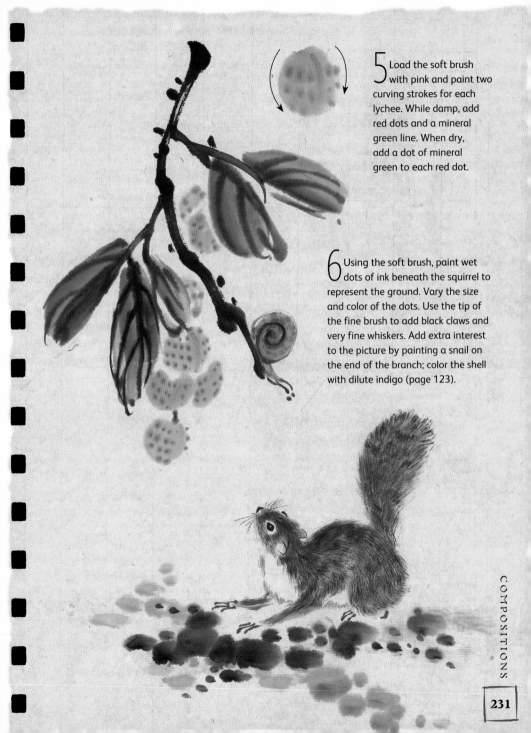

5 Load the soft brush with pink and paint two curving strokes for each lychee. While damp, add red dots and a mineral green line. When dry, add a dot of mineral green to each red dot.

6 Using the soft brush, paint wet dots of ink beneath the squirrel to represent the ground. Vary the size and color of the dots. Use the tip of the fine brush to add black claws and very fine whiskers. Add extra interest to the picture by painting a snail on the end of the branch; color the shell with dilute indigo (page 123).

Wisteria and Swallow

This picture could be painted with a sparrow or bluetit, and the wisteria could be pale pink, deeper purple, or white. By altering the colors and components, the picture will become uniquely yours.

YOU WILL NEED

Medium soft brush

❉

Small firm brush

❉

Blue

Purple

Yellow + white

Green

Burnt sienna

Black ink

Gray ink

1 Load a medium soft brush with blue and dip the tip in purple. With the tip pointing inward, paint two upper petals. Use purple for the lower petals. Add two dots of yellow mixed with white in the center.

2 Paint a central green stem emerging from the mass of open flowers, with blue and purple buds at the end. Paint burnt sienna sepals around each bud.

3 Using the tip of a small firm brush and black ink, paint the eye and beak of the bird, and a flat, dark head.

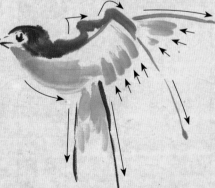

4 Color the throat with burnt sienna, the belly with gray ink, and the tail with both colors. Paint the wings with various shades of ink, making sure the swallow has its distinctive long wing and tail feathers.

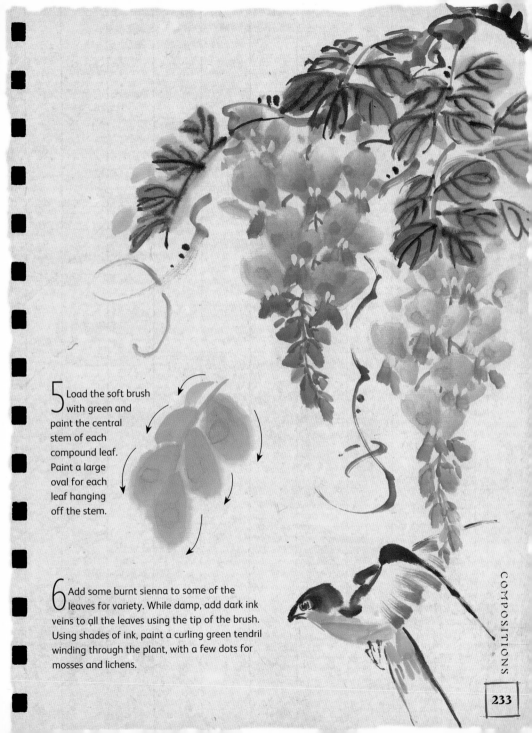

5 Load the soft brush with green and paint the central stem of each compound leaf. Paint a large oval for each leaf hanging off the stem.

6 Add some burnt sienna to some of the leaves for variety. While damp, add dark ink veins to all the leaves using the tip of the brush. Using shades of ink, paint a curling green tendril winding through the plant, with a few dots for mosses and lichens.

YOU WILL NEED

Fine brush

❈

Small firm brush

❈

Large soft brush

❈

Wash brush

❈

Black ink

Indigo + gray ink

Yellow

Burnt sienna

Leaf green

Sage green

White

Heron with Banana Leaf

The heron is often painted among river plants, such as reeds and sedges, and willow or water plants, such as lotus and lily. Here, it is painted with the banana, which is the symbol of self-discipline. Banana leaves are a favorite subject to paint—rarely the fruit—and Chinese scholars regarded banana leaves as precious things.

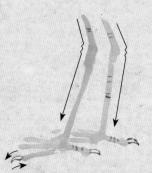

1 Using a fine brush and black ink, outline the beak, eye, "eyebrow," and head, followed by the general shape of the body, with some fine wing feathers. Change to a small firm brush and paint a black shoulder feather. Load the brush with a mixture of indigo and gray ink to add more feathers.

2 Load the brush with a mixture of yellow and burnt sienna and paint the legs, pausing at the knee to make the line a little thicker. Paint the toes, then use the fine brush and black ink to add curled claws and a few lines to indicate scales on the legs.

3 Using the tip of a large soft brush, paint two long black lines for the midrib of the leaves. Load the brush with leaf green and dip the tip in sage green. Paint large strokes away from the midrib using the side of the brush. While damp, add black ink veins with the tip of the brush.

4 Paint short strokes of green and ink below the heron's feet. Change to the firm brush to paint the eye yellow and the beak yellow and burnt sienna. Add strokes of white over the head, neck, and body of the heron. When the painting is dry, turn it over and use a wash brush to apply a yellow green wash to the back.

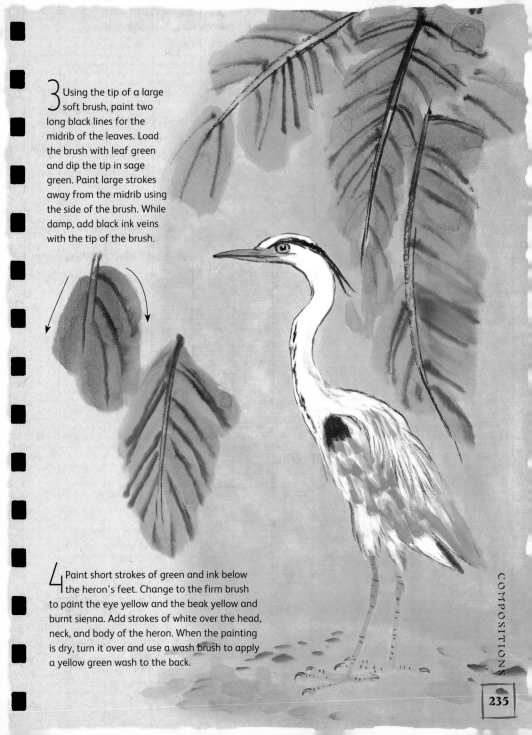

COMPOSITIONS

235

YOU WILL NEED

Medium soft brush

❖

Small firm brush

❖

Wash brush

❖

Orange

Red

Yellow

White

Black + gray ink

Leaf green

Sage green

Mineral blue + indigo

Camellia and Bird

Known as "Mountain Tea" in China, the camellia is a beautiful flower, symbolizing fidelity. Here, it is painted in a loose, freestyle fashion with a broken wash and snow, as well as a simple bird.

1 Load a medium soft brush with orange and dip the tip in red. Paint each petal using the side of the brush. Dot yellow in the center. When dry, add white lines topped with yellow dots for stamens and a long white pistil.

2 Using black ink and a small firm brush, paint a sturdy branch, pausing occasionally to create joints.

3 Load the soft brush with leaf green and dip the tip in sage green. Holding the brush at 45 degrees, paint two broad strokes for each leaf. Add a black vein to the center.

4 Load the soft brush with gray ink and paint a circle for the bird's head, leaving space for the eye.

5 Add broad gray strokes for the wings and belly, and sweep in three tail feathers. Use the tip of the brush to paint the eye and beak in black, and define the wings with black strokes.

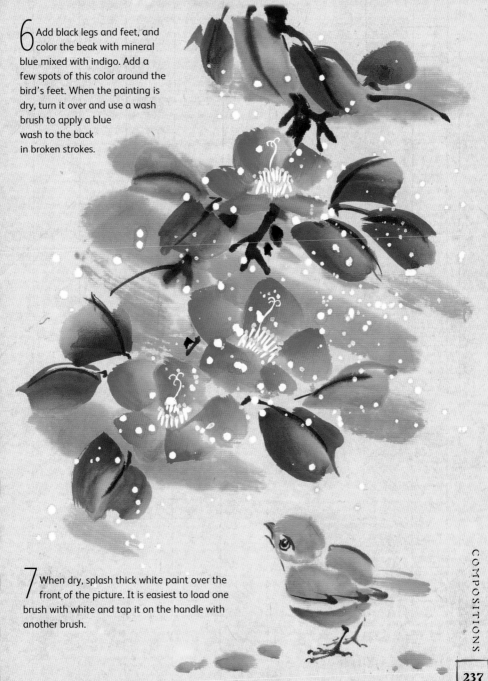

6 Add black legs and feet, and color the beak with mineral blue mixed with indigo. Add a few spots of this color around the bird's feet. When the painting is dry, turn it over and use a wash brush to apply a blue wash to the back in broken strokes.

7 When dry, splash thick white paint over the front of the picture. It is easiest to load one brush with white and tap it on the handle with another brush.

Flycatcher with Berries

An exotic red paradise flycatcher perches on a branch with berries in this composition. Try painting a magpie, hummingbird, parrot, or pheasant in the same way, perhaps on a branch with flowers or wonderful leaves.

1 Using a fine brush and black ink, paint the beak and eye. Outline the whole shape of the bird, including the wing feathers and long sweeping tail. Begin to brush in feathers on the head with a splayed small firm brush and gray and black ink.

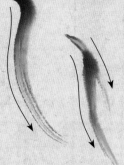

2 Using a dry firm brush and black ink, paint lively lines for the branch.

3 Paint one large stroke with the side of the firm brush followed by a shorter stroke for each leaf. Vary the leaves from green to blue. Mix green and blue together to paint the central vein.

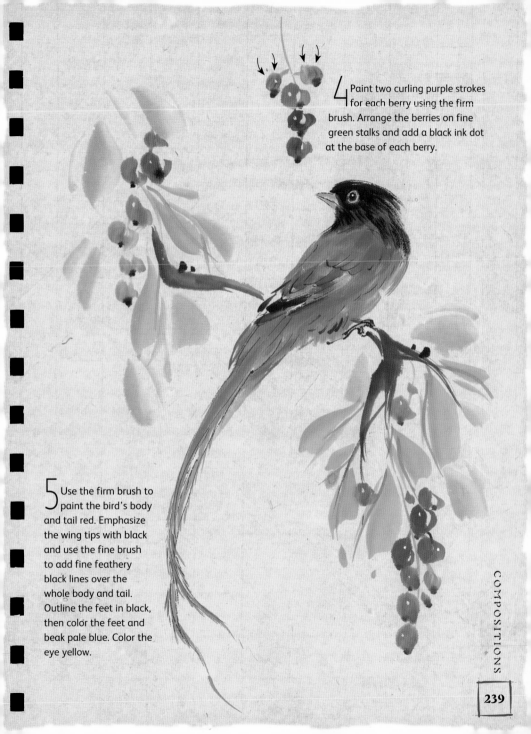

4 Paint two curling purple strokes for each berry using the firm brush. Arrange the berries on fine green stalks and add a black ink dot at the base of each berry.

5 Use the firm brush to paint the bird's body and tail red. Emphasize the wing tips with black and use the fine brush to add fine feathery black lines over the whole body and tail. Outline the feet in black, then color the feet and beak pale blue. Color the eye yellow.

YOU WILL NEED

Fine brush

❉

Small firm brush

❉

Medium soft brush

❉

Black ink

Gray ink

Red

Pink

Green

Burnt sienna

Blue

Yellow

Jay with Plum Blossom

Vary this composition by changing the bird to a sparrow, blackbird, or finch, and alter the plum blossom to a chrysanthemum, nasturtium, or pine. Alter the color of the rock or make it a different shape.

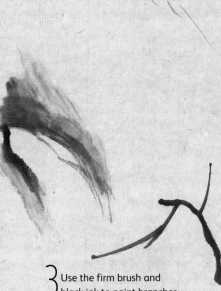

1 Using a fine brush and black ink, paint the eye and beak. Change to a small firm brush to dot in the gray and black markings on the head. Use the tip of the brush to outline the general shape of the bird in broken lines.

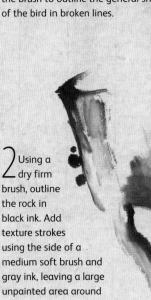

2 Using a dry firm brush, outline the rock in black ink. Add texture strokes using the side of a medium soft brush and gray ink, leaving a large unpainted area around the bird.

3 Use the firm brush and black ink to paint branches.

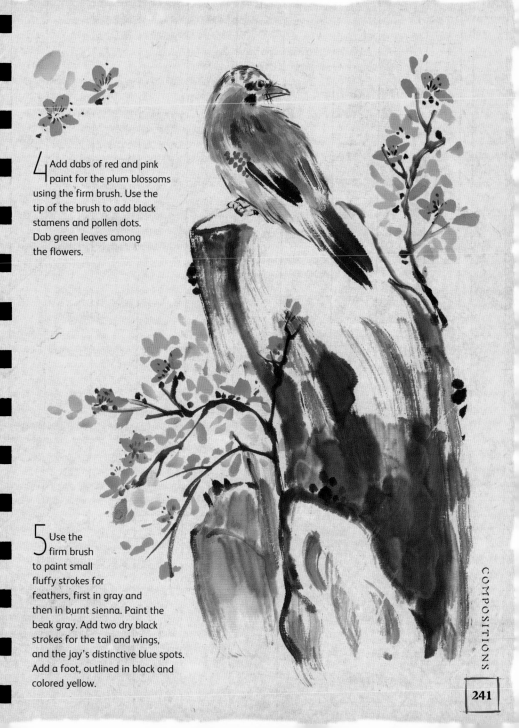

4 Add dabs of red and pink paint for the plum blossoms using the firm brush. Use the tip of the brush to add black stamens and pollen dots. Dab green leaves among the flowers.

5 Use the firm brush to paint small fluffy strokes for feathers, first in gray and then in burnt sienna. Paint the beak gray. Add two dry black strokes for the tail and wings, and the jay's distinctive blue spots. Add a foot, outlined in black and colored yellow.

Pavilion in the Hills

This pavilion is painted among trees and mountains and is probably a summer retreat or a traveler's lodge. The top edge of the mountain appears dark, while the lower edge blends away into mist.

YOU WILL NEED

Fine brush

❋

Small firm brush

❋

Medium soft brush

❋

Black ink

Burnt sienna

Pink

Indigo

Gray ink

Green

1 Using a fine brush and black ink, outline the roof and then the rest of the building. Add decorations around the roof with little V-shaped strokes. Add vertical strokes for the veranda fencing and roof tiling in ink, or do this later in color—vary the styling of the pavilion to suit your own composition.

2 Using a small firm brush, color the pavilion with burnt sienna and pink, or any colors you like. Paint the floor with strokes of dilute indigo, and add gray ink shadows under the roof and in the windows.

3 Load the firm brush with various dilutions of indigo and paint a series of dots close together. Leave space for a branch, then paint another patch of dots. Take care to observe the overall shape of the tree and branches, and leave a wider space in the middle for the trunk.

4 Paint a flock of birds above the trees with two tiny curved lines of black or gray ink using the tip of the firm brush.

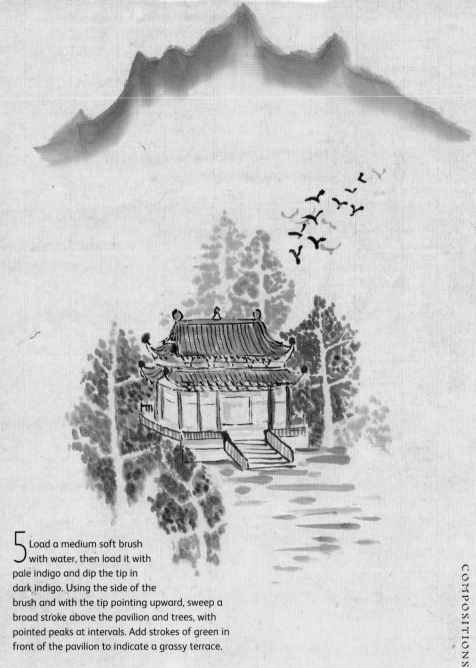

5 Load a medium soft brush with water, then load it with pale indigo and dip the tip in dark indigo. Using the side of the brush and with the tip pointing upward, sweep a broad stroke above the pavilion and trees, with pointed peaks at intervals. Add strokes of green in front of the pavilion to indicate a grassy terrace.

Woodland Homestead

This picture of a woodland homestead offers the chance to practice some landscape techniques. You could also add some distant mountains, people, or animals to the painting.

1 Using a medium soft brush and black ink, outline each group of rocks. Add texture to the rocks with short strokes of gray ink.

2 Outline the tree trunks using a dry small firm brush and dark ink. Add circles of rough bark to the largest tree, and a few black knots.

3 Try different types of foliage on each tree: groups of overlapping pine needles in dark ink; dots in various shades of indigo; and masses of short, upward-curving gray strokes.

YOU WILL NEED

Medium soft brush

❋

Small firm brush

❋

Black ink

Gray ink

Indigo

Green

Burnt sienna

MOTIF DIRECTORY

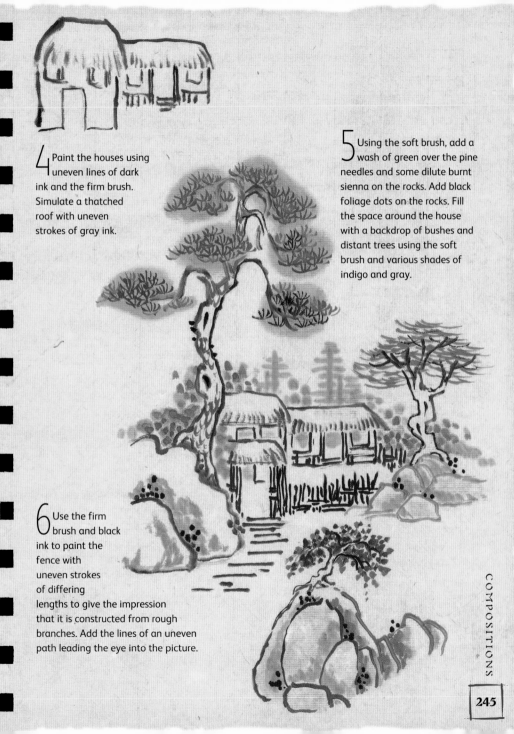

4 Paint the houses using uneven lines of dark ink and the firm brush. Simulate a thatched roof with uneven strokes of gray ink.

5 Using the soft brush, add a wash of green over the pine needles and some dilute burnt sienna on the rocks. Add black foliage dots on the rocks. Fill the space around the house with a backdrop of bushes and distant trees using the soft brush and various shades of indigo and gray.

6 Use the firm brush and black ink to paint the fence with uneven strokes of differing lengths to give the impression that it is constructed from rough branches. Add the lines of an uneven path leading the eye into the picture.

COMPOSITIONS

245

Girl Watching Fish

This very simple picture captures a moment of contemplation. Try using different colors for the fish and for the little girl's hair and clothes.

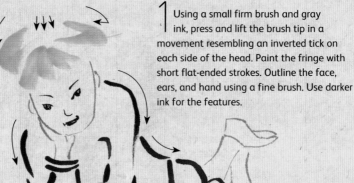

1 Using a small firm brush and gray ink, press and lift the brush tip in a movement resembling an inverted tick on each side of the head. Paint the fringe with short flat-ended strokes. Outline the face, ears, and hand using a fine brush. Use darker ink for the features.

2 Use the tip of the firm brush and black ink to paint lively lines for the clothes and shoreline. Draw the shoes and legs in gray ink with the fine brush.

3 Use the firm brush and gray ink to paint a leaf shape for the top of the fish. Add a line of dark ink for the dorsal fin. Draw the lips, eye, and gill with the fine brush.

4 Add a line for the belly and crosshatch the back of the fish to give scales. Use the tip of the firm brush to add four fins and a tail.

5 Load the firm brush with green and use the tip to paint some rushes on each side of the figure. Add some black ink stalks among the greenery. Paint the girl's skirt blue, her shoes pink, and her top white with a tiny dash of blue.

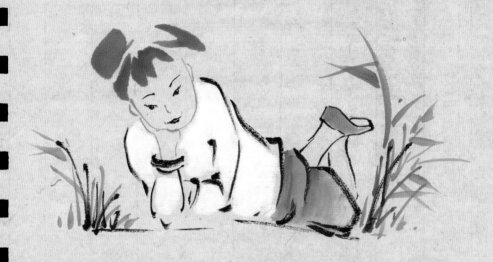

6 Use the tip of the brush to draw wavy blue lines among the fish to indicate water.

COMPOSITIONS

247

Piper and Puppy

The little piper, playing a tune to his puppy, provides some nice contrasts between the calligraphic strokes of the clothing and puppy, and the fine lines of the face, flute, and fingers.

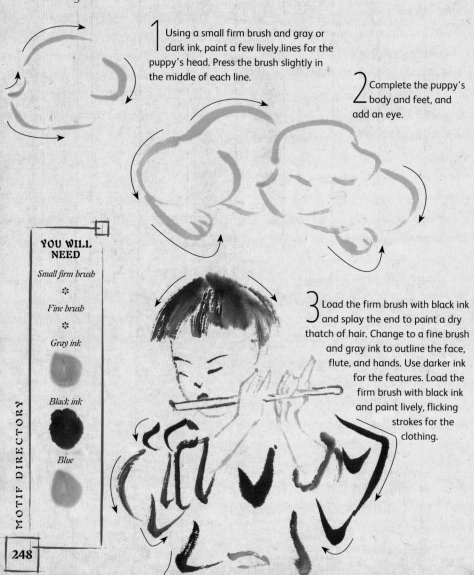

1 Using a small firm brush and gray or dark ink, paint a few lively lines for the puppy's head. Press the brush slightly in the middle of each line.

2 Complete the puppy's body and feet, and add an eye.

3 Load the firm brush with black ink and splay the end to paint a dry thatch of hair. Change to a fine brush and gray ink to outline the face, flute, and hands. Use darker ink for the features. Load the firm brush with black ink and paint lively, flicking strokes for the clothing.

YOU WILL NEED

Small firm brush

❊

Fine brush

❊

Gray ink

Black ink

Blue

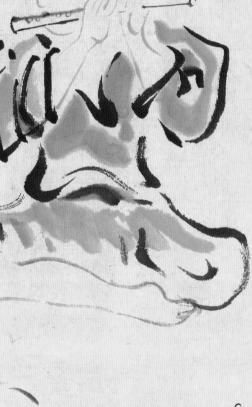

4 Add the legs and feet in gray ink. When dry, color the boy's clothing with mixtures of blue and gray ink.

5 Use the tip of the firm brush to give the puppy a small tail in dry dark ink.

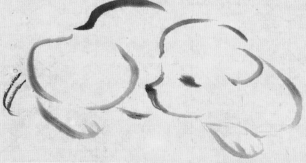

Child with Kite

This is a lovely depiction of a windy day. The picture can be reduced in size and added to another scene, such as a walk in the mountains or a picnic in the park.

1 Using a fine brush and black ink, draw two curves for the face with an eyelash.

YOU WILL NEED

Fine brush

❋

Small firm brush

❋

Black ink

Gray ink

Blue

Pink

Purple

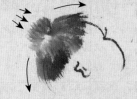

2 Load a small firm brush with dry dark ink and splay the tip to paint the boy's hair unevenly so that it looks windswept. Add an ear.

3 Using the tip of the firm brush and dark ink, paint the boy's jacket and trousers in short strokes. Each stroke should have a definite beginning and ending.

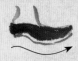

4 Add a dark curving stroke below the trousers too indicate the shoes, with a paler ink stroke below for the sole. Sketch in the ankles with gray ink.

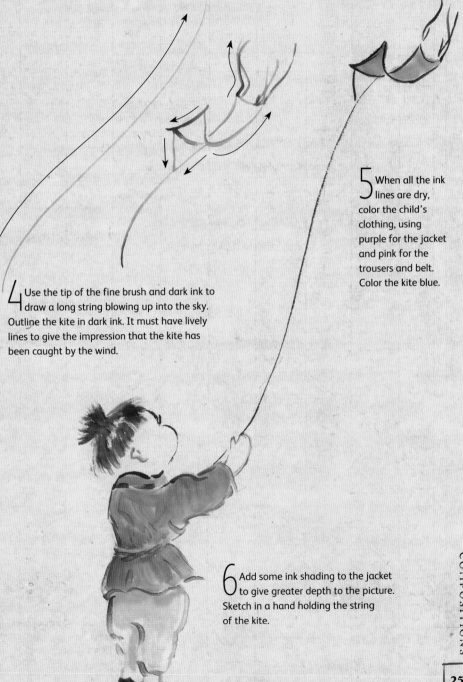

5 When all the ink lines are dry, color the child's clothing, using purple for the jacket and pink for the trousers and belt. Color the kite blue.

4 Use the tip of the fine brush and dark ink to draw a long string blowing up into the sky. Outline the kite in dark ink. It must have lively lines to give the impression that the kite has been caught by the wind.

6 Add some ink shading to the jacket to give greater depth to the picture. Sketch in a hand holding the string of the kite.

Girl with Her Catch

This picture of a little girl and her basket of fish would look nice on a greeting card. She could also be painted beside a river or lake in a landscape.

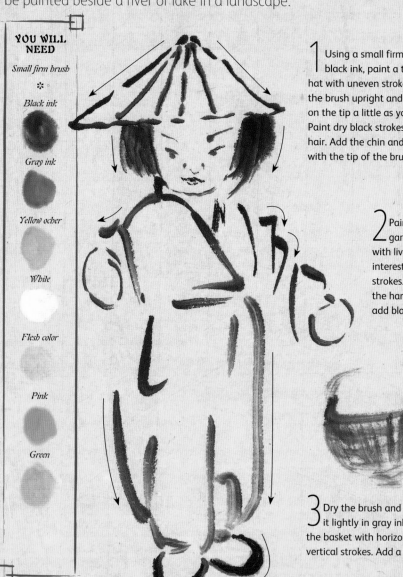

1 Using a small firm brush and black ink, paint a triangular hat with uneven strokes, holding the brush upright and bouncing on the tip a little as you draw. Paint dry black strokes for the hair. Add the chin and features with the tip of the brush.

2 Paint the garments with lively, interesting strokes. Outline the hands and add black shoes.

3 Dry the brush and then dip it lightly in gray ink. Weave the basket with horizontal and vertical strokes. Add a handle.

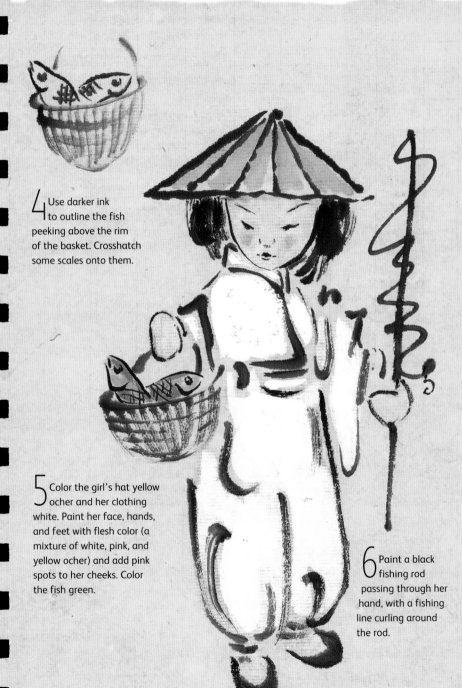

4 Use darker ink to outline the fish peeking above the rim of the basket. Crosshatch some scales onto them.

5 Color the girl's hat yellow ocher and her clothing white. Paint her face, hands, and feet with flesh color (a mixture of white, pink, and yellow ocher) and add pink spots to her cheeks. Color the fish green.

6 Paint a black fishing rod passing through her hand, with a fishing line curling around the rod.

Index

Suppliers

UNITED STATES
Dick Blick Art Materials
PO Box 1267
Galesburg, IL 61402-1267
General info: (800) 933 2542
info@dickblick.com
International: (309) 343
 6181
international@dickblick.com
www.dickblick.com

Jerry's Artarama
5325 Departure Drive
Raleigh, NC 27616
(800) 827 8478
www.jerrysartarama.com

UNITED KINGDOM
Louisa S.L. Yuen
Oriental Arts
5 Gardner Street
Brighton
East Sussex BN1 1UP
(01273) 819 168
louisayuen1000@yahoo.co.uk

Guanghwa Company
7–9 Newport Place
Chinatown
London WC2H 7JR
(020) 7437 3737
customers@guanghwa.com
www.guanghwa.com

Ying Hwa Co. Ltd
14 Gerrard Street
London W1D 5PT
(020) 7439 8825

AUSTRALIA
Art Requirements
1 Dickson Street
Wooloowin, QLD 4030
(07) 3857 2732

Eckersley's
97 Franklin Street
Melbourne, VIC 3000
(03) 9663 6799
art@eckersleys.com.au
www.eckersleys.com.au

HONG KONG
Man Luen Choon
International Supplies
2nd Floor, Harvest Building
29–35 Wing Kut Street
(852) 2544 6965
art@manluenchoon.com
www.manluenchoon.com

Author's acknowledgments

This book is dedicated to my Mum and Dad, with thanks for all their love and encouragement. Thanks must also go to my teacher Qu Lei Lei for letting me use his picture in the gallery, and to Louisa Yuen of Oriental Arts in Brighton for the use of equipment for the materials section.

Picture credits